WILLIAM MERRITT CHASE

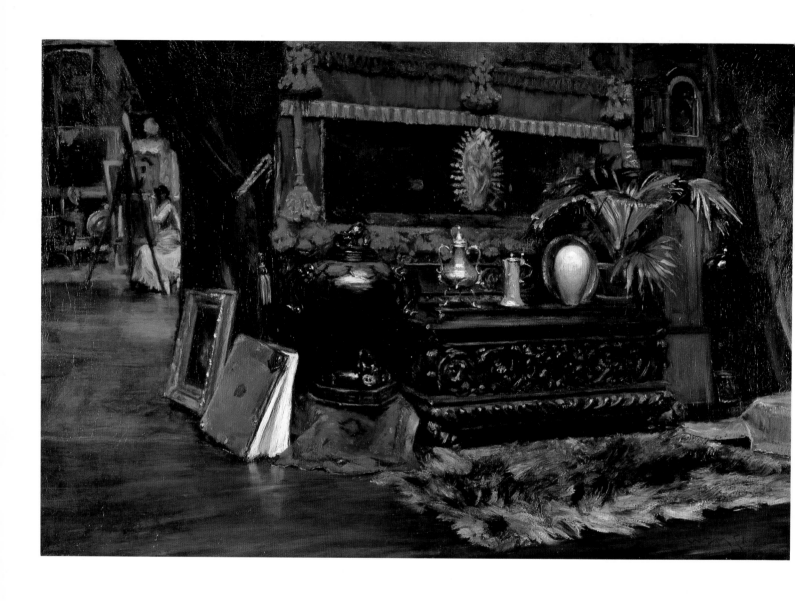

William Merritt Chase

BARBARA DAYER GALLATI

Harry N. Abrams, Inc., Publishers
IN ASSOCIATION WITH
The National Museum of American Art, Smithsonian Institution

Series Director: Margaret L. Kaplan
Editor: Robbie Capp
Designer: Ellen Nygaard Ford
Photo Research: Jennifer Bright

Library of Congress Cataloging-in-Publication Data

Gallati, Barbara Dayer.
 William Merritt Chase / Barbara Gallati.
 p. cm.—(Library of American art)
 Includes bibliographical references (p.) and index.
 ISBN 0–8109–4029–9
 1. Chase, William Merritt, 1849–1916—Criticism and
 interpretation. 2. Realism in art—United States. I. Title.
 II. Series: Library of American art (Harry N. Abrams, Inc.)
ND237.C48G36 1995
759.13—dc20 94–3487
 CIP

Frontispiece: *The Inner Studio, Tenth Street*
 c. 1880s. Oil on canvas, 32⅜ x 44¼"
 The Virginia Steele Collection,
 Henry E. Huntington Library and Art Gallery,
 San Marino, California
 (For commentary, see page 48)

Published in 1995 by Harry N. Abrams, Incorporated, New York
A Times Mirror Company

Printed and bound in Japan

Contents

Preface

Writing about William Merritt Chase was both a challenge and a joy. Naturally, one always hopes to present an interesting and accurate account of an artist's career and to bring something new to light. The particular challenge posed by Chase is that his art and life are already well documented—especially in the voluminous press coverage devoted to him in his own time, two biographies, and by the fruits of the long-term research conducted by Chase scholar Ronald Pisano. As witnessed by the frequency with which his name appears in the selected bibliography included here, it is clear that all of us involved in Chase studies—scholars, collectors, and dealers alike—are indebted to Mr. Pisano for constructing the modern foundation for the investigation of Chase's art.

Yet despite the abundance of documentary information existing on Chase, much remains to be said about his art—particularly in the area of interpreting his imagery in the broader American and European art-historical contexts. More than anything, this fact reflects the inherent merit of the work itself and reaffirms the appropriateness of Chase's position in the upper ranks of America's painters. My approach was governed, for the most part, by the straightforward and utterly pleasurable process of looking closely at Chase's works as individual statements, allowing my own tendency to exercise iconographic rather than formal analysis to prevail. This rewarding process raised new questions and generated new insights about the artist for me, many of which are introduced in the text that follows. Above all, it is my sincerest wish that the pleasure I derived from looking anew at Chase's art is transmitted here.

I am deeply grateful to Margaret Kaplan, Senior Vice President of Harry N. Abrams, Inc., and to Elizabeth Broun, Director of the National Museum of American Art, Smithsonian Institution, for giving me the opportunity to contribute to the Library of American Art series. I am also especially indebted to the many private collectors and institutions who graciously permitted their works to be reproduced in this volume. William H. Gerdts deserves separate mention, particularly for alerting me to the review that permits reidentification of Chase's pastel formerly known as *Gravesend Bay,* and always for his enthusiastic sharing of ideas and information. The following people also deserve special acknowledgment for their generous and invaluable help in the process of locating works, obtaining reproductions, and exchanging information: Warren Adelson, Adelson Galleries, New York; Carol Burtner, Virginia Museum of Fine Arts, Richmond; Donna DeSalvo, Alicia Longwell, and Kent Russell, The Parrish Art Museum, Southampton, New York; Martha Fleischman, Kennedy Galleries, New York; Hilliard Goldfarb, Isabella Stewart Gardner Museum, Boston; Joseph M. B. Guttmann Galleries, Los Angeles; David Henry and Lisa Peters,

6

Spanierman Gallery, New York; Frederick Hill and Bruce Weber, Berry-Hill Galleries, New York; Martha Hoppin, George Walter Vincent Smith Art Museum, Springfield, Massachusetts; Vance Jordan, Jordan-Volpe Gallery, New York; Laura C. Keim, Pennsylvania Academy of the Fine Arts, Philadelphia; Barbara J. MacAdam, Hood Museum of Art, Dartmouth College, Hanover, New Hampshire; M. P. Naud, Hirschl & Adler Galleries, New York; Martin E. Peterson, San Diego Museum of Art; Holly Wagoner, Terra Museum of American Art, Chicago; and Richard York, Richard York Gallery, New York.

Rex Wasserman, Prospect Park Historian and Archivist, New York City Department of Parks and Recreation, was extremely helpful in the matter of trying to determine the locations of Chase's park subjects.

Special thanks also go to the staff at Abrams: Jennifer Bright, Ellen R. Cohen, Ellen Nygaard Ford, and Joan Siebert, whose professionalism added yet another important, positive note to this experience; and to Robbie Capp for a painless editing process.

Finally, I am forever grateful to Barbara Head Millstein for her unfailing friendship and encouragement, and to Norman Taylor for his many trips to the library to track down citations—and for his quiet support through my evenings of writing when he would much rather have been at the movies.

BARBARA DAYER GALLATI
Brooklyn

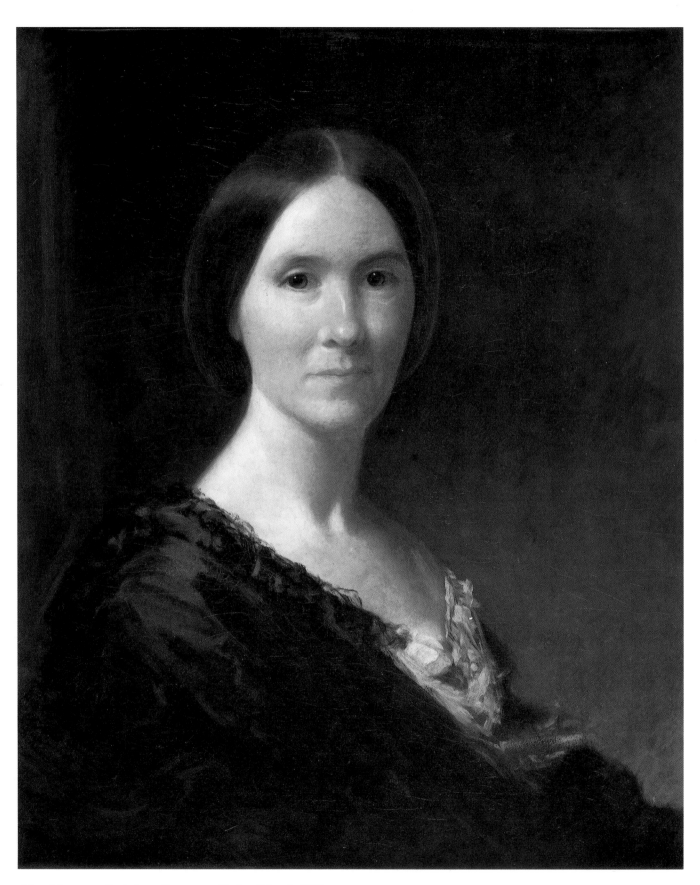

Mrs. Margaret Creighton Bateman, Shelter Island, N.Y.

I. "Eager to Learn and Susceptible to Impression": Chase's Early Years

WILLIAM MERRITT CHASE WAS BORN WITH an insatiable appetite for visual stimulation that was matched only by his desire to express his optical experience artistically. It was this genuine passion of the eye that governed Chase's life and was the principal factor in shaping a career that now reads as the stuff of a Horatio Alger narrative in which a middle-class boy from the American West attains the heights of professional and popular success in the art world. Similarly romanticized and nationalistic sentiments colored William Howe Downes's assessment of Chase's achievements and moved him to title his 1909 article about the painter, "A Typical American Artist." To be sure, any account of Chase's odyssey from his unremarkable Indiana childhood to a career as one of this country's most important artists indeed conforms to Alger's formulaic renderings of the American dream, but Chase's achievements as an artist, teacher, and promoter of American art are anything but typical when they are compared to those of his contemporaries.

The notion of the self-made man (or here, the self-made artist) is especially critical in interpreting Chase's life and aesthetics. Descriptions of Chase's outward or public persona invariably begin with his personal style of dress and carriage. Artist Harry Willson Watrous recalled his friend as "a gallant gentleman, the cynosure of all eyes, with mustache slightly tilted, sauntering down the Avenue wearing a flat brimmed French silk hat, a broad black ribbon hanging from his glasses, and accompanied by a beautiful white Russian wolfhound." The urbane, elegant image that Chase deliberately created for himself reflected not only his personal taste, but also his sincere belief in the American artist's deserved position of status and respect in society.

Critic John C. Van Dyke's apt characterization of Chase as "eager to learn and susceptible to impression" typifies the approach that has directed Chase studies. Chase is consistently looked to as an eclectic talent whose stylistic flexibility enabled him to switch effortlessly throughout his career from the dark, lushly painted surfaces of the Munich manner learned during his student years, to the brilliant palette and more delicately handled brushwork of a variant Impressionism. His skills embraced many mediums including oils, in which he worked most frequently, pastels, prints, and occasionally watercolor. No less important in earning him the reputation for eclecticism is that he limited himself to no single subject specialty. Acknowledged for his portraits, landscapes, still lifes, and figure and genre subjects, Chase's varied output allowed contemporaneous writers to extend alternate claims for his preeminent status as a mas-

Mrs. Margaret Creighton Bateman, Shelter Island, N.Y.

c. 1870. Oil on canvas, 24 x 20"
San Diego Museum of Art.
Gift of Mrs. Eleanor B. Parkes

Chase's commission to paint the portrait of Mrs. Horatio Bateman of Shelter Island, New York, was probably obtained on the recommendation of his instructor Joseph Eaton. The painting demonstrates Chase's newly acquired skill in rendering form with a gently modulated light, a technique that alleviated the harsh, photographic quality of his earlier portrait style as learned under Barton Hays. His relative stylistic advancement notwithstanding, the dull color and thinly painted surface give little indication of the portrait aesthetic he would subsequently adopt.

9

ter in each area. His technical versatility and the broad scope of subject matter he addressed deny easy categorization and admittedly lend themselves to the simplistic definition of Chase's oeuvre as eclectic.

Chase was unquestionably eclectic when it concerned technique. However, a survey of his subjects suggests just the opposite; that despite the wide range of mediums and techniques he used, Chase's art provides a carefully constructed view of the realities of his personal existence. Furthermore, those realities were not direct or casual documentations of modern life in general, but were, rather, deliberately manufactured visions that Chase manipulated in much the same way that he manufactured his public persona. Yet the weight of Chase's reputation as a realist par excellence has, from the beginning, discouraged thematic investigation of his art. As one critic declared in 1887, "All's one to him; whatever the eye can see, he is able to comprehend and reproduce." Granted, Chase could paint anything that he saw, but what he painted was a matter of choice and, as will be shown, his art was most often the expression of external reality molded to portray his private world. Thus, his most famous series of genre paintings focuses on the studio that was for years the center of his professional existence; his scenes of city parks concentrate on the intimate experience of public space; his figure subjects feature mainly family and friends; his landscapes of the 1890s concentrate on the area surrounding his Shinnecock, Long Island, studio; and few of his European subjects constitute the typical tourist's or artist's response to foreign scenes or cultures.

The exterior persona that Chase manufactured for himself leaves us with the vibrant impression of a larger-than-life character. Given his prodigious and diverse output, elegant attire and lifestyle, activity as a passionate collector of art and artifact, and seemingly inexhaustible energy as a teacher, one might expect the tendency for the grandiose to rule every aspect of his existence. Such expectations are defeated, however, with the realization of the artist's subtly expressed, but nonetheless apparent need for the intimate and familiar—an enclosed private universe—that is revealed in his art. This contradiction begins to find resolution in examining his upbringing and the values instilled in him during his youth, and is finally reconciled with the recognition that those same values structured his adult life.

Williamsburg (now Ninevah), the southern Indiana town where William Merritt Chase was born on November 1, 1849, had little to distinguish itself from hundreds of other rural communities that dotted the American Midwest in the middle of the nineteenth century. The eldest child of David Hester and Sarah (Swaim) Chase, William spent his uneventful early years in the frontier town where his father had initially operated a harness shop and later, a general store. The hardworking David Chase's business acumen left much to be desired, but that doubtless had little impact on the day-to-day existence of William (or Merritt, as he was then called) and his siblings, George and Amanda. Anecdotal accounts of Chase's childhood describe him as a quiet, but mischievous boy whose singular distinction was a love to draw, which was nurtured by informal art lessons from the local school teacher after the day's session.

Still Life with Fruit

1871. Oil on canvas, 30½ x 25″
The Parrish Art Museum, Southampton, New York.
Littlejohn Collection

Following the lead of many of his contemporaries, Chase invoked in this early still life the notion of the passage of time by referring to the natural cycle of growth and decay. The leaves of the grapevine in the upper register twine conspicuously above the central grouping of luscious, ripe specimens. Below rest isolated pieces of fruit that are beginning to spoil. As an additional reminder of the transience of the material, Chase inserted a small, but prominently placed butterfly, a symbol of the mutability of life as well as its brevity.

CHASE'S EARLY YEARS

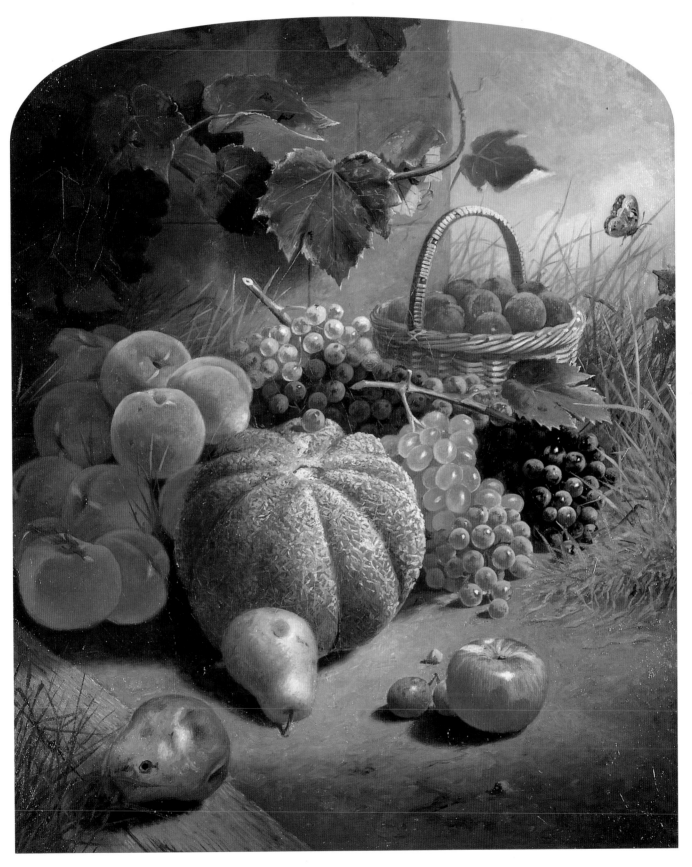

Still Life with Fruit

Ready for the Ride

1877. Oil on canvas, 53½ x 33½"
The Union League Club, New York

Ready for the Ride *was one of the most important paintings of Chase's early career. Painted in Munich, the painting belonged to dealer Samuel Avery by the time it was shown in the first exhibition of the Society of American Artists held at the Kurtz Gallery in New York in 1878, where it joined three additional paintings by Chase. Judging from reviews, the painting dominated the exhibition and, as one writer stated, "The motto adopted by the Hanging Committee seems to have been 'not names, but merit,' for a large number of the best pictures have found a place on the line irrespective of the celebrity of the artists that painted them. . . . Chase is spoken of by many as one of the most promising of the younger American artists. 'Ready for the Ride' is a very strongly treated picture, the coloring and drawing being remarkable. He seems to have aimed at a Rembrandt effect in this work, and the old Dutch school is plainly visible in the treatment of both the figure and the dark, shadowy background. . . . [It] is certainly the finest he has yet sent home." ("Fine Artists. Pictures in Brooklyn and New York,"* Brooklyn Daily Eagle, *March 11, 1878, p. 2.)*

Despite the encouragement and attention his naive artistry gained him, the boy was expected to enter his father's retail trade. The elder Chase's business fortunes constantly shifted and, after a series of unsatisfactory partnerships, he moved the family to the thriving city of Indianapolis in 1861 and opened a new partnership, the New York Boot and Shoe Store. There, William received his baptism in the sales trade on school holidays and, by 1867, when David Chase was running David H. Chase Boots Wholesale and Retail, local directories officially listed William Merritt Chase as a salesman.

The young Chase was an uninspired employee, who is reported to have spent more time drawing than selling shoes. His mother's sympathetic support combined with his father's helpless exasperation finally resulted in Chase's being permitted to enter art training under the self-taught painter Barton S. Hays (1826-1914), who was active in Indianapolis from 1858 to 1882. Hays, like many regional artists at the time, worked in a market that could not sustain

consistent demand for particular specialties, so he plied his brush to a variety of subjects—still life, portraiture, and animal genre—and also worked as a daguerreotype tinter. Although Chase's instruction from Hays could only be called mediocre at best, it was a critical step toward a career in the arts and, in the most basic of ways, introduced the notion of the necessity for artistic flexibility (at least in terms of subject matter) to Chase's nascent views of his own aesthetic.

Through Hays, Chase met another local artist, Jacob Cox (1810–1892), who had been a pivotal figure in the Indianapolis community since 1833. While he too was self-taught, Cox was more talented and successful than Hays, and with counsel from both, Chase was soon able to turn out work that promised to satisfy the standards of the provincial art market. His father's begrudging nod to his artistic leanings notwithstanding, William was still expected to put in his time behind the sales counter.

In a sudden move for independence, Chase and a friend enlisted in the U.S. Navy's apprentice program. On July 22, 1867, the boys left Indianapolis for Philadelphia, where they were assigned to the USS *Vermont,* and subsequently transferred to the USS *Portsmouth* at Annapolis. Only a short time passed before the initial excitement of the adventure faded into a bleak picture of boredom and hard work and, within three months, David Chase answered his son's plea to travel east to obtain his release. Chase resumed study with Hays when he returned to Indianapolis and was given the use of a large room in the Chase

"Keying Up"—The Court Jester

1875. Oil on canvas, 39¾ x 25"
Courtesy of the Pennsylvania Academy
of the Fine Arts, Philadelphia.
Gift of the Chapellier Galleries

After making a staggeringly successful debut at the Philadelphia Centennial Exposition, this painting continued to draw attention and helped to single Chase out as one of the brightest of the emerging talents in American art. On its display at the 1878 National Academy of Design annual, one writer proclaimed it "another example of the genius of that rising young American artist, William M. Chase, and the strongest of his we have yet seen. . . . The King's jester, dressed in full costume, cap and bells, is helping himself to a little stimulants from a small decanter. The expression of extreme satisfaction on his broad roguish face it would be difficult to equal, and the drawing of the fellow's short, thick-set figure will compare favorably with much of the work done by the leading figure painters of Europe. The coloring of the work is strength itself, and everything about the picture has received a careful attention from the artist that will surprise many of his detractors, who have gone so far as to call his freedom of touch carelessness." ("Fine Arts. The National Academy Exhibition," The Brooklyn Daily Eagle, April 7, 1878, p. 2.)

Unexpected Intrusion
(The Turkish Page)

1876. Oil on canvas, 48½ x 37½"
Cincinnnati Art Museum.
Gift of the J. Levy Galleries

Chase's high expectations regarding this painting's reception are proved by the sale price of seven hundred dollars he set for it when he sent it from Munich to New York for exhibition at the National Academy of Design in 1877. Also known as Boy Feeding a Cockatoo, *the painting's elaborate studio arrangement and its exotic flavor attest to Chase's early departure from the dark tonalities and subject matter common among Munich artists at the time.*

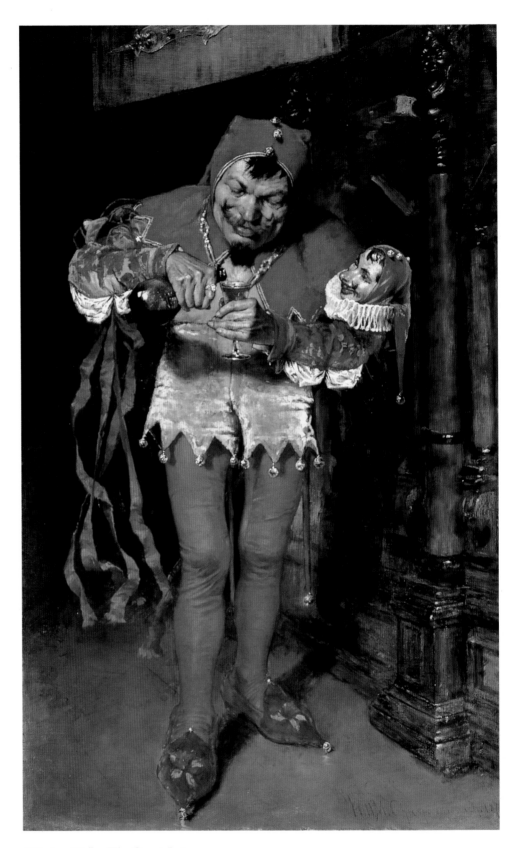

"Keying Up"—The Court Jester

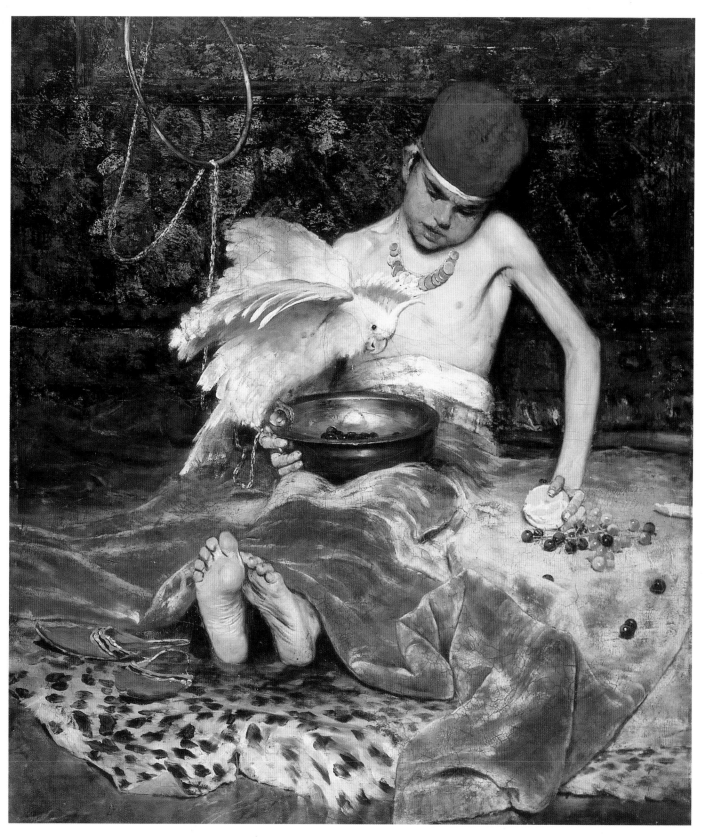

Unexpected Intrusion (The Turkish Page)

Frank Duveneck (1848–1919)
The Turkish Page

1876. Oil on canvas, 42 x 58¼"
Courtesy of the Pennsylvania Academy
of the Fine Arts, Philadelphia.
Joseph E. Temple Fund

As demonstrated here, Chase and Duveneck frequently painted from the same models when they were students in Munich. While it is often difficult to determine the extent to which each influenced the other in their joint painting sessions, in this case Chase must be credited with being the guiding force in creating this motif inasmuch as it falls so far outside the subjects and stylistic modes usually addressed by Duveneck at this time.

household for a studio. This generous gesture on his father's part can only be interpreted as an effort to mollify the errant son, who still fulfilled his filial duty by clerking in the shoe store.

The few portraits from Chase's hand dating from this period testify to the impact that Hays and Cox had on him with their blunt, unidealized manner, suggesting the influence of a literal, photographic approach. Both men recognized Chase's artistic potential and encouraged him to go to New York for serious study with Joseph Oriel Eaton (1829–1875), who had painted portraits in the Indianapolis area in the late 1840s. Just how David Chase was persuaded to agree to this plan is unknown but, in 1869, the twenty-year-old William Merritt Chase was on his way to the center of American art, New York. Eaton's plans took him to Europe shortly after Chase's arrival, but he allowed the young man the use of his studio in his absence. In the meantime, Chase enrolled in classes at the National Academy of Design, studying primarily under Lemuel Wilmarth (1835–1918), whose principal claim to artistic fame today rests in the fact that he was the first American artist to study in France with the noted academic painter Jean-Léon Gérôme.

Chase spent the academic year of 1869–70 in New York, with the exception of a brief period (possibly over the break between sessions at the Academy), when he shared space with the still-life painter David Munsey in Hays's Indianapolis studio. He was in New York when he received word in March 1870 from his financially beleaguered father informing him of yet another business reversal, and adding that he could no longer count on monetary support from home.

Unfortunate as it was, this news was probably the immediate impetus for Chase's entry into the professional sphere, and with Eaton's help, Chase sought

commissions for portraits and still lifes. The artist's *Mrs. Margaret Creighton Bateman, Shelter Island, N.Y.,* which dates to this period, demonstrates the painter's growing technical competence and proves that his one year of study in New York had enabled him to surpass his early instructors. Armed with improved skills and the confidence of having lived in the country's greatest urban art center, Chase quit this phase of his formal training to join his family in Saint Louis, where David Chase had relocated following his most recent business disaster.

Despite the friction that had existed between Chase and his father over his pursuit of a career in the arts, the younger man remained dedicated to his parents and was painfully aware of his responsibility to help support his younger siblings, whose number had grown to five with the births of Charles, Carrie, and Hattie. The moment to prove the practical merit of his artistic calling had arrived. He immediately secured a studio in the Insurance Exchange Building, but soon after shared space with James W. Pattison, who was then in charge of the art department at Washington University. Chase diligently applied himself and earned recognition for his efforts at the Eleventh Saint Louis Fair where he won twenty dollars for a small study of a head, and ten dollars for second prize in the still-life category.

The fancifully composed 1871 *Still Life with Fruit* documents the young painter's competence in a popular genre of the day, the outdoor still-life format. The imaginative, artificially arranged array of fruit presented ample opportunity for Chase to demonstrate his prowess in depicting objects of varying textures, shapes, and colors. The rich, bright palette and the transition in lighting from distant sunny sky to the shadowed foreground are not unpleasant, but the painting as a whole possesses an unintentionally whimsical expression of over-abundance that betrays Chase's eagerness to prove himself and his art through excess. Patently naive in its conception, the painting nonetheless reiterates the common language of the still-life mode in American art of the time. In fact, Chase's odd combination of fruits in their unlikely landscape setting was even less out of the ordinary than, for example, some still-life compositions by the more established artist, George Henry Hall, who was capable of joining a sliced watermelon, bunches of grapes, and pink roses in a landscape having a distant mountainous backdrop.

With paintings the likes of *Still Life with Fruit,* Chase entered the artistic mainstream as a competent, conservative painter, but one with more than the usual amount of ambition and talent to rise above the norm. Although Saint Louis was relatively rich in cultural advantages, it was still a backwater compared to New York—and New York was still in its cultural infancy compared to Europe. Chase's introduction to serious art training with Eaton and Wilmarth had opened the door to the larger cultural sphere, but to cross the threshold, he knew he must make the trans-Atlantic journey for further study.

As luck would have it, Chase's local reputation as an up-and-coming artist drew the interest of a group of area businessmen headed by art collector Captain W. R. Hodges. A consortium of seven gave the artist twenty-one hundred dollars to cover the cost of two years in Europe, in exchange for which he was

to paint a work for each and help them acquire works by foreign artists.

When Chase sailed for Europe in the summer of 1872 in the company of fellow artist Harry Chase (no relation), he had not yet decided where to pursue his studies. He spent the month of August in London, and then went on to Paris. Although he enjoyed the French capital immensely, he decided to forego the glorious distractions that Paris offered, fearing they would divert him from serious study. The Bavarian capital of Munich was at that time a popular alternative to Parisian training, as witnessed by the nearly three hundred Americans who studied there from 1870 to 1885. Compared to the modern spectacle of Paris, recently transformed by the prefect Baron Haussmann, Munich still retained its Old World atmosphere, but at the same time, was experiencing a wave of cultural and economic renewal spurred by the recent German victory in the Franco-Prussian War. The structured program of study offered at Munich's highly respected Royal Academy probably held greater attraction for Chase than did the more varied options available in the chaotic system of Parisian ateliers, which he also may have considered. Then, too, his knowledge of the Munich school must have guided his decision to press on to Germany. Though Wilmarth encouraged many of his students to train with his master, Gérôme, he himself had also studied at the Royal Academy in Munich prior to going to Paris. Chase must have known this and also heard more about the Academy from a fellow Saint Louis artist, John Mulvaney, who had just returned from Munich at the time they met.

Chase enrolled in the Academy in the fall of 1872 and roomed with another American, Walter Shirlaw, who was in his third year there after having started out as an engraver in Chicago. The Kentucky-born artist Frank Duveneck (who returned to Munich in 1875 after having interrupted his training there) spoke about Chase's rapid advance from the introductory drawing classes into the painting sessions. This trio of midwesterners—Duveneck, Chase, and Shirlaw—eventually became so close that they were known as "the Father, Son, and Holy Ghost," respectively, and were the central personalities and talents of the American circle in Munich.

From the start, Chase's independence singled him out from the other students, and in this connection it must be remembered that he had arrived in Munich a professional, albeit provincial artist. The paintings of his Munich period demonstrate his openness to experimentation and an accompanying tendency to resist a doctrinaire approach. Furthermore, this body of work reveals his response to the complex variety of aesthetic currents that converged in Munich in the early 1870s. Not the least of these influences were works by Peter Paul Rubens, Anthony Van Dyck, and Rembrandt van Rijn hanging in the galleries of Munich's Neue Pinakothek, all of which proved a revelation to Chase, whose regular museum visits began a habit of a lifetime that was incorporated into his own teaching methods.

Within a short time, Chase's art underwent a remarkable transformation that took him in the direction of his spirited 1875 *Hugo von Habermann*, a portrait of a German art student. This painting not only documents the appearance

of his fellow student, but also captures the mixture of intelligence, pride, and reserve signifying the young man's aristocratic upbringing. Stylistically, Habermann's portrait confirms Chase's adoption of the mode then in popular use by both the Munich faculty and students, in which they routinely painted each other in informal bust-length or half-length poses against a dark ground from which the dramatically lighted face emerges. The relatively active paint surface evidenced here results from Chase's use of the alla prima technique, and the painting as a whole suggests that he may have attended the experimental classes of Wilhelm von Diez (1839–1907), an instructor who was particularly favored by Duveneck.

In 1874, after having studied with Alexander von Wagner (1838–1919), Chase entered the master classes of the academic history painter Karl von Piloty (1826–1886), the newly appointed director of the Academy. Although Chase would consistently list Piloty as his instructor, little of Piloty's stylistic influence can be traced in his art. Despite his pupil's resistance to the dry academicism of his technique and subject matter, Piloty nonetheless admired Chase's work and, in 1877, commissioned portraits of his children from him, thus aiding Chase immeasurably when his stipend from his Saint Louis patrons ended. Piloty's benevolent attitude was characteristic of the general tolerance of the Academy's faculty and, if the teaching was not uniformly innovative, experimentation was at least permitted and the results sometimes respected.

The paintings of Chase's Munich period also reveal the strong influence of the Leibl-Kreis, a circle (Kreis) of German artists whose leader in technical and theoretical matters was Wilhelm Leibl (1844–1900). A friend of Gustave Courbet, Leibl perpetuated Courbet's realist aesthetic in Munich, where the collective energy of the Leibl-Kreis was at its height from 1871 to 1873. As artists, they shared the same reverence for the act of painting itself, a sentiment that was reflected in the group's growing emphasis on a fresh, alla prima painting technique coupled with a diminishing reliance on narrative or historical subjects. For Leibl, manner was paramount and, by his own admission, it mattered little to him whether he painted landscapes, people, or animals—all of which he treated in the dark, old-master tonalities that characterized his art. Leibl's aesthetic, which gave priority to technique over narrative, was an important influence on Chase, who was already antagonistic toward traditional history painting and genre modes.

Although they were not part of the Leibl-Kreis, the close-knit circle of American students in Munich surely knew their art and doubtless discussed it during the late-night gatherings that constituted their social life. Certainly Chase's mandate to purchase European art for his Saint Louis backers ensured his awareness of contemporary German art and, by necessity, took him beyond the Academy walls. His circa-1875 portrait *The Art Dealer Otto Fleischmann* (Bowdoin College Museum of Art, Brunswick, Maine) attests to Chase's links with the contemporary art market. Fleischmann's gallery featured many of the area's more progressive artists and it was from the German dealer that Chase acquired Leibl's 1869 painting *The Coquette* (Wallraf-Richartz Museum, Cologne) in 1878

(one of two by Leibl that Chase eventually owned). The acquisition was the first notable instance of Chase's surrender to the strong desire to possess works by other artists, and marks the beginning of his long career as a major collector in his own right. Chase's admiration for *The Coquette* was strikingly declared in a number of his Munich paintings, the finest of which is the 1877 *Ready for the Ride,* a work that was purchased by the important American dealer Samuel Avery for three hundred dollars and shown at the inaugural exhibition of the Society of American Artists in 1878. Received by critics as one of the outstanding works in the renegade Society's debut showing, *Ready for the Ride* helped to establish Chase as one of the "new men" in American art, and treated the audience to one of its first views of the Munich school's admixture of relative tonal values, lush paint surfaces, and veneration for such earlier masters as Diego Velázquez and Frans Hals.

Chase had already made an unquestionably brilliant showing in America at the 1876 Centennial Exposition held in Philadelphia, where his *"Keying Up"— The Court Jester* gained him a medal of honor. The artist's choice of an unusually hot palette to portray the curious subject of a dwarf dressed in a jester's costume was almost certainly a move calculated to set his work apart from the other American works adjacent to it in the galleries. Indeed, it declared Chase's alignment with the international art world, in this instance with an adaptation of the dwarf and jester subjects made popular by Edouardo Zamacoïs y Zabala (1842–1871), whose famed 1867 *The Favorite of the King* Chase may have known by the 1870s (and which he certainly would have known as part of William H. Vanderbilt's collection). Zamacoïs's subjects of this sort were highly appreciated in the United States in the late 1860s, and Chase was liable to have read Eugene Benson's admiring 1869 *Art Journal* commentary on the Spaniard's paintings that portrayed the "picturesque, the grotesque, and the elaborate, all in one frame." The importance of the painting in Chase's mind is borne out by the number of preparatory studies leading up to the final image of the drolly grotesque figure who prepares himself for his next performance with an alcoholic bracer. The painting again brought Chase to the forefront when it was displayed at the 1878 National Academy of Design exhibition, where it delighted the critics.

The vast differences in coloration, subject, and mood that separate *Ready for the Ride* and *"Keying Up"—The Court Jester* are symptomatic of Chase's precocious stylistic fluency, and reveal even in this early stage of his development tendencies that would be the hallmark of his mature career. Several other important canvases from his Munich phase augured the future, among them *Unexpected Intrusion (The Turkish Page)* of 1876 and *The Moorish Warrior,* painted in about 1878. The first of these underscores the intense communal nature of student life for Americans in Munich in that *Unexpected Intrusion (The Turkish Page)* and Frank Duveneck's *The Turkish Page* were painted from the same arrangement conceived by Chase in his Munich studio. Both artists obviously reveled in the challenge to paint the exotically outfitted youth who listlessly feeds an equally exotic cockatoo. The luscious assemblage of patterns, textures, and reflective

The Moorish Warrior

c. 1878. Oil on canvas, 58⅜ x 93⅝"
The Brooklyn Museum, 69.43
Gift of John R. H. Blum and A. Augustus
Healy Fund

The Moorish Warrior was not known to an American audience, because it was painted during the artist's student years in Europe, where it remained into the twentieth century. The painting's uncharacteristically large size signals Chase's ambition and confidence and testifies as well to his passion for exotic, Orientalist subjects and his developing love of antiquarian paraphernalia. Until recently, the left and right edges of the canvas were folded over (most probably by a former owner to accommodate framing), resulting in a distortion of the artist's original treatment of pictorial space. Now, with the previously hidden parts of the canvas open to view, the painting not only reveals Chase's signature, but also his early interest in constructing his compositions along a series of oblique angles that divide the pictorial space into a succession of planes.

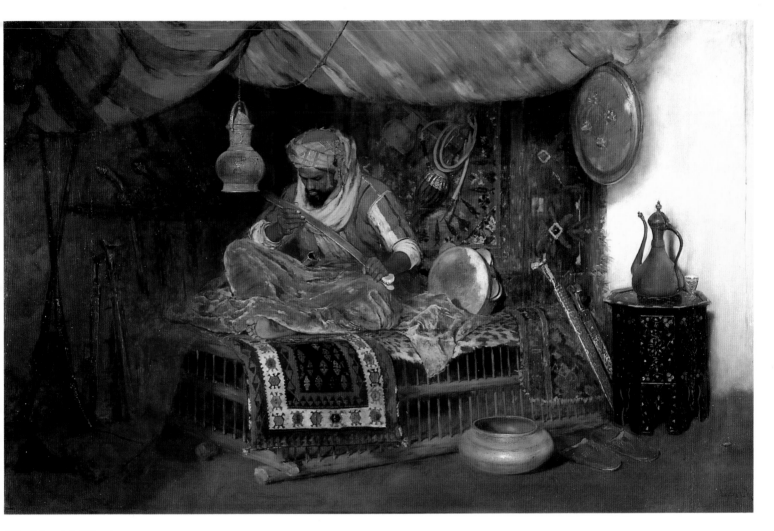

The Moorish Warrior

surfaces finds its source in Chase's personal taste, and is an early document of his benign, but powerful addiction to acquire objects needed for such compositional schemes, and his repeated delight in painting the things of his eye's desire.

Similar comments may be made regarding *The Moorish Warrior,* an ambitiously scaled canvas that presents a no less exotic model ensconced among Chase's growing collection of studio props. In matters of contemporary artistic trends, these paintings blended with the increasing number of Orientalist subjects that flooded the European and, later, the American art market. However, unlike the paintings of such Orientalists as Gérôme and the American Frederick Bridgman, Chase's explorations of the subject profess to be none other than carefully orchestrated variations on the studio theme that were reconstituted visions of his own daily surroundings. A subtle hint to that effect is found in the still-burning, but discarded cigar on the floor on the right that implies the artist's presence.

Chase would stay in Europe until the summer of 1878, but his student years in Munich effectively ended in May of 1877 when he went to Venice with Duveneck and John H. Twachtman. Chase's nine-month residence there gave him splendid opportunity to satisfy his increasingly acquisitive nature and to paint in a setting far different from the fairly parochial (or at least by then for Chase, unchallenging) Munich. By all accounts, the first months of his stay there were productive and exciting ones and he filled his days painting, socializing, visiting museums, and scouring antiquary shops on frenetic buying sprees, joyously amassing the fabrics, carpets, brasses, paintings, and furniture with which he would begin to decorate his New York studio. As time went on, however, the monies from the sales to Avery and Piloty dwindled to nothing, and Chase's health also seriously declined. The three impoverished artists were reduced to borrowing in order to eat and, in the end, only Duveneck's receipt of a portrait commission from Mrs. Arthur Bronson, the wealthy sister of New York writer, Richard Watson Gilder, enabled Chase to return to Munich.

For the most part, Chase's facture and palette remained unaffected by his Venetian sojourn. Where one might expect his art to reveal startling visible evidence of his response to a city noted for its magnificent views and dazzling effects of reflected light, Chase persisted in painting in the studio or focused on street scenes which he executed in a surprisingly subdued range of hues. Only a few of the nearly forty paintings stemming from the trip indicate the awakening of a passing concern for natural light effects. What did emerge, however, was a renewed interest in still life and the introduction of the fish subject to his repertoire that later became the mainstay of his still-life productions.

It was in Venice, also, that Chase decided to return to America, having, after much deliberation, agreed to join the faculty of the Art Students League in New York in the fall of 1878. Although he originally had doubts about the wisdom of his choice, he later credited his teacher, Piloty, for convincing him that his future was in America, "the land," Piloty said, "where opportunity is seized and utilized."

Gray Day on the Lagoon

c. 1877. Oil on panel, 13 x 19"
Bequest of Ernest Wadsworth Longfellow
Courtesy, Museum of Fine Arts, Boston.

Based on stylistic grounds, this undated painting is generally believed to have been painted during Chase's nine-month Venetian sojourn that began in 1877 and extended into 1878. The distant shape of Giudecca Island marks the horizon line, but the majority of the composition is given over to sky and water, a format foreshadowing Chase's more tonalist renderings of waters along the urban coastline of New York painted in the 1880s.

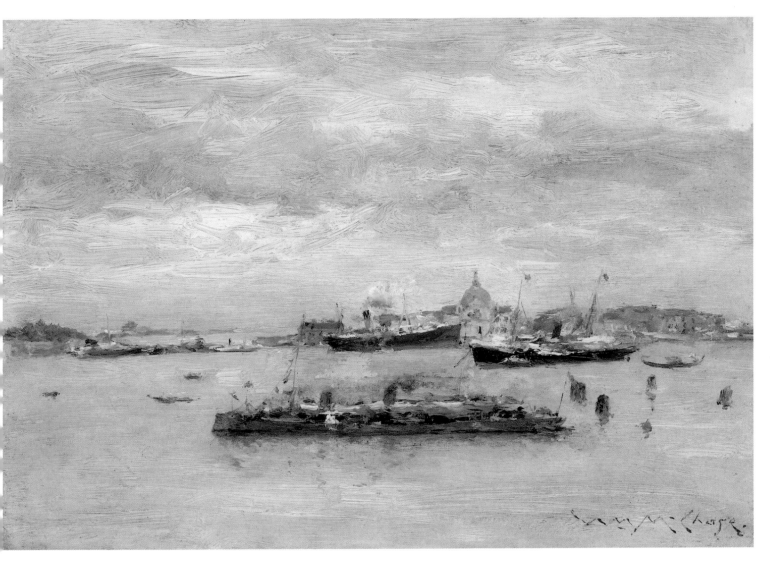

Gray Day on the Lagoon

William Merritt Chase

II. Inaugurating a Period of Transition: A Career Is Established

CHASE ARRIVED IN NEW YORK LATE IN SUMMER 1878, riding on the crest of the wave of fame generated by his paintings and those of the other members of Munich's American contingent, Duveneck and Shirlaw, at the first exhibition staged by the Society of American Artists. Over the next few years, the memory of the 1878 exhibition where their Munich paintings had made such a strong showing continued to play a pivotal role in the writings of the more thoughtful art critics, one of whom—Mariana Griswold van Rensselaer— wrote in 1881, "To a period of transition Mr. Chase belongs, having indeed greatly helped to inaugurate it." Van Rensselaer cited the Munich style as instrumental in introducing a new artistic era in American art, but went on to say that Duveneck and Shirlaw had not produced much since returning to the United States. On the other hand, she praised Chase, who "has gone beyond the level of the picture which first proved to us his power, and has won for himself a place in the very first rank of his contemporaries—a reputation of ever-growing breadth as among the strongest and most satisfactorily productive of American artists, past or present."

Chase's somewhat sudden defection from the style that had gained him his initial fame is not surprising given the critical backlash that had erupted in some quarters against the Munich faction over the power it wielded in the Society of American Artists. Earl Shinn's biting 1879 commentary excoriating the Munich painters for their "flimsy, theatrical, decorative superficiality" could not have failed to hit a sensitive nerve in the ambitious Chase, who was intent upon advancing his career.

The years 1878 through 1886 were crucial in that the habits and associations Chase established during that period set the tone and pattern for the rest of his life. During this time he literally reinvented himself by transforming his rather conventional appearance into a unique statement of artful sophistication. Not merely a matter of vanity, Chase used this act of self-(re)creation as a means to elevate and legitimize the position of artists and art in American society. One of his students later wrote, "His dress was a part of his art psychology. As students it made us respect him the more, and, in turn, respect ourselves." The metamorphosis extended to all areas of his life, and found its most tangible popular expression in the magnificent studio that became the theater for the production of his art.

The teaching post at the Art Students League that Chase claimed on returning to New York was the first of many important instructing endeavors that

William Merritt Chase

c. 1878. Albumen print, $2\frac{1}{2}$ x $3\frac{1}{2}$"
The Parrish Art Museum, Southampton, New York
The William Merritt Chase Archives,
Gift of Mrs. Virginia Brumenschendel

occupied him for a lifetime. While his earnings from teaching were essential to his livelihood, he was also, without question, one of the most passionate and influential art instructors that this country would see. A partial summary of his teaching history includes the Art Students League (1878–96; 1907–11); the Brooklyn Art Association (1887; 1891–96); and the Pennsylvania Academy of the Fine Arts (1896–1909). His own Shinnecock School of Art occupied his summers from 1891 to 1902, and in 1896, he founded the Chase School of Art in Manhattan, teaching there steadily until 1907. (The parent institution of the Parsons School of Design, the school operated as the New York School of Art after Chase relinquished his administrative duties in 1898.) Chase's particular combination of skills as a teacher were brought to the fore in his summer courses that took students to Europe almost annually from 1903 to 1913, when he guided them through the world's great museums, arranged meetings with noted foreign artists, and gave studio and plein-air instruction.

Although Chase's dedication and value as an instructor were seldom questioned, his years of teaching were occasionally marred by political rivalries, the most notable being the tensions that existed between him and the other major American art instructor of the early twentieth century, Robert Henri. The two (both realist painters of a very different sort) engaged in what was literally a battle for student loyalties that temporarily ceased with Chase's 1907 resignation from the New York School of Art and his return to the Art Students League. Chase left the League in 1911 when Henri's volatile presence there became intolerable for him.

From the beginning, Chase was deeply embroiled in the political machinations of the New York art scene. His early affiliation with the Society of American Artists was a political act in itself. Remarkably, though, his combination of diplomatic skill, personal magnetism, and artistic talent enabled him to survive not only the Society's internal struggles during a ten-year presidency from 1885 to 1895, but also opened the doors of the rival National Academy of Design (to which he was elected to full membership in 1890). Chase's membership in The Ten American Artists (commonly called The Ten), had it been in the early years of the group's history, might also have been considered a bold political statement, but because he joined in 1905 (to fill the vacancy left by the death of John Twachtman in 1902), his presence in that group gave faint echo to the secessionist principles that had led to its 1897 formation when ten artists broke from the Society of American Artists. As it was, his membership in The Ten testified to the mood of accord then coming into play among the National Academy of Design, the Society of American Artists, and The Ten, whose membership lists by then included many of the same names.

Chase's overall capacity to coexist peacefully in the competitive art world was in large part a result of the wide network of personal and professional friendships that he formed in the late 1870s and early 1880s. A number of these associations developed in the context of the Tile Club, an exclusive artists' group whose membership was ultimately limited to thirty with vacancies open-

ing only through death, resignation, or residence abroad. This loosely orga-
nized male preserve had no officers, dues, or bylaws, and held rigidly to only one
requirement: that members be elected by unanimous vote. The club formed in
1877, as an outgrowth of discussions among photographer Napoleon Sarony,
and painters Edwin Austin Abbey, John H. Twachtman, Elihu Vedder, and oth-
ers. The Tile Club's name derived from its founders' common interest in the
English decorative arts movement and the popular practice of painting clay
tiles. The club's weekly meetings were nominally devoted to tile painting, but
more important, the gatherings offered the opportunity for exchanging ideas
in a relaxed atmosphere. The fraternal nature of this club doubtless filled the
void Chase experienced when he left the Munich camaraderie that he had so
enjoyed as a student. Moreover, it brought him into close contact with men of
a variety of interests, talents, and spheres of influence, among them, painters
Winslow Homer, George H. Boughton, and Frank D. Millet, sculptor Augustus
Saint-Gaudens, and architect Stanford White.

The club's agenda took on elaborate dimensions when *Scribner's Magazine*
began to subsidize club excursions in exchange for articles and illustrations pro-
filing its events. Chase helped to orchestrate the club's famed outings, especial-
ly the 1879 three-week trip up the Hudson River for which he dismantled part
of his studio to transform the hulking barge the *John C. Earle* into an appropri-
ately artistic environment. The travelers sketched and painted their way to Lake
Champlain and back, all the while enjoying surroundings suggesting that they
had never left their New York studios. In fact, they journeyed with all the com-
forts of home including potted plants, a piano, tapestries, paintings, Japanese
lanterns, comfortable furniture, and elaborate meals served by Chase's servant,
Daniel, and two additional men hired to share the burden of attending to the
needs of the floating island of New York's bohemian elite.

On a quieter social level, but one much more important in determining the
direction Chase's life would take, was his contact with the circle of artists and
writers who gathered informally at the home of Julius Gerson. The manager of
the art department of the noted lithographic firm of Louis Prang and Compa-
ny, Gerson was well connected in the art community. As a member of the Palette
Club, whose roster included Chase's former teacher Lemuel Wilmarth, Gerson
undoubtedly knew Chase's art before they met. Chase entered the Gerson salon,
as it were, in 1880, through introductions made by Frederick S. Church
(1842–1923) at the behest of Gerson's three daughters, Alice, Virginia, and
Minnie, who had seen *Ready for the Ride* in 1878 and wanted to meet the man
who painted it.

Chase warmed to the Gersons immediately, finding the lively evenings in
their home the closest thing to a family atmosphere that he had experienced
since leaving his own home in the west. The three Gerson sisters and their
brother, Julius, were remarkably well versed in the affairs of culture, owing to
their father's personal and professional interests, and they apparently flour-
ished in the proper, albeit unconventional, bohemian atmosphere in which they

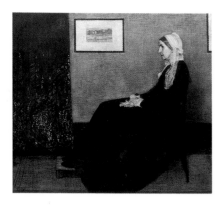

James Abbott McNeill Whistler
(1834–1903)
*Arrangement in Grey and Black
No. 1: the Artist's Mother*

1872. Oil on canvas, 57⅞ x 64⅝"
Musée d'Orsay, Paris

*Chase testified to his lasting enthusiasm
for this painting in an 1896 talk on
Velázquez saying, "Of all the art work
that I have seen in France there is no
modern picture which would not suffer
by comparison, were it hung among the
canvases of Velázquez—with a single
exception . . . that splendid painting in
the Luxembourg, the portrait of his
mother, by James McNeill Whistler."*

Study of a Young Girl
(also known as *At Her Ease*)

c. 1884. Oil on canvas, 44 x 42"
National Academy of Design, New York

*Chase was well aware of how bold an
aesthetic statement this painting made,
for it represented him in the first exhibi-
tion of the avant-garde Belgian group,
Les Vingt, held in Brussels in 1884.*

were raised after their mother's death. Alice and her sister Virginia frequently modeled for Church and soon after meeting them, Chase gained permission to sketch them as well. Virginia was talented in her own right and eventually achieved a modicum of success as an author and illustrator of children's books. Among her models were Napoleon Sarony's daughter Belle, and the poet Joaquin Miller's daughter Juanita, the latter of whom posed for Chase's 1888 *Hide and Seek* (see page 45). In the 1880s, the Gersons rented the third floor of 11 East Twenty-ninth Street, the home of Joaquin Miller's father-in-law, Horace Leland. Juanita Miller remembered the Gersons as a "most artistic family" whose rooms were the settings for elaborate theatricals and tableaux with musical accompaniment provided by the young Julius. She also recalled that the "carefully correct and immaculate William M. Chase" was invariably seated very close to Alice Gerson who was, by then (probably 1885 or early 1886), engaged to him.

Chase and Alice Gerson married in 1886 when she was twenty years old and he was thirty-seven. The lengthy courtship was, of course, necessitated by her youth, but it is likely, too, that Chase preferred to maintain his unfettered bachelorhood until his career was solidly established. Interestingly, he did not take part in the lucrative competitive sales exhibitions for Christmas-card designs organized in 1880 and 1881 by Louis Prang and Company (and hence, by Julius Gerson). Although these competitions were entirely respectable, judging by the notables on the jury (among them John La Farge and Louis Comfort Tiffany) and by the names of the 1881 winners (Elihu Vedder, Dora Wheeler, Charles Caryl Coleman, and Rosina Emmet), Chase probably balked at the commercialism the endeavor implied and had in his sights more aesthetically elevated goals that would not associate him in the public eye with commercial pursuits.

Through these years Chase cultivated a cosmopolitan outlook which perforce compelled him to remain in direct contact with the artists and art movements of Europe. If America held the future for art, Europe still held the key to what that future would be. He spent each summer in Europe from 1881 through 1885, visiting major international art capitals—Madrid, Paris, Antwerp, and London—and meeting some of the most advanced artists of the day including John Singer Sargent, Carolus-Duran, Alfred Stevens, Giovanni Boldini, and James Abbott McNeill Whistler. These trips, most often taken in the company of other American artists (especially James Carroll Beckwith and Robert Blum), were not simply vacations, but part of Chase's relentless efforts to train his eye; to investigate the merit of the old masters and to assess the newest developments in painting.

Chase's European summers of the early 1880s were to have a lasting effect on his career. Few, if any, American artists could begin to match his knowledge of contemporary European art. With such credentials, he was eminently qualified to play a major role with Beckwith in selecting the European art shown at the historic "Pedestal Fund Art Loan Exhibition" held in New York in 1883 to raise funds for the installation of Frédéric-Auguste Bartholdi's *Liberty Enlightening the World* (the Statue of Liberty) given to the people of the United States.

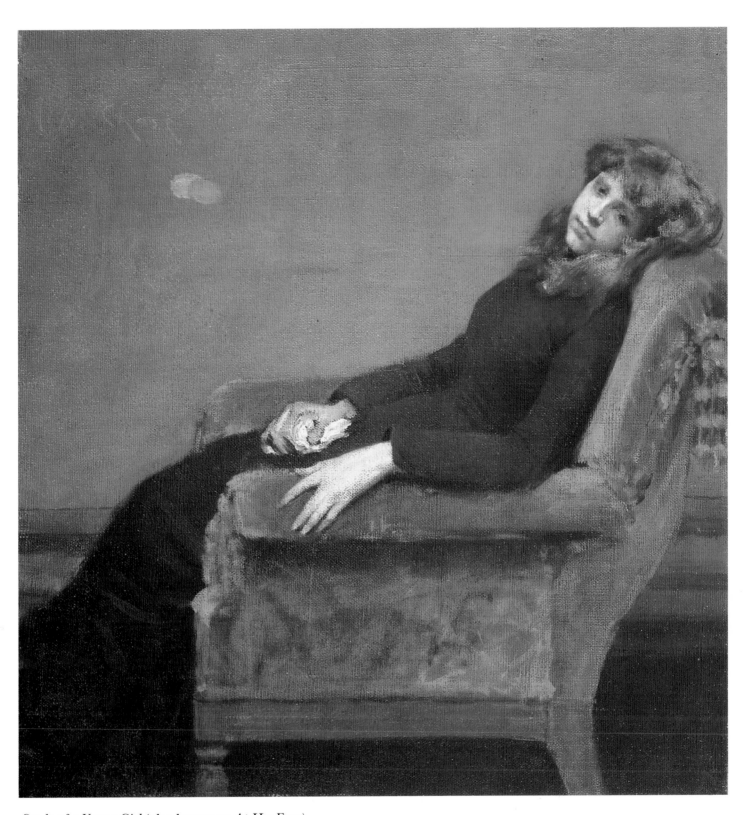

Study of a Young Girl (also known as *At Her Ease)*

*Portrait of Alice Gerson
(Mrs. William Merritt Chase)*

c. 1885. Graphite on paper, 8⅜ x 5⁷/₁₆"
Terra Foundation for the Arts,
Daniel J. Terra Collection, 1992.11
Courtesy of Terra Museum of
American Art, Chicago

*Because Chase's technique was founded
on the practice of directly painting on
canvas, this comparatively fully worked
drawing is a rarity in his oeuvre. The
work offers a touching souvenir of his
courtship of Alice Gerson, whose tender
gaze embodies the special emotional con-
nections between the artist and his model.*

Through the efforts of Chase and Beckwith, the American public received a
rare opportunity to see nearly two hundred paintings by such progressive Euro-
pean painters as Edgar Degas, Edouard Manet, and Gustave Courbet, in addi-
tion to significant works by contemporary Dutch and Italian artists. The highly
publicized exhibition inevitably brought attention to both Chase and Beckwith,
but of the two, it was Chase who capitalized on the momentum spurred by the
press to retain the reputation as an arbiter of advanced artistic taste. In this con-
nection, it must also be added that Chase was for a number of years a central fig-
ure in the Free Art League and argued passionately for the repeal of the
crippling 30-percent import tariff imposed on foreign art until the tax was final-
ly eliminated in 1913.

It goes without saying that Chase's constant study of art registered in the art

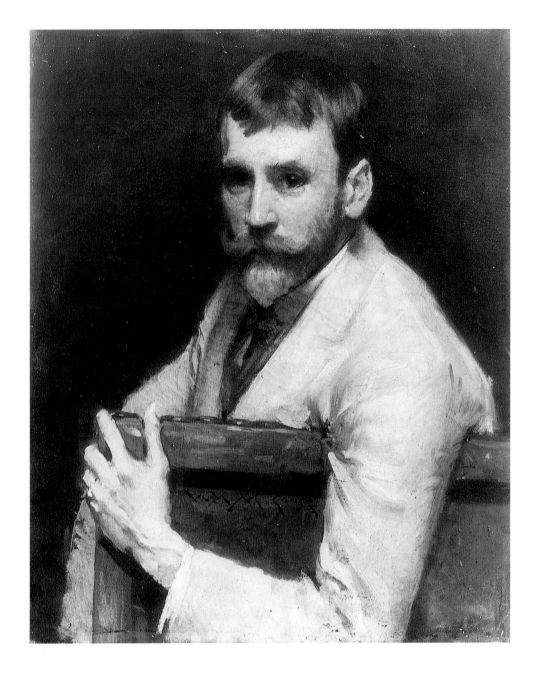

Portrait of Robert Blum

c. 1885. Oil on canvas, 24 x 19½"
Cincinnati Art Museum.
Annual Membership Purchase

The friendship between Chase and Blum was unique in its duration and closeness. The two probably met around 1880, drawn together by like philosophies and interests, and, after Chase's marriage, the younger man was a regular and welcome visitor in the Chase household.

of his own making. The decade of the 1880s, in addition to being a period of transition for the arts in America, was an exceptionally vital period of transition for Chase during which he feasted on and digested whatever he looked upon, assimilating it to produce his boldest experiments in media, iconography, and facture. The advice that he later gave his students was born of this experience: "Keep yourself in as receptive a state of mind as possible, and be like a sponge, ready to absorb all you can . . . I have never been so foolish and foolhardy as to refrain from stealing for fear I should be considered as not 'original.' Originality is found in the greatest composite which you can bring together."

One of the most remarkable of Chase's "composites" is a circa-1884 work known as *Study of a Young Girl* (also known as *At Her Ease*). The painting bears the unmistakeable imprint of a work that Chase had surely seen in 1882 that was

Girl in Japanese Kimono

c. 1890. Oil on canvas, 24¾ x 15¾"
The Brooklyn Museum, 86.197.2.
Gift of Isabella S. Kurtz in memory of
Charles M. Kurtz

This is one of a number of similarly conceived paintings of what seems to be the same young woman dressed in a Japanese kimono and posed in half-length or bust-portrait format. Unlike his more complex compositions on this theme in which the model poses in a relatively detailed interior, as, for example, The Blue Kimono, *this and other of these simple paintings are invested with a strong portrait quality (almost to the exclusion of other concerns) thus suggesting that Chase was primarily interested in portraying the features of this particular young woman. This canvas was once owned by the important collector Thomas B. Clarke, whose records listed it under the title* Girl in Costume *(but did not include its date of acquisition).*

The Blue Kimono
(Girl in Blue Kimono)

c. 1888. Oil on canvas, 57 x 44½"
The Parrish Art Museum, Southampton,
New York. Littlejohn Collection

*This and others from Chase's "kimono"
paintings are difficult to date and some
(including this one) have been pub-
lished under years ranging as much as a
decade apart. An additional problem is
trying to identify the sitters in this series.
They occasionally resemble Chase's wife,
Alice, and his sister Hattie, but not
sufficiently enough to allow a conclusive
identification. Chase's adoption of the
kimono motif was probably a product of
a variety of converging influences: his
own inborn taste for beautiful fabrics
and exotic objects further encouraged by
Robert Blum's passion for Japanese art
and culture; the art of Whistler and
Stevens; and the general expression of
japonaiserie in European art that fil-
tered into American visual culture.*

a major attraction at the Society of American Artists exhibition—Whistler's
1872 *Arrangement in Grey and Black No. 1: the Artist's Mother.* Chase clearly drew
on Whistler's painting for the severe, asymmetrical composition and the prin-
cipal motif of the female figure seated in a chair oriented to the left. His
borrowings extended to the attempt to approximate Whistler's elegant compo-
sitional tensions manifested here in the eccentric cropping of the dress and of
the chair legs and back. For the rest, however, Chase seems to have purposely set
out to create a visual antithesis of Whistler's famed image, contrasting youth
with old age, hot tonalities with cool, strict facial profile with outward gaze, and
a static calm with a febrile restlessness. Even the unusually rough weave of the
canvas used by Chase sets up a physical opposition to Whistler's smooth, refined
surface and the floating interlocked ovals of color in the upper-left quadrant of

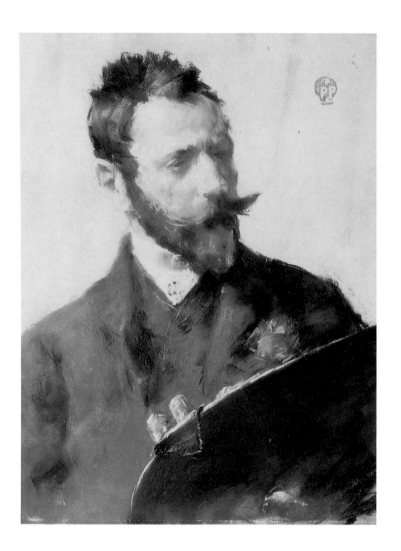

Self-Portrait

c. 1884. Pastel on paper, 17¼ x 13½"
Collection Mr. and Mrs. Raymond J. Horowitz

The vivid color and technical flair displayed in this pastel (which is believed to be the self-portrait exhibited by Chase at the 1884 exhibition of the Society of Painters in Pastel) confirm Chase's artistic and personal self-confidence. The dashing image corresponds to a description of Chase published years later: "By nature an optimist, possessed of a fervent enthusiasm, artistic in everything, an honest believer in himself, and in the future of American art." (W. Lewis Fraser, "William Merritt Chase," The Century Magazine, vol. 45, November 1892, p. 155.)

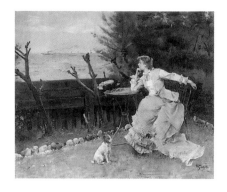

Alfred Stevens (1823–1906)
In Deep Thought

1881. Oil on canvas, 18¼ x 21½"
The Saint Louis Art Museum, Purchase

Stevens's influence on Chase went far beyond the simple advice to brighten his palette. Chase probably saw this painting in Stevens's Paris studio in 1881. The obliquely angled compositions, subdued moods, and seaside motif established in this and another then well-known work by Stevens (La veuve et ses enfants, 1883, Musées Royaux des Beaux-Arts de Belgique, Brussels) are sufficient to suggest that Chase based his 1888 Afternoon by the Sea *on these paintings.*

the painting have no other purpose than to function as an abstract "Whistlerian" colophon that balances the composition. Chase's intellectualization of the creative process demonstrated here contradicts the notion that he was simply a "realist," and suggests, instead, that he devoted far more calculated thought to his work than has been assumed. What is more, such calculation, as in the case cited here, signals Chase's willful and pointed assertion of his skills against those of a recognized contemporary master.

Less overt responses to the works of his European contemporaries flow throughout Chase's art. In some instances, his adoption of a motif, for example his series of paintings featuring models dressed in Japanese kimonos, simply constitutes his general reaction to an international iconographic trend and its decorative appeal. More specific borrowings may be cited with respect to the art of Alfred Stevens, whose marine, studio, and figure subjects wielded a strong power over Chase's vision. Acknowledged, but still relatively unexplored are the stylistic and iconographic correspondences between Chase's art and that of the Italian painter Giuseppe de Nittis and the Spanish painter Mariano Fortuny y Carbó. Deeper investigation of these connections holds the promise of further demonstrating the use to which artists like Chase put a rich array of interna-

Afternoon by the Sea (formerly known as *Gravesend Bay*)

c. 1888. Pastel on linen, 19¼ x 29½"
Courtesy Hirschl & Adler Galleries, New York

Until recently, this pastel was known as Gravesend Bay, *the name of another work also shown at the 1890 exhibition of the Society of Painters in Pastel. The following quoted review, in addition to noting an unusual effort on Chase's part to address narrative content, provides conclusive documentation to support the title change: "In the* Afternoon by the Sea *Mr. Chase has attempted a subject more in the nature of genre than is usual for him. A young mother hush-* ing to sleep a child in her arms, sits in her chair on a terrace by the sea, while a girl of twelve [most likely Hattie Chase] leans on the railing, idly watching the boats as they come and go. The party is completed by two dogs, nicely character- ized and cleverly painted; a poodle, shaved lion-fashion, and a pug, with its close, short fell of hair neatly modelling its fat body." ("The Painters in Pastel. The Fourth Exhibition," The Studio, Vol. V, no. 24, May 17, 1890, p. 237.)*

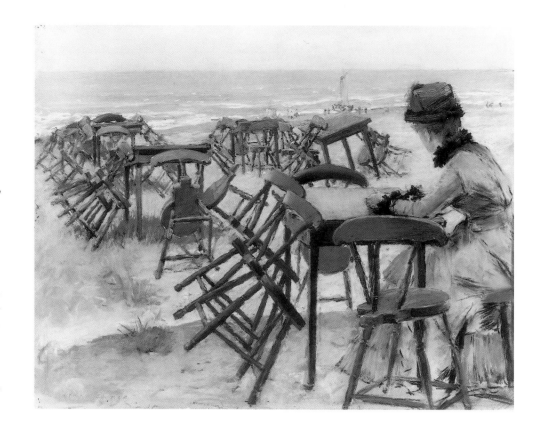

End of the Season

c. 1885. Pastel on board, 13¾ x 17¾"
Mount Holyoke College Art Museum,
South Hadley, Massachusetts.
Gift of Jeanette C. Dickie (Class of 1932)

American audiences were probably stunned by this composition, in which Chase fully exploited the pure design potential of the chairs and tables to express spatial recession, and in doing so, relegated the figure of the woman to the periphery. This radical composition in tandem with the medium of pastel (which was just then experiencing a revival) announced to Chase's viewers that through him a new art had arrived.

William Merritt Chase and art
class, New York School of Art

c. 1905. Gelatin silver print, 6 x 8"
mounted on cardboard
The Parrish Art Museum, Southampton, New York
The William Merritt Chase Archives,
Gift of Jackson Chase Storm

tional influences that converged in and transformed the American visual arts in the 1880s.

Establishing his position in the profession remained the operative factor in Chase's work of the 1880s, whether it was achieved through inventively reworking major contemporary visual icons to declare his own aesthetic stance or achieved through spearheading a major movement, as was the case with Chase's part in the Society of Painters in Pastel. Though the short-lived society headed by Robert Blum held only four exhibitions (in 1884, 1888, 1889, and 1890), Chase's dominance as an exhibitor with the group and his rapid mastery of the medium inextricably linked his name with the late-nineteenth-century pastel revival that for a time brought the medium into competition with oils in the fine-arts hierarchy.

By 1886, Chase's career was solidly in place. He had established himself as an authority in international art matters, shown himself to be an effective teacher, managed to develop a wide network of contacts within the art community, and, miraculously transformed himself into a living symbol of the new era in American culture. Even he must have recognized the momentous nature of his accomplishments, and with this awareness came the readiness for another phase in his life, which was ushered in with his marriage to the twenty-year-old Alice Gerson.

He closed out the year with his sensationally well received one-man exhibition of more than one hundred thirty works at the Boston Art Club, a show that left the critics to declare, "He is emphatically of his day and an interpreter of his day in art."

A CAREER IS ESTABLISHED

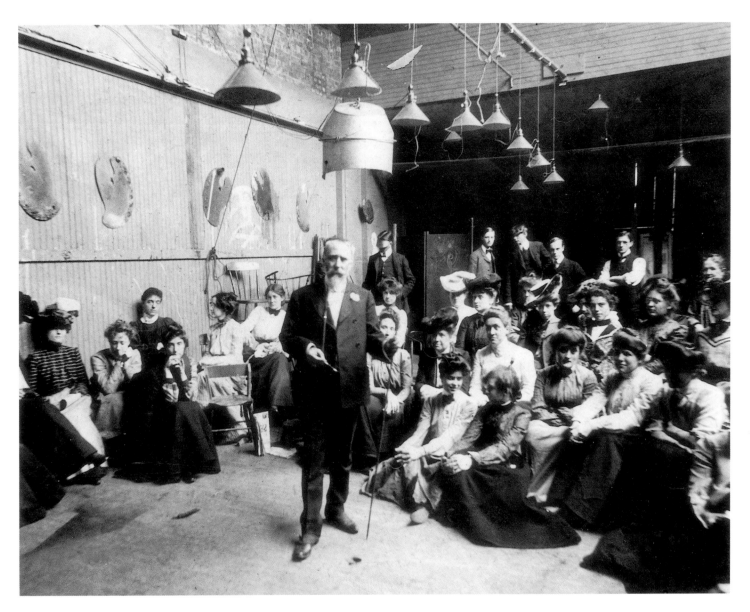

William Merritt Chase and art class, New York School of Art

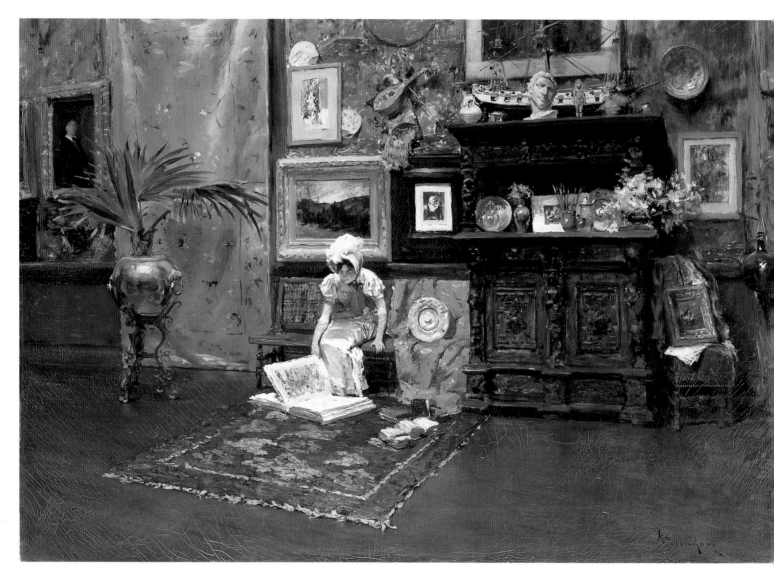

In the Studio

III. "A Fitting Frame" for the Artist: Chase's Studio

The vast, dimly lighted apartment was itself mysterious, a temple of luxury quite as much as of art . . . bits of shining brass, reflections from lustred ware . . . hangings from Fez or Tutuan, bits of embroidery, costumes in silk or in velvet . . . easels, paints and palettes, and rows of canvases leaning against the wall—the studied litter, in short of a successful artist, whose surroundings contribute to the popular conception of his genius.

This passage from Charles Dudley Warner's 1897 novel, *The Golden House*, describes a fictional New York artist's studio where a bohemian crowd awaits the midnight performance of a famous Spanish dancer. Warner's plot was surely fiction, but there can be no denying that he had based his scene on William Merritt Chase's renowned Tenth Street studio, which had been closed and dismantled just the year before. Warner's use of Chase's studio for inspiration in his own literary art was not an isolated case. It was indicative of the general public's fascination with the "artistic" space as the cultural locus of creative energy, much of which had been generated by the ongoing publicity surrounding Chase's studio from the early days of his occupancy of it in 1878. It was principally through Chase that the notion of the American artist's studio as a simple workplace or salesroom died. For Chase, the studio became a work of art in itself; a product and extension of the artistic personality that created it.

Even before he left Munich, Chase had vowed that he would have the finest studio in New York, having in mind as his model the richly appointed ateliers of successful European artists that were not only working studios, but were also repositories for collections of art and bric-a-brac, and places to entertain patrons and friends. The old-world atmosphere and rich cultural heritage preserved in these European studios entranced Chase, and he busied himself collecting the objects that would form the basis for the environment he planned to construct for himself in New York.

Chase's dream of a grand studio was not an idle one. Almost immediately after his return to New York in 1878, he secured a room in the stronghold of the city's art community, the Tenth Street Studio Building. Designed by the noted architect Richard Morris Hunt and completed in 1857, the structure was the first purpose-built complex of artists' studios in the United States and was, for a time, the urban center of the Hudson River School aesthetic, owing to the tenancies of such luminaries as Albert Bierstadt, Frederic E. Church, Sanford R. Gifford, and Worthington Whittredge. At first Chase occupied one of the smaller studios, but within a short time and through machinations that remain a

In the Studio

c. 1881. Oil on canvas, 28⅛ x 40¹⁄₁₆"
The Brooklyn Museum, 13.50.
Gift of Mrs. Carll H. De Silver in memory of her husband

This painting, although usually given a circa-1880 date, more likely deserves a date of 1881 or after. Its vibrant palette indicates that Chase had heeded the advice given to him by Alfred Stevens in the summer of 1881 to eliminate the dark, old-master look that he had adopted in Munich. However, Chase inserted an overt reference to his early aesthetic loyalties by prominently displaying a reproduction of Frans Hals's famed Malle Babbe *near the visual center of this composition.*

mystery, he negotiated a tenancy for the grandest space in the building, the two-story gallery that had originally been designed as an exhibition space, but more recently had been used by Bierstadt to paint his grandiose visions of the American West.

It is no small irony that Chase would acquire Bierstadt's space, for both men exploited their studios effectively to advance their reputations. Bierstadt's career was built on picturing the natural splendor of the nation's frontier wilderness, and he merchandised these American wonders so blatantly that he invoked the scorn of critics both for his art and for his "devices to rouse and stimulate public curiosity." The formidable writer Clarence Cook abhored Bierstadt's techniques of self-promotion and, in 1864, entreated, "We call upon all artists who wish to elevate their profession above that of the showman, to help us abate it."

Bierstadt had more or less led the way in changing the perception of the studio environment, decorating his Tenth Street interior with souvenirs of his western journeys that augmented the experience of viewing his art. With the 1866 completion of his palatial home and studio, Malkasten, dramatically situated on the Hudson River north of New York, Bierstadt surpassed all other American artists of his generation in the material demonstration of financial success and in creating an impressive atmosphere in which to showcase his work.

To a degree, Chase did what Bierstadt did. In the same space that had belonged to Bierstadt, he set an even more elaborate scenario to promote himself, his art, and, what is more important here, the art life. And, although it may have remained unspoken, the passing of New York's premiere studio from the older to the younger artist probably registered tellingly as symbolic of the final passing of the Hudson River School aesthetic to make way for the new generation of artists then returning from training in Europe. As early as 1879, line reproductions of sumptuously decorated corners of Chase's studio were published in art journals. Artists, collectors, and public alike thronged to his West Tenth Street premises to attend the artist's famed Saturday open houses. Yet, unlike Bierstadt, Chase was not condemned for what could be interpreted as intelligent marketing strategies, and the same Clarence Cook who thirty years earlier had taken Bierstadt to task for his vulgar showmanship, ignored the publicity aimed at Chase and his studio and, in fact, participated in its promotion by saying, "It is a true studio because it is given up entirely to the study and practice of art, and at the same time it is a good example of what, to the taste of some of us, at least, a living-room ought to be."

Why, then, was Chase exempt from the criticisms that had been lodged against Bierstadt only a generation before? Much of it had to do with the enormous changes that had taken place in American culture over the preceding decades, among which was the virtual explosion of press coverage directed at art, stimulated by the founding of major museums in the 1870s, the growth of private collections, and the return of a tremendous number of American art students trained in Paris, Munich, and London. Volumes have been written about this complex transition, but, in short, American artists and their audiences

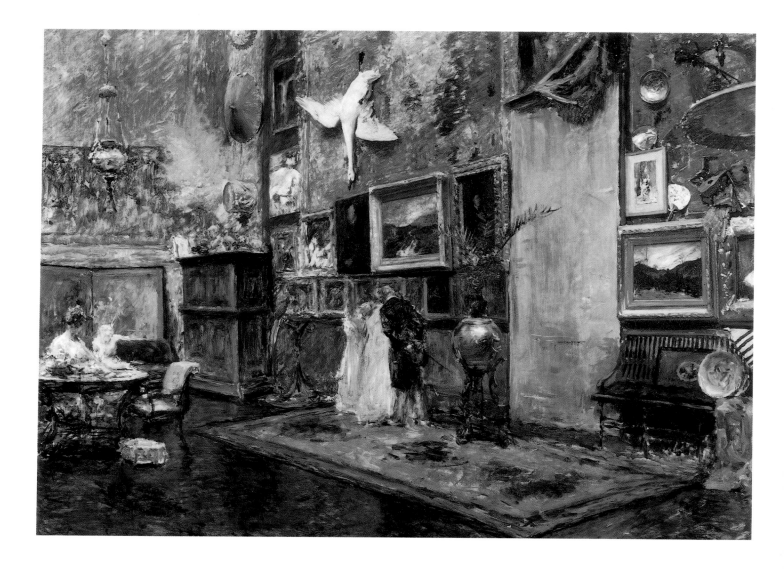

desired to slough off what they perceived as a provincial (i.e., exclusively American) aura and to enter the international art arena, the ultimate purpose being to authenticate the cultural credentials of the United States. In a broader context, the transition in America's self-image from that of developing country to international power is materially evidenced in the contrast between the objects collected by Bierstadt and Chase. The ideological (and pragmatic) shift in agendas from Western to global expansion (implicit in the close of the frontier by 1890) was anticipated in the methods and subjects of art production as exemplified here in the tastes of Bierstadt and Chase.

Chase's early critical reception marked him as a purveyor of the dramatic Munich style, and found logical correlation in the public's acceptance of him as a flamboyant personality. Consequently, such a figure as Chase could hardly be expected to function in an ascetic atmosphere. Furthermore, keen public interest in penetrating the mysteries of the artist's studio was evidenced and fed by a plethora of articles that started to appear in the late 1870s highlighting even the plainest, most austere rooms where America's famous painters created high art. At the same time, the introduction of the Aesthetic Movement in the United States ratified and made fashionable the desire to decorate even the middle-

Tenth Street Studio

c. 1880–81 and c. 1910. Oil on canvas, 46⅞ x 66″
The Carnegie Museum of Art, Pittsburgh.
Purchase, 17.22

Painted over a period of three decades, this painting is the product of a blend of direct observation and memory, which accounts for the disparate factures displayed in the canvas. The Carnegie Institute acquired the painting from the artist's estate in 1917 on the advice of Childe Hassam, who deemed it "the best Chase in existence—very important and moreover an artistically historic canvas." (Childe Hassam to John Beatty, May 11, 1917, Carnegie Institute Papers, Archives of American Art, Washington, D.C.)

class domestic interior according to "artistic" methods and stirred public demand for exemplars of taste on which to base artistic choices for the home.

Thus, when Chase arrived in New York, he entered a community that was primed to receive him. The general awareness of the momentous changes taking place in the arts soon to be known under the attractive rubric of "The American Renaissance" (a phrase coined by journalist and literary critic William C. Brownell in 1880), created a mood of expectancy that Chase was genuinely willing and prepared to satisfy simply by virtue of his own personal taste and the need to construct his own aesthetic haven.

Chase's Tenth Street studio gloriously affirmed and validated an already existing trend in American culture and provided an outstanding model for others to follow. Through him, the rarefied atmosphere of art became accessible, but it still retained its mystery. As Arthur Hoeber noted, Chase's studio was the "sanctum sanctorum of the Aesthetic fraternity," where one could commune at the altar of art. The notion of a renaissance in American culture automatically implied the idea of the Italian Renaissance and the traditions of the Old World so highly appreciated by Chase. The appeal of the Old World and the new-found opportunities to establish correspondences between American art and the grand traditions of Europe were reflected in vivid descriptions of Chase's studio, where the patina of time seemed to coat each object. His student Gifford Beal recalled:

In the large central studio the ceiling was lofty, and dust had been allowed to accumulate on all objects on the side walls and those suspended from the ceilings, such as hanging-lamps, etc. so that the local color on the bottoms of these objects melted gradually in the dust collected in their tops. In contrast to this the floor was highly polished, and all around the studio to a height of about seven feet were numerous articles of glistening brass, copper pots, with outsides of dead black and insides of flaming brilliance. Spanish furniture, superb hangings, and on the wall a huge white swan suspended on a piece of maroon-colored velvet. . . . The effect was beautiful and extraordinary.

Chase's studio was an emblem of artistic refinement, thereby transcending the definitions of ordinary space. This concept was further amplified when Chase incorporated the studio into his subject matter, thus materially elevating it to the realm of high art. There were strong precedents for using the studio as a subject in painting, one of the most important for Chase being the work of the Belgian artist Alfred Stevens (1823–1906). Chase had already developed a profound respect for Stevens before meeting him in Paris in 1881. Stevens's paintings had consistently gathered accolades at international exhibitions and, by 1879, he was represented in at least eleven major American collections including those of A. T. Stewart, William K. Vanderbilt, and Catherine Lorillard Wolfe, all New Yorkers whose collections Chase knew. From the 1850s on, one of Stevens's passions was painting pictures set in his own studio. As he became more successful and moved into grander spaces, indulging along the way his own appetite for collecting objets d'art, his paintings became more elaborate,

functioning as records of his personal taste and also as allegories of the painter's universe. Stevens's most intricately conceived painting of his elegantly appointed Paris studio on the rue des Martyrs, *Le Salon du peintre*, was acquired by W. K. Vanderbilt in 1880 and installed soon thereafter in the magnificent Fifth Avenue palace designed and built for Vanderbilt by Richard Morris Hunt. Chase's knowledge of the painting is confirmed by his later reworking of a significant motif from its composition in *A Friendly Call* (c. 1894 or 1895, National Gallery of Art, Washington, Chester Dale Collection). As it is entirely likely that Chase knew Stevens's painting by 1880, it may be considered a major impetus behind his first explorations of the studio theme that appeared that year.

The series of studio pictures that Chase executed mainly in the 1880s not only provides accurate documentation of the Tenth Street interior, but it also graphically records the studio's many purposes. It was a gallery and a showplace, of course, but it was also a place for painting, study, meditation, teaching, and theatrical entertainment. Above all, however, Chase's studio paintings are works of art made for the eye to feast upon.

In the Studio is one of the artist's earliest paintings in the series. In it, a young woman is shown quietly examining an oversized volume of art. Surrounded by a colorful profusion of wall hangings, paintings, musical instruments, antique furniture, and other objects too numerous to mention, she becomes an incidental footnote in the composition, functioning mainly as an element to provide scale and as a needed passage of light color in the scheme of the painting. Her quaint, old-fashioned costume rules out the possibility of identifying her as a patron, and it is likely that the young woman was a student or friend pressed into posing for the artist. While the primary subject is, of course, the view of one wall in the main gallery of the studio rooms, the underlying meaning resides in the space itself, and particularly in the space that is implied, but not seen. The arrangement of objects is viewed from a considerable distance. The full height of the wall is outside of the range of vision, but it is emphasized by the cropping of the painting that hangs above the massive wooden cupboard, and the whole scene spreads out on a line slightly angled away from the picture plane, thus augmenting the sense of continuing space beyond the limits of the picture frame. In this microcosmic sampling of the whole, the viewer is given sufficient information to gauge the nature of the contents and the enormity (hence the importance) of the artist's studio.

Chase adopted a similar viewpoint in another, larger work titled *Tenth Street Studio* that was probably begun in 1880, but not completed until about 1910. In this painting, we are given a view of the remaining portion of the wall featured in *In the Studio*, where three finely dressed figures inspect a work of art. (The woman seated at the table on the left is a later addition, possibly inserted for compositional balance late in the painting's development.) The impression of solitude and calm imposed by the seemingly cavernous space modifies the basic content of the image, shifting it from a standard depiction of patrons considering potential purchases to one in which the art atmosphere takes precedence over commercial concerns.

John Singer Sargent (1856–1925)
The Daughters of Edward D. Boit

1882. Oil on canvas, 87 x 87"
Gift of Mary Louisa Boit, Florence D. Boit, Jane
Hubbard Boit, and Julia Overing Boit, in
memory of their father, Edward Darley Boit
Courtesy, Museum of Fine Arts, Boston

*Chase probably first saw this painting
in 1883, when it was shown at the
Paris Salon and gathered praise for its
unconventional use of space. A renewed
interest in the painting may have been
sparked by Henry James's lengthy com-
mentary on it that appeared in* Harper's
Magazine *of October 1887 in which
James stated, "The treatment is eminent-
ly unconventional, and there is none of
the usual symmetrical balancing of the
figures in the foreground. The place is
regarded as a whole; it is a scene, a com-
prehensive impression."*

The daring use of space evidenced in the two works discussed above, in which a large portion of the central or foreground area remains empty, introduces a compositional device that Chase would put to greater service in subsequent paintings, particularly in the 1888 *Hide and Seek*. This painting especially reveals the growing distance between Chase's innovative experiments and the work of the older generation of American painters. In *Hide and Seek*, Chase addresses a standard genre subject, children at play, a common theme in the work of such artists as John George Brown and Seymour Francis Guy, both of whom were immensely popular at this time. Here, however, Chase eschewed any semblance of convention and, instead, plunged into a new pictorial space that was one of the signal traits of the European avant-garde. Using the new language of space received principally through the work of Degas and Sargent, Chase's *Hide and Seek* displays the hallmark features of the revised approach to interior space: the asymmetric arrangement of figures, the empty expanse of space at the center of the composition, and the planar definition of spatial recession. Chase also emphatically announced his awareness of the new vernacular by effectively using a favored device of Degas—the abruptly cropped figure seen here in the form of the small girl on the lower left whose shining hair works to lead the eye diagonally across the bare floor to her companion in play.

While Velázquez's remarkable *Las Meninas* (1656, Prado, Madrid) is traditionally cited as the seminal formal precedent for this type of spatially eccentric composition, Sargent's 1882 *The Daughters of Edward D. Boit* is usually credited with being the most immediate source of inspiration for Chase, who may have known it from its 1883 display at the Paris Salon (where Chase's *Portrait of Miss Dora Wheeler* [see page 90] was also on view), or from its 1888 exhibition at Boston's St. Botolph Club. Unlike Sargent, who was (more or less) tied to the necessity of portraying the children's faces because his painting was a portrait, Chase was free to ignore any predetermined aesthetic codes that would inhibit his freedom in painting the figure. Thus, while it is known that the model for both girls in *Hide and Seek* was the daughter of Chase's close friend Joaquin Miller, her identity is incidental to the viewer's experience of the painting. The figures are reduced to brilliantly executed passages of paint whose chief purpose is guided by the principle of "art for art's sake." It is, perhaps, no mere coincidence, however, that the deliberately placed chair on the left (the only piece of furniture in the composition) clearly identifies the site of the action as Chase's studio. Unquestionably the same chair depicted in the artist's famed *Meditation*, a pastel that had been exhibited to great acclaim in 1886 and 1887, its presence marks the site as Chase's, and therefore allows the painting to exist above all as a definitive cipher of the unique interior.

Carmencita (see page 46), Chase's noted portrait of the popular Spanish dancer, is also significant in the context of his studio pictures even though the setting for the portrait is not given detailed explication in the painting. In it, the idea of the studio exerts itself through association owing to the fact that three of the fiery Spanish dancer's performances took place in Chase's Tenth Street studio, the first of which occurred at Sargent's instigation.

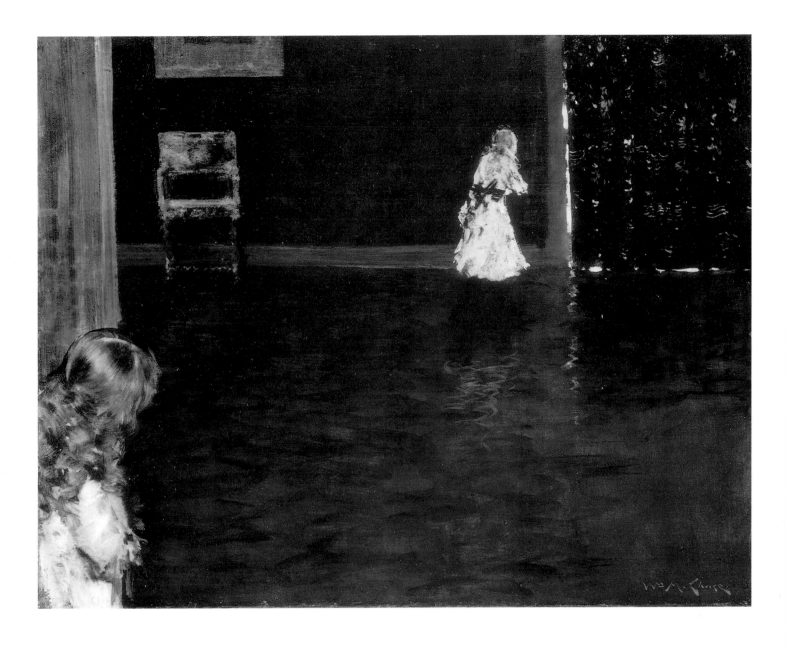

"La Carmencita," born Carmen Dauset in 1868 near Seville, Spain, had probably first attracted Sargent's attention at the Paris Exposition Universelle in 1889. In February 1890, she was performing nightly at New York's Koster and Bial's Concert Hall at Twenty-third Street and Sixth Avenue, and also made herself available for private performances at fees ranging up to one hundred and fifty dollars per evening. She had already performed at the New York studios of James Carroll Beckwith and Sargent, the latter of whom had nearly completed a portrait of the exotic "Pearl of Seville" when he wrote to Chase asking him to host an evening performance by the dancer for the special enjoyment of the powerful Boston collector Isabella Stewart Gardner. It is generally assumed that Sargent's underlying motive in persuading Chase to lend his studio for the event was to convince Isabella Gardner (who already owned his grand *El Jaleo*) to purchase his *La Carmencita* and, knowing that his studio was too small and dark for the impressive performance he envisioned, called upon Chase, saying, "I only

Hide and Seek

1888. Oil on canvas, 27⅝ x 35⅞"
The Phillips Collection, Washington, D.C.

Chase's investigation of space is most radically expressed in this painting in which he exaggerated compositional modes current in the art of such progressive painters as Whistler, Sargent, and Degas. A masterwork in the examination of pictorial space, its revolutionary aspects are mitigated by the painting's playful subject matter and mundane title. Informed viewers, however, were likely to have seen through the narrative screen that veiled the painting's true subject: the artist's space and his control over it.

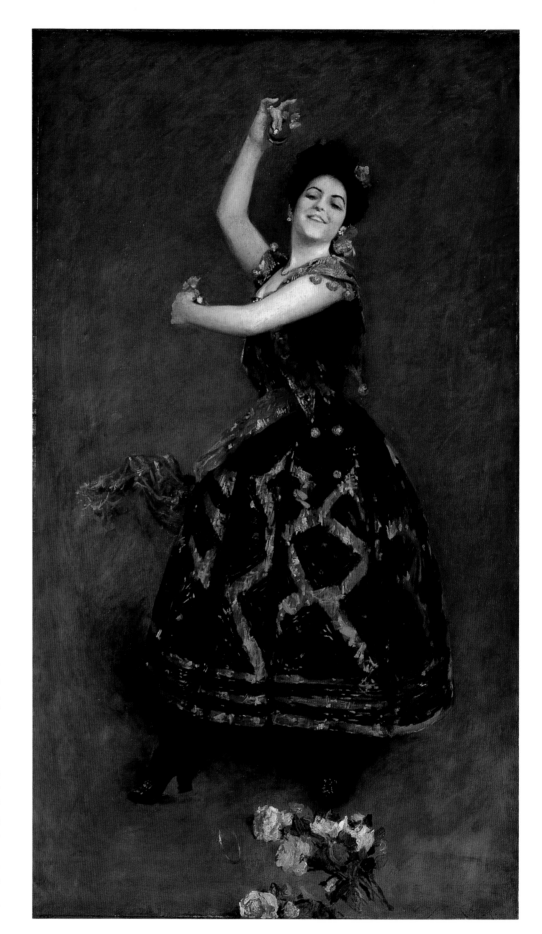

Carmencita

1890. Oil on canvas, 70 x 40⅛"
The Metropolitan Museum of Art, New York.
Gift of Sir William Van Horne, 1906

The Spanish dancer Carmen Dauset, known to her admiring public as Carmencita, or the "Pearl of Seville," performed at least three times in Chase's studio in 1890. One writer noted that the second evening was "far more jolly" than the previous occasion when she had danced for the Boston collector Isabella Stewart Gardner. The third performance was reserved entirely for a male audience composed chiefly of artists. ("American Notes," The Studio, May 3 and May 10, 1890.)

venture to propose this as I think there is some chance of your enjoying the idea and because your studio would be such a stunning place."

At about midnight on April 1, 1890, a small audience made up of Mrs. Gardner and friends of Chase and Sargent gathered in Chase's grand gallery. Despite an unpromising beginning to the evening owing to the dancer's bad temper (made worse by Chase and Sargent's collective insistence on removing her heavy makeup and combing her disheveled hair), Carmencita delivered a spirited performance that stirred members of the audience to throw flowers and jewelry at her feet. Unfortunately for Sargent, the night's entertainment did not bring about the hoped-for sale of his portrait. For Chase, however, the evening proved an inspiration, and he subsequently hosted more performances by the dancer and convinced her to sit for him.

Chase's portrait of the temperamental performer fully realizes the frenzied dance gyrations that kept New York audiences fascinated. And, as Warner's *The Golden House* attests, memories of Carmencita's evenings at Chase's studio lingered in the minds of cosmopolitan New Yorkers for years. The artist Dora Wheeler later recalled, "It was the most wild and primitive thing I have ever seen . . . and the most artistic." In contrast to Sargent's portrayal of Carmencita as the arrogant personality who seems just to have stepped into the glaring footlights, Chase's image captures the joy of the dance in all of its movement, and evokes the sound of her castanets, her tapping feet, and the clattering coins that trim her dress. The sense of immediacy and motion is further enhanced by the round, gold bracelet tossed at her feet that has not yet settled to the floor. More to the point, Chase's inclusion of the bracelet and the flowers is a direct reference to details of the first performance held in his famous studio and thereby underscores the connections between the woman and the celebrated venue in which she danced.

Chase provided other lasting and more intimate views of his studio that elucidated contrasting aspects of the art life. *A Corner of My Studio* (see page 48) is a beautifully executed pictorial vignette that suggests the overall decor of the larger space. The bulk of the composition is given over to describing the details of a carved chest, velvet hangings, brass coffee urn, and other collectibles in the foreground. Through the doorway to the left is a young woman—doubtless one of Chase's students—who is working at an easel. The secondary position assigned the motif of the young artist momentarily obscures the crucial nature of her presence, which, if further considered, may be credited with investing the painting with its true meaning. By literally placing the image of "the artist at work" behind the sumptuous array of objects, Chase reveals his attitude toward art: that the process of collecting and creating were reflexive activities, both of which were guided by an internal response to a visual world of his making. For him, the two meshed seamlessly, but as implied in this painting, the artistic process lay at the root (or literally "behind") his obsessive collecting, and that the ultimate purpose of the studio was, indeed, to establish the appropriate environment for inspired work.

This meaning is echoed in *The Inner Studio, Tenth Street* and *Connoisseur—*

John Singer Sargent (1856–1925)
La Carmencita

1890. Oil on canvas, 90 x 54½"
Musée d'Orsay, Paris

Sargent's portrait of Carmencita was deemed "the picture of the year . . . with something of that halo of decay which gives a lurid fascination to the creations of Baudelaire," by the English press when it was shown at the Royal Academy in 1891. (Art Journal, 1891, p. 198.) On the other hand, at least one American critic was less impressed with it when he saw it at the Society of American Artists the year before: "When we heard that Mr. Sargent was painting this lady, we found it very natural, remembering . . . that of all things this artist abhors the tame and conventional: it seemed therefore, that here was a subject made to his mind. But Carmencita as painted by Mr. Sargent has lost some of her wildness—or, was she never so wild as the lavish imagination of the newspaper reporter has painted her? Is there an esoteric Carmencita, who keeps her 'sinful postures' and her wanton contortions for the artists' five o'clock teas, and the exclusive entertainment of our Puritan Bohemians?" (Clarence Cook, The Studio, vol. V, No. 23, May 10, 1890, p. 230.)

A Corner of My Studio

c. 1885. Oil on canvas, 24⅜ x 36¼"
The Fine Arts Museums of San Francisco.
Gift of Mr. and Mrs. John D. Rockefeller 3rd,
1979.7.29

American periodicals abounded with articles about artists' studios in the late nineteenth century which, in turn, inspired general decorating trends for domestic interiors. One writer was quick to note, however, "It must not be forgotten that the charm of an artist's studio such as those of Mr. Chase, Mr. Shirlaw, or Mr. Tiffany, is due to the owner's horror of conventionality, and his feeling for unity and harmony, and so long as these are obtained, and his eye fed and kept in tune, he does not care for the intrinsic value of his belongings, nor is it necessary that apple-pie-order should reign supreme." (Clarence Cook, "Casts and Tapestry in Room-Decoration," The Monthly Illustrator, vol. IV, no. 14, June 1895, p. 323.)

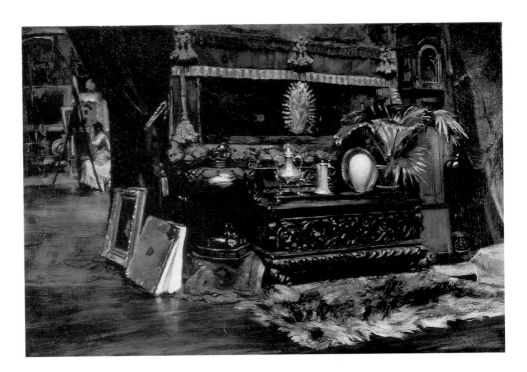

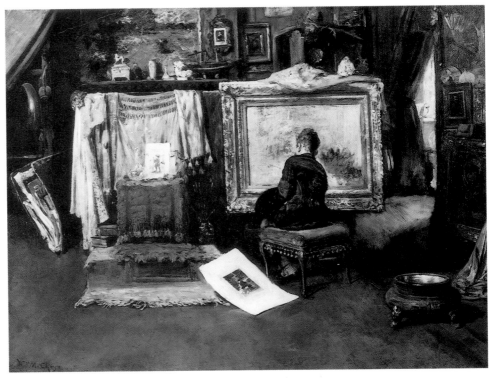

The Inner Studio, Tenth Street

c. 1880s. Oil on canvas, 32⅜ x 44¼"
The Virginia Steele Collection,
Henry E. Huntington Library and Art Gallery,
San Marino, California

Despite the profusion of detail Chase's paintings offer in documenting the appearance of his historic studio, the underlying theme of these studio subjects was the importance of art and the creation and/or examination of it. This elegantly constructed composition literally directs the viewer to read the painting on the easel as the true subject of this work. The eye is forced to the dark form of the woman, silhouetted in the center of the painting that she investigates. We even strain to see what she sees, but Chase has foiled the effort, purposely confounding the boundaries between real and pictorial space and mystifying the object of vision, the painting that we will never "see."

The Studio Corner (see page 51) in which young women (again, most likely students or, in the case of the latter painting, possibly one of the Gerson sisters) are shown quietly contemplating works of art. In contrast to *In the Studio* and *Tenth Street Studio* discussed above, the figures attain prominence, not merely as compositional devices, but now as signifiers of the art of looking. The theme of looking at art in itself was not unusual subject matter, but these particular studio interiors differed from other depictions of galleries, salesrooms, and artists' studios because they concentrated on the active and solitary experience of

studying the art object. Chase's women take advantage of the secluded corners of the studio to look, to hone their skills in connoisseurship. Because of his emphasis on the intellectual activity of looking, Chase's women viewers cannot be confused with similarly isolated females who populated the later paintings of such artists as Thomas Wilmer Dewing, William McGregor Paxton, or Lillian Westcott Hale, whose iconographies are generally read either to equate the woman with the beautiful objects around her or to equate the aesthetic experience with leisure pastimes of the upper middleclass. Indeed, *A Corner of My Studio, The Inner Studio, Tenth Street,* and *Connoisseur—The Studio Corner* are vital reminders that the majority of Chases's students were women.

In a similar vein, the notion of the studio as a workplace is subtly introduced in a small painting known as *Weary* (see page 51). With a deftly ironic twist, Chase has painted a picture of a model posed as if she is in the midst of a rest from posing. In one sense, Chase may be seen to have been only one of many artists whose languorous female subjects were part of a general trend in figure genre. And though this painting might be a specific response to Whistler's famous 1863 drypoint of the same name, portraying a similarly posed figure, Chase's treatment of the theme departs from the others in its attention to the model's surroundings. We can almost imagine the painting for which she has been sitting, for its principal elements are provided here in the Japanese screen, chair, and Oriental carpet. The artificiality of this enclosed "composition within a composition" is signaled by the inclusion of the brass pots and samovar that occupy a space partially obscured by the screen—an area that would not be seen in the fictive painting. This space extends to a doorway marked by a shimmering sliver of light that suggests an open, airy, bright room beyond. Thus, the screen divides the "real," larger world of the studio from the artfully arranged niche where the model finds reprieve from the tedium of posing. The dichotomy established between the two types of space ("real" and "artificial") and the introduction of the question of what is posed and what is not (certainly, the model is posed to look as if she is not posing) opens up a host of issues revolving around realism and artistic production. Moreover, as *Weary* and Chase's other studio paintings demonstrate, the studio and the diverse objects it housed functioned as sites of conscious invention whose collective meaning by far surpassed mere issues of taste. The famed esthete Count Robert de Montesquiou expressed similar thoughts about the elaborate studio and collection of Alfred Stevens when he described Stevens's equally self-consciously constructed environment as "a mine of selected bric-a-brac . . . incongruous elements, but associated by a major reason, a raison d'être even more important than taste itself; the desire to paint them, to transubstantiate them out of contingency and time into fictitious yet more real interiors, forever protected from moving and ending."

Chase's studio paintings perform the function ascribed by Montesquiou to comparable works by Stevens. Despite the existence of probably hundreds of photographs that document the appearance of Chase's studio, the most valuable views of it remain those from the painter's hand. Yet the photographs, more

than the paintings, served to keep the artist's studio in the public eye even well after its closing in December 1895 and the auction of its contents at the American Art Galleries in January 1896. Rumors spread about Chase's reasons for closing the studio and, although his motives were never clearly stated, the financial drain of maintaining the space must have been the greatest factor in making the decision.

Chase's announcement of his plan to shut the studio that had become a cultural landmark shocked the art world, and the auction of its contents that took place over a four-day period became an event in itself. In addition to works by Chase, a portion of his collection of paintings by other artists also went on the block. Included were canvases by Wilhelm Leibl, John La Farge, Berthe Morisot, Eva Gonzales, Théodore Géricault, Mariano Fortuny y Carbó, Charles Loring Elliott, and William Morris Hunt, all of which reflect the catholicity of his taste.

More breathtaking in terms of sheer volume (eighteen hundred lots) and variety were other collections within the collection: thirty-one musical instruments including Japanese gongs and fiddles, Chinese and Turkish stringed instruments; American Indian, African, and Indian drums; a collection of shoes; thirty-seven Russian samovars; a Zulu war shield; canes; fans; picture frames; stuffed birds including a swan, two ibises, a pelican, and a raven; a collection of Phoenician, Spanish, and Roman glass; fifty-five locks; swords, knives, and guns; Spanish bridles and other equestrian trappings; thirty-seven Spanish or "Moresque" plaques; Persian wares; Japanese wares including ceramics, marionettes, masks, and rice spoons; thirty-seven brass candlesticks; furniture, rugs, tapestries; bows and arrows; a Peruvian-Indian head; and six hundred rings, ranging in period and culture from ancient Egyptian to contemporary Japanese.

Despite the considerable press advertising the sales and the crowds that attended the preview exhibition, the auction realized only twenty-one thousand dollars. The disappointing results caused one writer to justify Chase's publicized plan to abandon New York saying, "Is it surprising that he has resolved to shake from his feet the dust of his ungrateful country, and join the distinguished contingent of the expatriated across the Atlantic?"

Chase, however, did not make his absence permanent and, as is well known, resumed teaching and painting in New York later in 1896. Not surprisingly, he continued to collect; but he never again attempted to establish a studio comparable to the one on Tenth Street. Nevertheless, writers often persisted in finding the number, purpose, and location of Chase's subsequent studios worthy of headline. In fact, the number of working studios the artist maintained became something of a curiosity and a popular means by which to gauge Chase's success. A 1909 article in *House Beautiful* enumerated three New York studios: one on Fifth Avenue near the Waldorf-Astoria, "a place for posing his high-rank portrait patrons. Fourth Avenue, rather plainly furnished is a larger room where he works in a more general way; on the floor above this large studio is another of similar size, for the use of his favorite famous pupils." Yet another article published in 1910 was titled "The Artist of Many Studios."

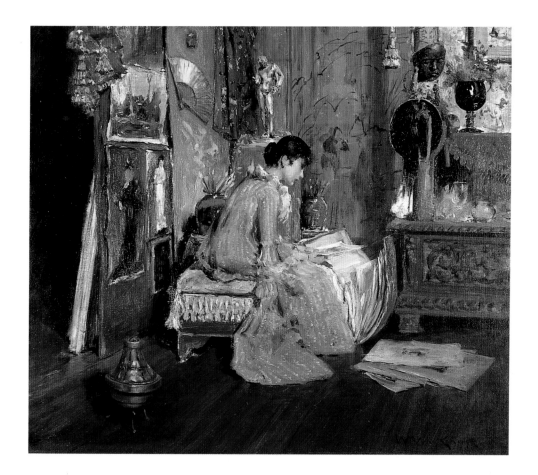

Connoisseur—The Studio Corner

c. 1882? Oil on canvas, 20 x 22″
Canajoharie Library and Art Gallery,
Canajoharie, New York

A writer for Godey's Magazine *characterized Chase saying, "He is artistic in everything; his tastes are repeated in his surroundings; he lives and banquets on all that arouses the interest of his eye." Chase often suggested in his paintings the pleasures to be had from the act of looking. His lectures emphasized the importance of seeing with a fresh eye, unhampered by assumptions. This work incorporates these essential ideas relevant to Chase's aesthetic: the importance of the appropriate environment for the study of art, and the notion of the pure pleasure of looking.*

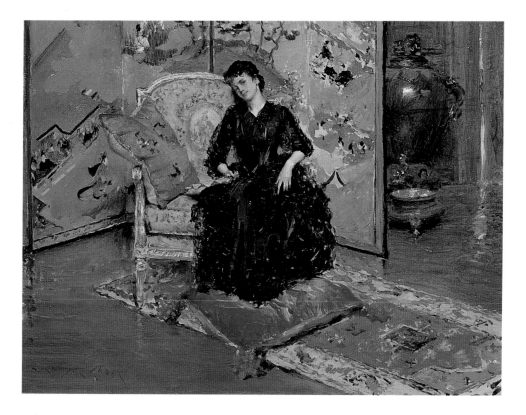

Weary

c. 1889. Oil on panel, 9⁷⁄₁₆ x 12³⁄₈″
Berry-Hill Galleries, Inc., New York

Chase's often brilliant management of pictorial space is evident in this composition, based on a complex series of angles that define a small corner of his studio. The sophisticated design intent is at first obscured by the richness of color and surface, but study of the structure reveals such patterns as, for instance, the set of chevron shapes beginning with the angled point at the red tassle of the floor cushion that repeats in the hem of the dress, the waistline, the neckline, and finds resolution in the off-center placement of the model's jawline. Although the model functions to center the composition, the overall effect is one of asymmetry, where equilibrium is achieved through carefully orchestrated counterbalances of light and dark areas of color or patterned versus plain surfaces.

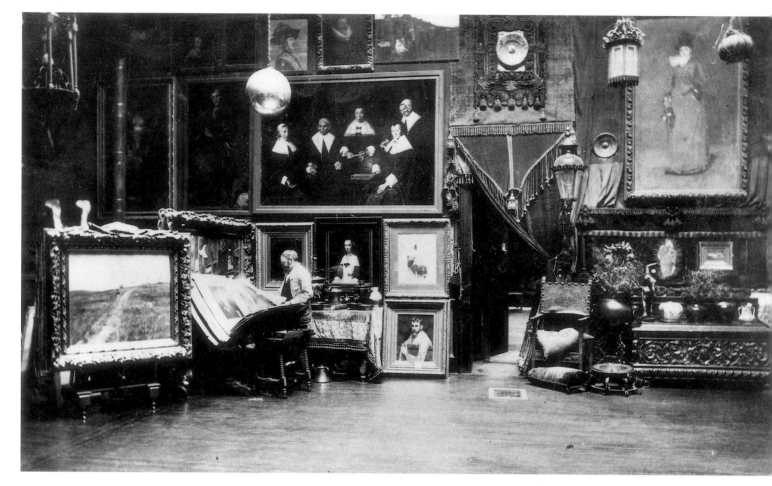

William Merritt Chase in his Tenth Street studio

Chase, of course, set up a studio wherever he went, and hence had a series of temporary studios throughout Europe to accommodate himself and his summer students. These he seldom painted, but some of the interiors, as recorded on the canvases of his students, appear to be no more than large, serviceable spaces.

The one exception among his foreign studios was the romantic villa situated in the Tuscan hills just north of Florence. Chase had rented the fifteenth-century villa in 1907, the year of his return to Italy after thirty years' absence. For the following three summers he leased the house and finally purchased it in 1910. According to art critic Gustave Kobbé, the villa was:

most picturesque . . . and when Mr. Chase bought it it was furnished in part with antique objects corresponding to its age . . . the stone walls of the villa are four feet in thickness . . . all the floors are of glazed clay, and are painted in beautiful colors. The visitor on entering finds himself in a room forty feet by thirty wide, the ceiling is white and gold.

Chase, who had earlier tried to transform a corner of the New World into the Old in his Tenth Street studio, obviously discovered an eminently sympathetic environment in the villa, whose already lavish decor was enhanced by the artist's subsequent extravagant purchases. However, he did not devote the same energies to portraying this essentially ready-made, but genuine atmosphere as he had done with his Tenth Street space and, to a lesser extent, his Shinnecock studio. Instead, Chase concentrated on exterior views of the villa and the surrounding countryside.

By this time, the artist seems to have become psychologically detached from the succession of interior spaces in which he worked, at least sufficiently for these interiors to have lost the mystery and joy attached to the Tenth Street studio that had been the geographic center of his life for nearly twenty years. As one writer had stated about the Tenth Street studio in 1891, it was "a fitting frame for the clever, refined, and interesting artist who owns it."

With the 1896 closing of the Tenth Street studio, and the 1902 closing of the Shinnecock School (entailing his absence from the summer studio because of classes abroad), Chase relinquished claim to an important segment of subject matter that had been instrumental in establishing him as an artistic force. In losing the continuity of place (or, as the writer quoted above called it, the "frame") that Chase had so scrupulously and completely constructed for himself, there came a corresponding loss of passion and inventiveness in his art that seems to confirm that Chase indeed required an intimacy with his subject matter and an active hand in shaping it.

Portrait of Mrs. C. (Alice Gerson Chase)

IV. "A Special Harmony": The Painter's Family Portraits

WHEN CHASE AND ALICE BREMOND GERSON MARRIED in 1886, the couple entered a restless domestic existence that did not see them truly settled until they purchased a Manhattan townhouse at 234 East Fifteenth Street in 1895. Their first nine years together were marked by nomadic household moves taking them from East Ninth Street, to West Fourth Street, to East Fortieth Street, and to West Eleventh Street. These uprootings were punctuated by brief stops in Brooklyn and in Hoboken, New Jersey (while the Shinnecock house was being remodeled), with occasional summers in Orange, New Jersey, and Bath Beach, Brooklyn, before they started to summer regularly at Shinnecock in 1892. While there can be no doubt that the true geographical center of Chase's life during the first decade of his marriage was the Tenth Street studio (where the couple had even lived for a short time after their marriage), there can also be no doubt that Alice Chase was the emotional center of his existence.

Chase's first biographer, Katherine Metcalf Roof, described the Chase household as one of "special harmony" and, judging from her impressions of Chase family life, it is to Alice Chase that the credit for that harmony must go. The mother of eight children who survived to adulthood, Alice Chase seems to have weathered gracefully the constant comings and goings of a notoriously impractical, albeit thoroughly devoted, husband. Not only was she remarkable in her ability to manage the constantly shifting households and numerous trips abroad, she was also her husband's closest confidant and his frequent model. Ironically, Chase unwittingly duplicated his father's erratic patterns and, though eminently successful, he nonetheless subjected his large family to a succession of moves and financial uncertainties that echoed his youthful experience of family life. Chase treasured his family and home, but the largest measure of the responsibility to maintain the private life that he cherished fell on the shoulders of Alice Chase.

The evolution of the couple's relationship may be traced in the numerous portraits Chase painted of his wife in which she is transformed over the years from a dreamy-eyed young girl to a figure of matronly stature. Among the most visually arresting and psychologically complex of the portraits of Alice Chase is the painting known as *Portrait of Mrs. C,* in which she is shown as a diminutive, almost childlike figure whose sober self-possession is faintly disquieting in its effect. Here is Chase's child bride who, while elevated to the status of queenly authority, still retains the innocent reticence of youth. The sophisticated

*Portrait of Mrs. C.
(Alice Gerson Chase)*

c. 1890–95. Oil on canvas, 72 x 48″
The Carnegie Museum of Art, Pittsburgh.
Purchase, 09.6

This image of Chase's young wife, Alice, powerfully conveys a range of conflicting messages that may reflect his own complex feelings for her.

55

Alice Gerson Chase

c. 1886. Oil on canvas, 36 x 28"
Courtesy of Adelson Galleries, Inc., New York

This portrait is probably the first that Chase painted of Alice after their marriage. Katherine Metcalf Roof described their artist/model relationship saying, "Aside from his personal feeling and the practical convenience of propinquity, it was evident that something in his wife's type especially appealed to the painter. Yet few of the pictures are portraits in the exact sense of the word, and therein lies one of the mysteries of the art of portraiture. Mrs. Chase never grew to dislike posing, as many members of painters' families do. Indeed, she was as frequently a volunteer as a conscript, devising costumes suitable to her type with the purpose of pleasing the painter's eye or of suggesting a subject. She says that he seldom kept her posing long enough to be fatiguing. The sureness of his seeing made the process swift." (Roof, The Life and Art of William Merritt Chase, *p. 254.)*

evening clothes and regal pose contradict the sense of vulnerability that registers in her expression, and the two opposing sensibilities—worldliness and innocence—merge to create a delightful, but potent tension.

A comparable tension is elicited in *Artist's Daughter in Mother's Dress* (*Young Girl in Black*), where, in this case, Chase's eldest child, Alice Dieudonnée, is posed "dressing up" in her mother's clothes. This curiously solemn image is essentially the converse of the earlier portrait of her mother in that it conveys a similarly conflated (but "chronologically reversed") image of the child and the adult. The young girl's strangely impassive gaze runs counter to the idea of a playful childhood masquerade and suggests, instead, a bittersweet mood evocative of the passing of youth. Coincidentally, this painting marks the point at which Chase began to depend less on his wife as a model for his formal "exhibition" portraits and turned more frequently to portraying her namesake, a daughter who resembled her and who approached the same age Alice Gerson had been when she first met Chase.

The stable home life that Alice Chase maintained was conducive to and utterly supportive of her husband's art; so much so that his family life extended into the studio and vice versa. Few late-nineteenth-century American painters have left such a personal record of their private lives in their art. Granted, Abbott H. Thayer and George de Forest Brush consistently used their children as models, but they did so via an iconography cloaked in allusions to the Renaissance masters; and, while Frank W. Benson also frequently used his daughters as models, he incorporated them into generic scenes that actually revealed little about how he lived. Chase's wife and children, on the other hand, entered the public domain as recognizable personalities, owing to their repeated appearances in paintings that specifically identified or portrayed them in surroundings already associated with Chase. Framed in their own domestic milieu, their painted images undoubtedly implied a reality bordering on the photographic for the contemporaneous viewer. Yet the reality was, of course, subordinate to Chase's subjective, painterly vision and it consisted of his carefully selected constructs of an artfully arranged life offered in a seemingly casual, documentary manner.

The Open Air Breakfast (see page 58), of about 1888, is a complex work that features members of the artist's immediate family circle in a genre format. The light palette and emphasis on natural, sunlit effects align him with the Impressionist aesthetic. Most important, however, in establishing the artist's affiliation with "new art" born in France, is the ostensibly unposed quality of the composition, which thoroughly renounced the academic hierarchy of subject in its celebration of the uneventful quotidian rhythms of contemporary life. Gathered for a leisurely alfresco meal in their Brooklyn backyard are the artist's sister-in-law (probably Minnie), who lounges in the hammock, Alice Chase with the couple's first-born daughter, Alice (nicknamed "Cosy"), and Chase's sister Hattie.

If spontaneity was Chase's intended effect, this painting may be considered a dismal failure, for all signs of casual activity are subservient to artistic ends. The spectator is treated to the same type of view across an "empty" foreground

Young Girl in Black: Artist's Daughter in Mother's Dress

c. 1899. Oil on canvas, 60 x 36⅛"
Hirshhorn Museum and Sculpture Garden,
Smithsonian Institution, Washington, D.C.
Gift of the Joseph H. Hirshhorn Foundation, 1966

Alice Dieudonnée Chase's slouching posture and slightly off-balance stance add a curious note to this painting which finds its explanation in the fact that in its original state, the canvas included a chair on the right on which the girl rested her left hand. While the elimination of the chair may have improved the overall composition, painting out the chair also forced the artist to modify the position of the left arm and hand, a change that introduced an awkwardness to the pose that could not be corrected without reconstructing the figure entirely.

c. 1888. Oil on canvas, 37⁷/₁₆ x 56¾"
Toledo Museum of Art, Ohio.
Purchased with funds from the Florence Scott
Libbey Bequest in memory of her father,
Maurice A. Scott

*Chase's constant desire to explore the
issue of the transformation of real into
pictorial space is cogently expressed here.
In this painting, he melded the notions
of interior and exterior space by literally
furnishing the out-of-doors, thus turn-
ing the outer world into a studio of his
own devising.*

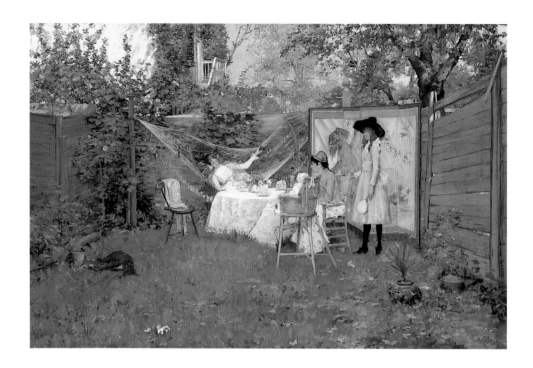

Sketch of My Hound "Kuttie"

c. 1885. Oil on panel, 13 x 16"
Private collection

*Chase's particular fondness for dogs was
manifested both in his personal image
that he conveyed to the public and in his
art. As his first biographer noted, Chase
was often "accompanied by his almost
equally famous Russian greyhound,
which, if not the first Russian grey-
hound to be seen in New York, was at
least the first one to become a marked
character of the boulevards." (Katherine
Metcalf Roof,* The Life and Art of
William Merritt Chase, *p. 87.) This
sketch is one of two identically titled
works (in some cases listed as "Kattie")
shown by Chase in Boston in 1886 and
in the 1887 presale exhibition at Moore's
Art Galleries, where both were listed as
part of the artist's private collection and
not for sale.*

space that Chase had used for the larger of his Tenth Street studio pictures. But
here, the sumptuous array of studio objects finds its visual equivalent in the lush
greenery that protectively encloses the group as if to imprint the idea of a mod-
ern, domestic, *hortus conclusus* on the mind of the viewer. The eye is guided
through the irregular, trapezoidal space in a zigzag route, demarcated by pas-
sages of dark pigment (in the pot at lower right, the dog at left, the chair draped
with the pink shawl, and the pillow at Minnie Gerson's head) to focus ultimate-
ly on the deep blacks of Alice's hair and Hattie's hat and stockings. It is with
these darkest of darks that Chase delineates his central motif—his wife, his sis-
ter Hattie, and, tangentially, his child. The trio is further segregated from the
larger composition by its placement against the Japanese screen, an object that
immediately calls to mind the larger scope of the artist's aesthetic concerns.

Consciously or not, Chase framed his family within the boundaries of his
art, declaring the two inseparable. Yet it is likely that the artist intended this
meaning. The motif of Alice (in an Oriental cap) with Cosy in a highchair posi-
tioned against a Japanese screen repeats the elements Chase had used for an
earlier painting, *Happy Hours* (unlocated). Hattie's pose echoes that of Chase's
circa 1887 portrait of her and consequently, her figure, too, functions as a delib-
erate, self-quoting device. Her sidelong, but steady gaze diverts attention from
the group at the center of the canvas and fixes the spectator's attention on the
artist, who exists outside of the pictorial scheme in the same conceptual space
shared by the viewer. Thus, Hattie's iconographic purpose may be equated with
that of the theatrical aside in that she pointedly declares the artifice of the
arrangement to the viewer. In essence, Hattie acknowledges both types of space.
She is physically connected to the pictorial arrangement by her strong grasp of
the back of Alice's chair, but she is consciously connected to the spectator-
painter's space by virtue of her gaze.

Chase reiterated this theme of reflexivity in even stronger terms in a later, similarly complex composition, *Hall at Shinnecock.* Frequently discussed in the context of Chase's admiration for Velázquez's *Las Meninas* (which he had studied intensively at the Prado in Madrid), the pastel not only realizes Chase's homage to the Spanish master, but also—by means of the artist's reflected image in the right mirrored panel of the armoire at the far end of the hall—overtly continues the dialogue begun in *The Open Air Breakfast* between artificial, pictorial space and the "true" space of the painter. Again, as in the previous work, Chase uses the gaze of a figure (in this case, his daughter Cosy) to bridge the gulf between art and reality and, just as Hattie's hold on the chair physically linked her with the rest of the group in *The Open Air Breakfast,* Cosy's left hand connects with the art that unfolds in her sister's lap and thereby leads the viewer's eye into illusionistic space. Chase apparently enjoyed the formal qualities of the accordianlike unfolding of colorful sheets (most likely reproductions of Japanese prints), and the motif occurs in other examples of his work. In this instance, however, it is not only the association with Japanese art and its impact on late-nineteenth-century Western painting that is germane, but also the fact that the artist used an object(s) signifying art itself as a device to draw the viewer into pictorial space.

Others have also noted Chase's tendency to blur the boundaries between real and pictorial space, pointing to the artist's frequent use of "pictures within pictures" and mirrored reflections in his compositions as tools to open the discourse on the nature of space and its use in interpreting the psychological interiority of the sitter. More than this, however, Chase's habit of framing his sitters in space defined by such mediating elements reveals his own proclivity to view the world consistently in terms of its pictorial potential. Thus, although *Reflections,* for example, does rely on the common *fin de siècle* iconography of the mir-

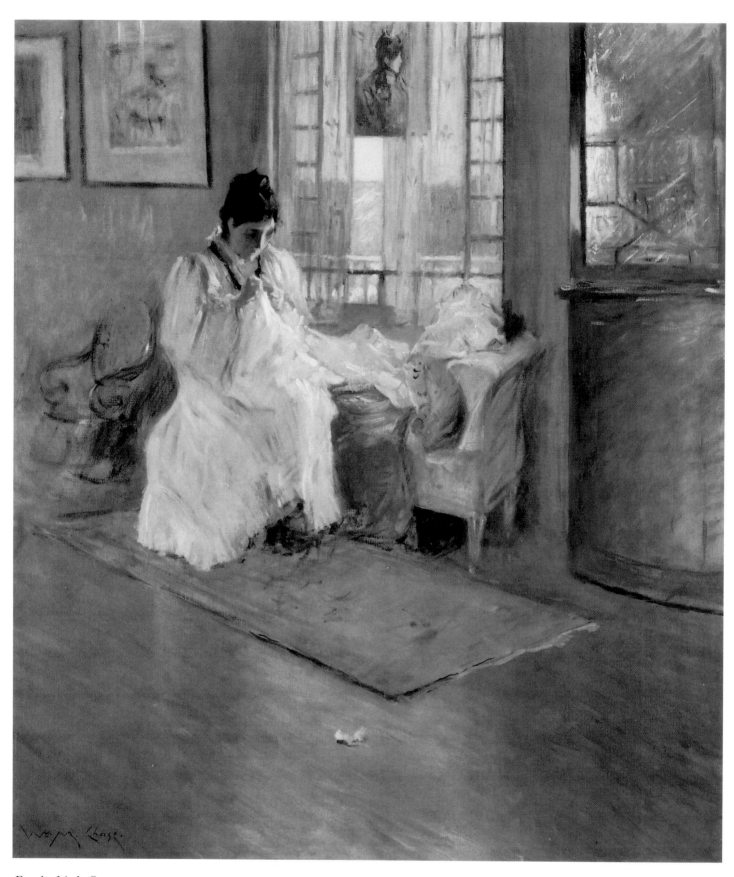

For the Little One

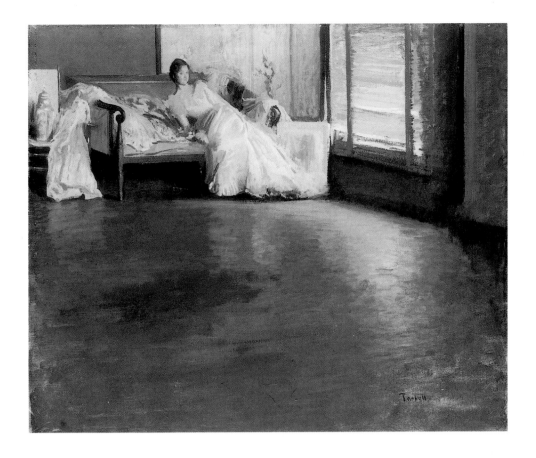

Edmund Tarbell (1862–1938)
Across the Room

c. 1899. Oil on canvas, 25 x 30⅛″
The Metropolitan Museum of Art, New York.
Bequest of Miss Adelaide Milton de Groot
(1876–1967), 1967

When this painting was shown at the 1899 exhibition of The Ten American Painters, one critic commented that "it might just as well have been called 'The Studio Floor' [because] three-quarters of the picture represented its polished surface, reflecting a little light that came in through the closed slats of the blind." (C. H. Caffin, Artist, 25, May/June, p. vii.) Most writers rightly attribute Tarbell's compositional eccentricities to his admiration for the art of Degas, but fail to mention that he was just as likely to have found inspiration closer to home in the art of Chase.

rored image and also suggests a latent meaning having to do with Alice Chase's inner thoughts, the painting ultimately speaks more to the artist's own mode of looking. The practice of "framing" observed reality or literally excerpting portions of the daily visual experience and converting it into art was part and parcel of Chase's approach to his subject matter; and, while the composition of *Reflections* (see page 64) is articulated as a deliberate artifice, the framing of Alice Chase in the mirror as if to create a simulated, painted image, again recalls the conceptual continuity maintained in the artist's synthesis of observed and constructed realities.

With the exception of *The Open Air Breakfast*, Chase reserved his portrayals of his family as identifiable individuals for interior scenes or portraits, a practice that emphasizes how closely attached he was to the circumscribed interior spaces of his personal life. In contrast to his paintings of the spacious stretches of the Shinnecock hills or beaches in which his wife and children functioned as anonymous, sometimes even faceless, compositional elements, Chase's interiors with figures inevitably engage the viewer not only because they are fascinating compositions in themselves, but also because they elaborate on aspects of a celebrated artist's "private" life.

A comparison of Chase's circa-1895 *For the Little One* and Edmund Tarbell's circa-1899 *Across the Room* offers a cogent argument for the inherent intimacy of Chase's art. While both painters exploited the dramatic potential of the new approach to pictorial space, Chase emphatically inserted an element of familial

For the Little One

c. 1895. Oil on canvas, 40 x 35¼″
The Metropolitan Museum of Art, New York.
Amelia B. Lazarus Fund by exchange, 1917.
(13.90)

Sadakichi Hartmann, above all other critics of the period, seems to have been especially attuned to the narrative element in Chase's art. This unusually sentimental work, however, failed to satisfy the critic's taste on all levels, as revealed in Hartmann's commentary on the occasion of its display at the 1897 exhibition of the Society of American Artists: "Chase's technic seems to me steadily progressing. . . . For the Little One, although rather shallow in content reveal[s] subtleties that are on a par with Degas." (Art News, Vol. 1, May 1897, p. 2.)

At the Window

c. 1890. Pastel on gray paper mounted
on canvas, 17½ x 10"
The Brooklyn Museum, 33.28.
Gift of Mrs. Henry Wolf, Austin M. Wolf,
and Hamilton A. Wolf

*Although this portrait of Alice Chase is
not as highly finished as many of the
artist's large, "exhibition" pieces in pas-
tel, this work nonetheless demonstrates
his mastery of the medium. In this
instance, Chase's principal interest was
capturing the mixture of indoor and
outdoor light as it gently modeled the
face of his young wife. The subdued
mood, the full cut of her robe, and the
undefined area in the lower portion of
the composition lead to speculation that
the portrait may have been executed
during her confinement when she car-
ried William Merritt Chase, Jr. (born
June 1890).*

Hall at Shinnecock

1892. Pastel on canvas, 32⅛ x 41"
Terra Foundation for the Arts,
Daniel J. Terra Collection, 1988.26.
Courtesy of Terra Museum of
American Art, Chicago

*Even after the demise of the Society of
Painters in Pastel, Chase continued to
create important works in the pastel
medium. From a purely formal stand-
point, this pastel offers a summation of
the artist's career inasmuch as it incor-
porates genre, still life, portraiture, and
even obliquely refers to his landscape
subjects by means of the prominent bou-
quet, cut from the indigenous Shin-
necock bushes and displayed in the large
vase on the right. In terms of content, the
work suggests the seamless continuities
of Chase's existence wherein art and life
were one.*

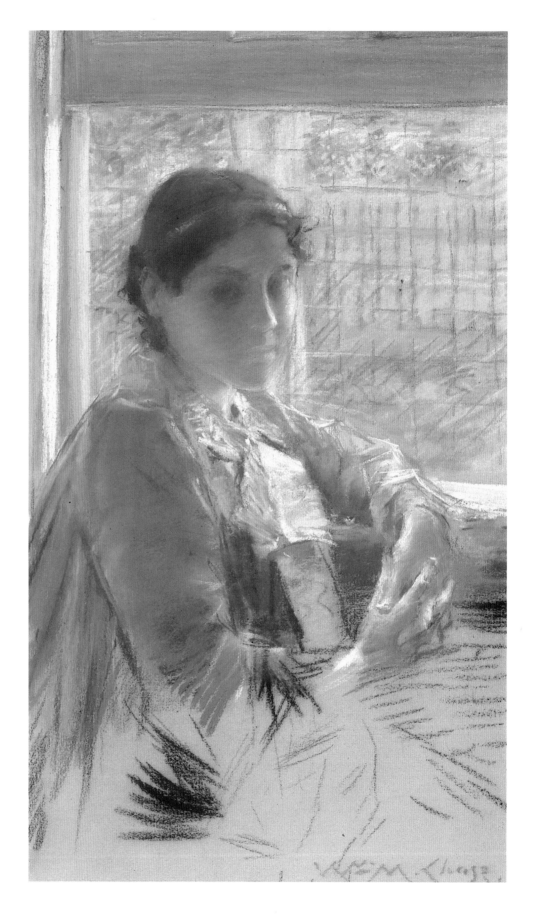

62

Hall at Shinnecock

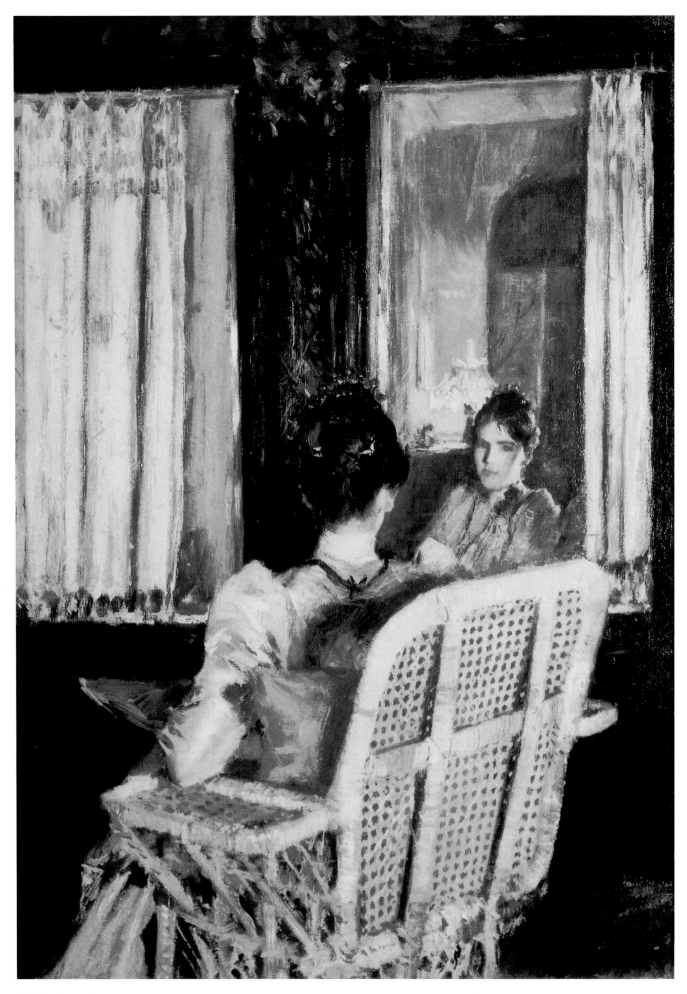

Reflections

Chase frequently called his daughter Cosy his "Little Red Note," in reference to the fact that she often performed the formal function of providing a critical spot of red in his compositions. Consequently, she reportedly always wore a bit of red in case she was needed to pose on short notice. Chase's children generally bore the task of posing in good stead, but on one occasion, Cosy fainted from exhaustion during a modeling session and, as a get-well offering, Chase gave her a charm bracelet inscribed Little Red Note, on the following day. Although not necessarily directly related to the incident described above, this small work captures a sense of physical exhaustion, which, be it from play or from modeling, inspired the artist to convey it immediately in paint. The spontaneity of the process is witnessed in the energetic application of the broad, summary brushstrokes, and in areas of the canvas that reveal the ground layer of paint.

Reflections

c. 1893. Oil on canvas, 25 x 18"
Collection Mr. and Mrs. Raymond J. Horowitz

A number of Chase's important works rely on the iconography of the mirrored image, a motif that enjoyed marked currency among artists of the late nineteenth century. Chase's adoption of the motif did not go unnoticed by the critics, one of whom stated, "It is useless to object to the picture that is a pun in paint. The lady is reflecting about some matter; we see her reflection in the glass. The picture is a good one, nevertheless; and those painters who speak most strongly against the 'literary sort of thing' cannot be kept from perpetrating such 'literature' as this." ("The Exhibition of the Society of American Artists," The Art Amateur, vol. 30, no. 5, April 1894, p. 127.)

sentiment in his painting simply by titling it as he did. In contrast, Tarbell concentrated exclusively on the formal characteristics of his work, which was first titled *The White Dress* when it was shown at the 1899 exhibition of The Ten, and given its current title later that year. By 1897, when *For the Little One* was first exhibited, Chase devotees would have been able to recognize the sitter as Alice Chase and the setting as the Shinnecock summer house. Yet even without such prior knowledge, the tender, narrative quality invested in this image separates this painting from Tarbell's basically impersonal, albeit formally adventurous, study of a studio model. A similar, yet more intense, chord is struck in Chase's

At Play

c. 1895. Oil on canvas, 72¼ x 36¼"
Collection of Mr. and Mrs. Rodman C. Rockefeller

Chase was often heard to say, "Stand still while I get that," thus interrupting his children's play in order to capture one of their carefree moments on canvas. The children, always immaculately dressed, were convenient subjects for the artist, whose fatherly pride and affection is transmitted in his art.

Mrs. Chase and Cosy

c. 1895. Oil on canvas, $55\frac{1}{4}$ x $26\frac{1}{4}''$
UNL-F.M. Hall Collection,
Sheldon Memorial Art Gallery
University of Nebraska-Lincoln, 1933.H-16

Chase's portraits of his family exhibit a genuine warmth that is intensified here by the close juxtaposition of the faces of Alice Chase and her daughter Cosy in a painting sometimes known as Mother's Love. *The viewer's focus is skillfully directed to the tenderly expressive faces by the chiaroscuro treatment of light and by the gentle frame formed by Cosy's encircling arms.*

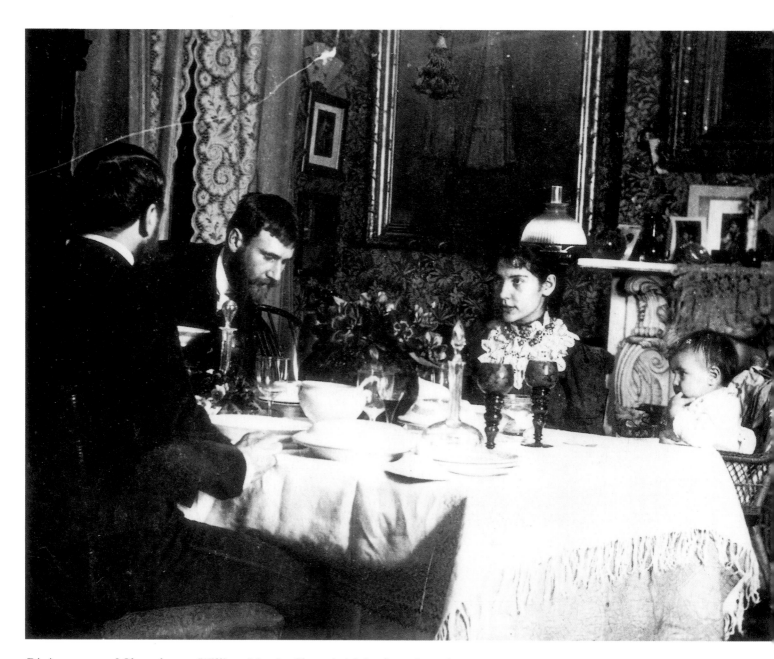

Dining room of Chase home: William Merritt Chase (with back to viewer),
Robert Blum, Alice Gerson Chase, and Alice Dieudonnée Chase

At the Window, which shows a quietly emotive Mrs. Chase in closer view.

The artist's unsurpassed affection for his children was repeatedly expressed in his almost daily letters written from Europe, and is also manifested in his paintings. As Katherine Roof noted, "Of course it was the natural destiny of all the children, especially the girls, to pose for their father." Whether it is in the canvases portraying the children in seemingly uninhibited moments of play, as in *At Play,* or in those displaying more calculated compositions as in *Did You Speak to Me?* (see page 118), Chase's paternal pride and tolerance for their youthful presences in the studio are conveyed in these images.

Chase's deceptively effortless translations of life into art did, indeed, depend on that "special harmony" that Roof remembered as defining the Chase household. The availability of a family of cooperative, attractive models left the artist with no need for the services of professional ones. What is more, his success as a figure painter rested largely on his emotional affinity for his sitters, and the tender emotional resonances that infuse his family pictures separate these works from the large majority of his portraits. Whether they are on a grand scale, as in *Mrs. Chase and Cosy,* or intimately sized, as in *Tired,* Chase's paintings of his wife and children bear witness to his reverence for the family unit, and his need for the support it provided him.

Dining room of Chase home: William Merritt Chase (with back to viewer), Robert Blum, Alice Gerson Chase, and Alice Dieudonnée Chase

c. 1888. Gelatin printing-out paper, 2¾ x 3¾"
The Parrish Art Museum, Southampton, New York
The William Merritt Chase Archives,
Gift of Jackson Chase Storm

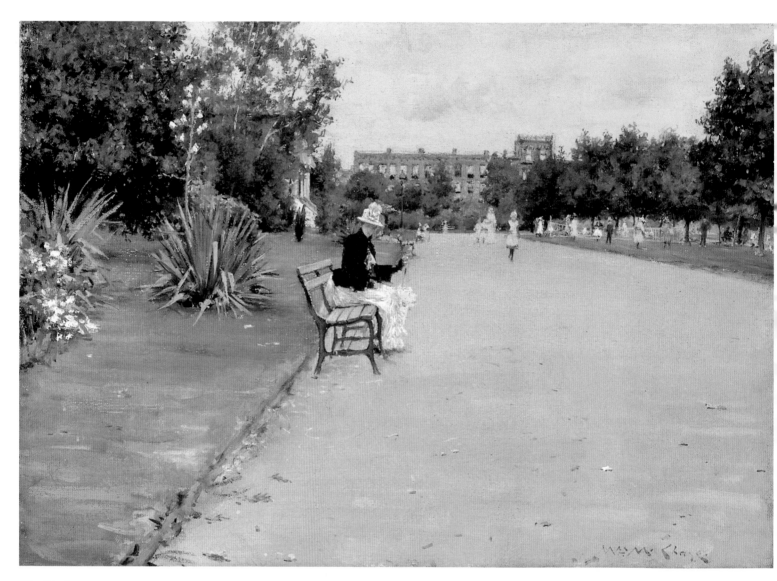

The Park

V. Intimate Views of Open Spaces: Chase's Landscapes

I N 1888, MONTAGUE MARKS, WRITING UNDER the pseudonym "Montezuma" for the *Art Amateur,* commented, "[William Merritt Chase] seems to be 'going in' exclusively for landscapes just now, a departure one cannot regret, so long as he gives such charming, sparkling bits of out-door life as he has been painting in and about Brooklyn." Indeed, as Marks noticed, Chase had, for nearly two years, dedicated a significant amount of his energies to painting landscape subjects. The reasons why the artist began to focus on landscape at this time are not difficult to ascertain, inasmuch as he likely found a strong impetus to pursue more avidly the plein-air painting techniques with which he had already experimented, especially after seeing the massive exhibition of French Impressionist art mounted by Durand-Ruel in New York in the spring of 1886.

Why Chase decided to concentrate almost entirely on scenes of Brooklyn at this time is another matter and one determined by both practical and aesthetic concerns. Without question, Chase's 1886 marriage imposed new financial constraints that included foregoing his annual summer trips to Europe, but these restrictions certainly would not have limited the artist's choice of outdoor subjects to the extent demonstrated by his art. Indeed, paintings bearing the titles *On the Lake—Prospect Park, Brooklyn Docks, The Hills Back of Brooklyn,* and *At West Brighton—Coney Island* (all of which were products of his first American summer of painting after several summers abroad and shown at his 1886 one-man exhibition in Boston) give witness to his sudden devotion to depicting the varied landscape aspects that the city of Brooklyn had to offer.

It must be noted, however, that as sensitive to innovative presentation (particularly in terms of his treatment of space) and as stylistically flexible as he was, Chase was never committed to recording the spectacle of modern life that was at the core of the Impressionist movement. Consequently, what he chose *not* to paint is sometimes just as revealing as what he did include. Chase apparently found no visual joy in the crush of urban crowds, the architectural wonders of a city that was literally growing before his eyes, the clouds of steam rising from hot engines, or the weekend and evening leisure activities of the middle classes—all of which were dominant themes in the new French art. He did, however, discover in Brooklyn (and later in Manhattan's Central Park) an analogous subject matter that subtly incorporated the issues of rural-to-urban transition without explicitly recording the urban scene.

Contemporaneous viewers would have been aware of the deliberateness of Chase's choices, for his small "charming, sparkling bits of outdoor life" (as

The Park

c. 1887. Oil on canvas, 13⅝ x 19⅝"
Art Institute of Chicago.
Bequest of Dr. John J. Ireland, 1968.88

Exhibition records reveal that Chase was fairly specific when it came to titling his Prospect and Central Park paintings. However, he also exhibited a number of park subjects under such generic titles as, for example, The Park. *Although contemporary reviewers referred to Chase's paintings of Brooklyn's Tompkins Park, no paintings bearing Tompkins Park titles are documented. It is suggested here that many of the generically titled park paintings, including this one, are the artist's Tompkins Park works, some of which have come to be misidentified as Prospect Park views.*

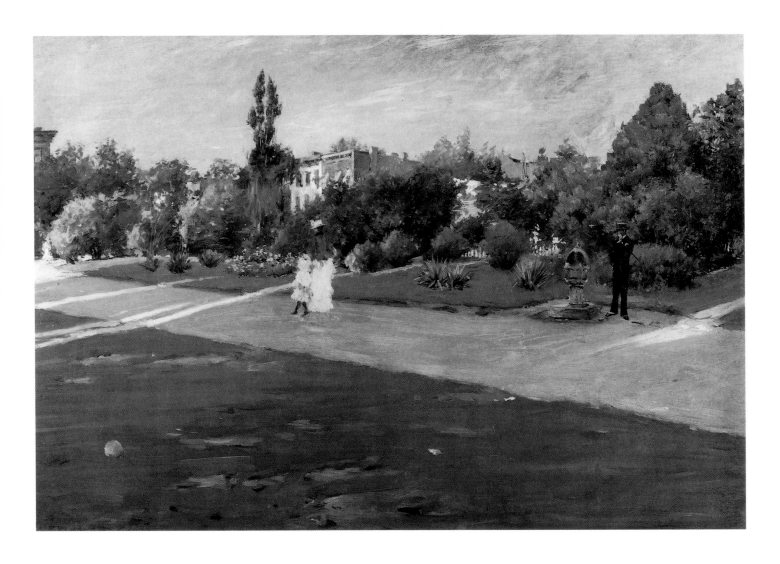

Prospect Park, Brooklyn

c. 1887. Oil on panel, 16⅛ x 24⅛"
The Parrish Art Museum, Southampton, New York
Littlejohn Collection

Chase's park subjects usually show these public spaces to be the preserve of mothers, nursemaids, and children, thus reflecting the fact that his painting sessions took place on weekdays, when most men were working. In this park scene in which an unaccompanied man is featured, the rare male presence imposes a narrative sensibility that is difficult to ignore, but equally difficult to define. Although traditionally known under the title cited here, this painting is most likely one of Chase's Tompkins Park subjects.

Marks called them) simultaneously veiled and referred to the fact of Brooklyn's urbanization. The Brooklyn Bridge had opened in 1883 and became the impetus to and material symbol of the city of Brooklyn's rapid population growth from 850,000 in 1880 to 1,166,000 in 1890. Yet Chase's paintings of parks and areas like Gravesend (then a fashionable resort) are curiously unpopulated, as if the artist purposely ignored (or edited out) the crowds who frequented these places. With the burgeoning number of city parks, Chase discovered his own unique rejoinder to the "new" art subject in the creation of what were essentially intimate views of open, public park spaces that had been carved out of acreage that was otherwise being quickly swallowed up by encroaching urbanization.

Despite all that is known about Chase's movements, details regarding his residence in Brooklyn are frustratingly scarce, and the exact locations of his Brooklyn park scenes, all undated, are yet to be sorted out satisfactorily. Roof's 1917 biography of the artist states that the Chases lived in Brooklyn briefly following their marriage and thus provides a reason for the sudden proliferation of Brooklyn subjects in Chase's art that surfaced in 1886. Yet after he moved to Manhattan, Chase continued to paint scenes of Brooklyn, many of which, like

CHASE'S LANDSCAPES

Park Bench

c. 1890. Oil on canvas, 12 x 16"
Gift of Arthur Weisenberger
Museum of Fine Arts, Boston

Chase's view of this isolated spot along a path in a section of Central Park called the Ramble possesses a deceptively spontaneous, photographic impression that is augmented by distortions of scale and space as if the composition were seen through a lens. However, Chase left nothing to chance in the construction of this composition, which is stabilized by a dominant vertical element that slices the composition exactly in half. The conceptual vertical (as it travels through the dark, partially obscured, linear tree trunk in the upper third of the canvas, continues through the vertical sections of the bench, and passes through the birds in the foreground) anchors the eye, preventing the gaze from being overwhelmed by the variety of powerful diagonals that battle for compositional priority throughout the canvas.

The Park, suggest a connection with specific sites on a level deeper than simple aesthetic preference. In *The Park* and in a painting traditionally titled *Prospect Park,* a sense of neighborly familiarity or community prevails, strengthened by the presence of the modest houses that border closely on the park precincts. It is suggested here that these are views of Brooklyn's Tompkins Park, a small park located in the Bedford-Stuyvesant section of Brooklyn and designed in the 1870s by Frederick Law Olmsted and Calvert Vaux, the same team that had collaborated on the designs of Central Park and Prospect Park. These small paintings of relatively anonymous park scenes contrast markedly with a more conventionally "scenic" composition like *Boat House, Prospect Park* (see page 74) that documents a specific and well-known public recreation area. What is more, the flat terrain, the straight graveled paths, the close proximity of the surrounding residences, and the regularly planted trees visible on the right of *The Park* are at variance with the serpentine paths, irregular plantings, and hilly topography of Prospect Park and argue for the smaller Tompkins Park site that was designed on the order of a residential square.

Roof stated that the Chases lived in Brooklyn "for a few months with the painter's parents." That phrase, offered in passing, may provide the key to sorting out Chase's park subjects. The 1886–87 Brooklyn city directory lists only one David H. Chase, who lived at 483 Marcy Avenue, a street that borders the western side of Tompkins Park and runs north in the general direction of the Wallabout Basin, where Chase also painted. Although it cannot be stated with absolute certainty that this was Chase's father's residence, circumstantial evidence points to it. The artist's parents' home would have provided a convenient base from which Chase could easily continue exploring Brooklyn (even after he moved to Manhattan), and its Marcy Avenue address would account for his particular interest in and intimate approach to Tompkins Park, which was a

CHASES'S LANDSCAPES

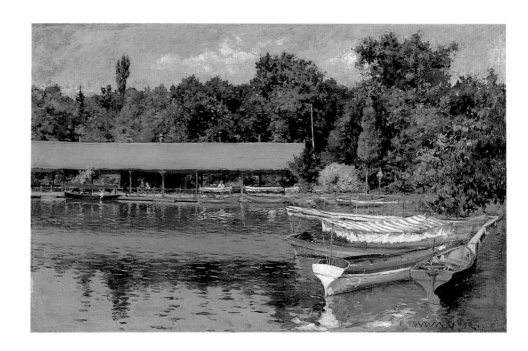

Boat House, Prospect Park

c. 1887. Oil on board, 10¼ x 16″
Private collection

Chase probably painted this view of the rustic shelter that once bordered Prospect Park's Lullwater (a quiet offshoot of the park's larger lake) from the vantage point of a boat floating a short distance from the shore. More than simply an experiment with pleinairism, this painting demonstrates the extent to which Chase had incorporated the practice into his repertoire of techniques, and also cogently documents the formal boundaries that he would not cross as he flirted with an Impressionist aesthetic.

A Bit of the Terrace (Early Stroll in the Park)

c. 1890. Oil on canvas, 20¾ x 24½″
Private collection

Chase was particularly attracted to this area of Central Park featuring the grand Bethesda Fountain Terrace, the fountain itself, and the terrace approach to the lake seen here. As in his other park views, Chase chose to portray the park as it was used by women and children, and consequently avoided the iconography of the space as a stage for a social, fashionable promenade. The child in the foreground is mostly likely his daughter Cosy, whose presence "domesticates" the scene and whose form gives the crowning touch to the composition in a manner foreshadowing the artist's later use of his daughters as compositional devices in his Shinnecock landscapes.

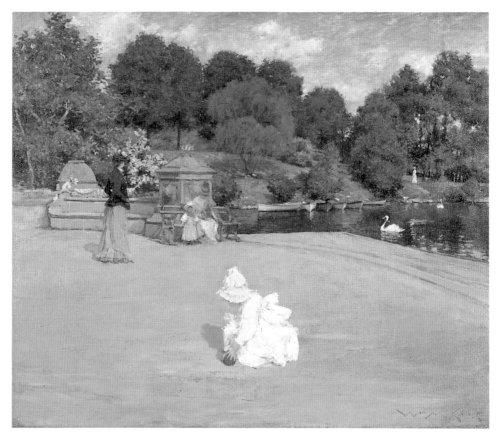

mere two blocks away. Regardless of the question about the Marcy Avenue address, the present reassessment of Chase's Brooklyn park scenes now permits two other paintings, *Prospect Park, Brooklyn* (Colby College, Waterville, Maine) and an unlocated work, *Summer Scene in the Park*, to be securely sited at Tompkins Park.

74

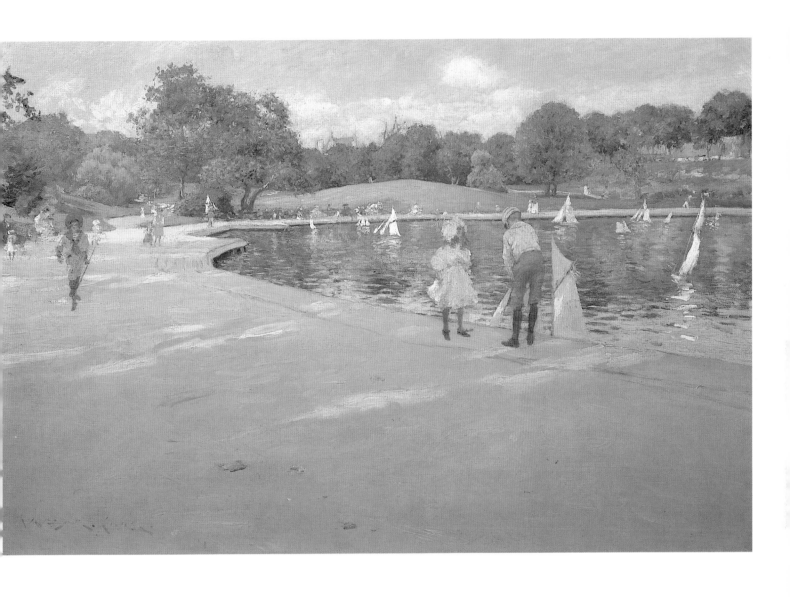

*The Lake for Miniature Yachts
(Central Park)*

1890. Oil on canvas, 16 x 24"
Collection of Peter G. Terian

Charles De Kay gave special attention to this painting, pointing out that the scene portrayed was one "rarely troubled by any but special lovers of the Park." He added, though, 'The Lake for Miniature Yachts—the pond above Inventors' Gate, which is also called Ornamental Water—can be seen from Fifth Avenue." (Charles De Kay, "Mr. Chase and Cen-tral Park," Harper's Weekly, *XXXV, no. 1793, May 2, 1891, p. 327.) Chase could easily have depicted the small lake from another vantage point in order to erase any hint of the city at its borders, but he chose, instead, to refer to Central Park in its urban context, by including the rooflines of the palatial apartments that lined Fifth Avenue.*

Although his park subjects were not universally appreciated, critics responded favorably to Chase's Brooklyn paintings. One recognized them as his attempt to paint "without regard to the conventions of any school" and declared that the landscapes "from the strange region, as picturesque in its way as anything in Holland or Normandy, between Prospect Park and the city of Brooklyn, might indeed suggest to our wandering landscape artists that they should not keep their eyes hermetically sealed while in their own country." Such opinions helped to reaffirm Chase's position as an artist whose keen awareness of foreign trends was appropriately translated into an American vernacular.

In 1890, Chase turned to territory more familiar to the average New Yorker—Central Park. The change in park venues came about because of the minor cause célèbre that had erupted that year when Chase was refused a permit to paint in Prospect Park. Details of the artist's dispute with the temporarily infamous park official, Aneurin Jones, appeared in *The New York Times* and *The Brooklyn Daily Eagle,* but despite (or because) of the publicity, Chase never received his permit and apparently never returned to Prospect Park to paint. While the small *Park Bench* proves that Chase occasionally painted intimate corners in the grandly designed Central Park, as he had done in Brooklyn's parks, his paintings of the Manhattan preserve generally demonstrate a greater attentiveness to the architectural elements that shaped the use of the land.

The shift in viewpoint that separates the Tompkins Park and Central Park compositions may be attributed not only to the essential differences imposed by the topography (both natural and engineered), but also to the artist's personal experience of the spaces he portrayed. Although his Central Park pictures, like his Brooklyn paintings, maintain a vision of quiet, civilized enjoyment of public land, Chase's general view of Central Park is more or less that of the tourist whose aim is to capture a broad, panoramic representation of a specific setting. Almost invariably, Chase emphasized the sculptural or architectural features of the park, thereby citing it as a place for a special visit rather than a place of daily use. In the case of his Tompkins Park subjects, however, Chase usually adhered to the same general compositional format characterized by a narrower, more circumscribed view amplified by an abrupt spatial recession that repeatedly terminates with the low-built houses bordering the park. This repetitive approach seems to have been manifested only in the Tompkins Park pictures, and this very consistency in painterly vision suggests that this was how Chase and his family commonly used (and saw) this space.

As the first major American artist to embrace the city park as a frequent subject for his art, Chase further distinguished himself from his fellow artists, and was given the unofficial title of "artistic interpreter" of Central Park and Brooklyn's Prospect Park by Charles De Kay in an 1891 article, "Mr. Chase and Central Park." De Kay, an influential art writer and longtime friend of Chase since the early days of the Society of American Artists, lauded Chase especially because of his refusal to cater to public taste, citing the park paintings as principal examples of the artist's fresh approach to a distinctly American subject. Coming on the heels of disappointing sales of Chase's work at an Ortgies auc-

tion (an outcome that doubtless reflected the nation's general economic woes at the time), De Kay's article presented a plea for greater attention to the artist whose park scenes acted as a "tonic for minds weary of sordid ideas." De Kay thus touched upon rather complex ideas concerning the purposes for which the municipal park system was established. He went further by proposing that Chase's park paintings might educate the masses to the necessity of maintaining public parks for the sake of future generations. It is highly unlikely that Chase ever entertained the idea of appending such a didactic content to these paintings, but given the popularity of his earlier Brooklyn scenes, it is feasible that under the influence of such politicized attitudes as exemplified in De Kay's writing, he anticipated the even greater market potential of Central Park subjects, and consequently chose to portray more readily identifiable areas of the grounds.

In 1891, coinciding with the opening of Chase's influential Shinnecock Summer School of Art for Men and Women, the topography of Long Island's Shinnecock Hills replaced the urban park view in Chase's art. As in the past, the practical circumstances of his life, rather than a conscious move to address a fresh subject, motivated the shift in his artistic vision and, for twelve consecutive summers, Chase's plein-air teachings at Shinnecock informed his own artistic production.

The school itself is said to have been the idea of Mrs. William S. Hoyt, a wealthy amateur painter who summered in Shinnecock and who proposed the project to Chase in 1890. Chase agreed to head the school and, with financial backing from other area residents, including Samuel L. Parrish and Mrs. Henry Kirke Porter, arrangements were soon put into place for building a complex called the Art Village, consisting of a large studio and dormitory cottages for student housing.

The first sessions were held during the summer of 1891 and, by 1892, the student body numbered more than one hundred men and women who flocked to the eastern end of Long Island not only to perfect their artistic skills under the guidance of one of the country's premiere art instructors, but also to take advantage of the recreational opportunities the site offered. The school's 1897 promotional brochure outlining the curriculum of classes, criticisms, and lectures also shrewdly advertised the Art Village as an ideal vacation spot.

Chase, of course, was the greatest draw for prospective students, many of whom recorded his aphoristic comments for posterity. The most lasting impressions the students took away with them, however, were of their teacher's outdoor painting demonstrations and visits to his private home and studio, located approximately three miles from the Art Village. The house, first occupied by the Chase family in 1892, was designed by Stanford White in 1888 and, although not originally intended for the artist, was eminently suited to his large family and easily converted to accommodate his studio needs.

Chase immediately incorporated into his art both interior and exterior views of the rambling, "colonial" style house that was situated on the crest of one of the low, rolling hills that characterize the Shinnecock landscape. Although

The Bayberry Bush

c. 1897. Oil on canvas, 25½ x 33⅛"
The Parrish Art Museum, Southampton, New York
Littlejohn Collection

Most critics emphasized the compositional and coloristic techniques that Chase used to construct his highly admired Shinnecock landscapes. A typical contemporaneous appraisal of such paintings easily applies to The Bayberry Bush: *"The sensation of changing light and moving air, the vibrating depth of the pale azure skies, the sheen of the beach grasses and the quiet green grays of the moss covered sand dunes are given with surprising fidelity and exquisite gradation while the unerring instinct of the colorist never fails to rightly place the figures whose costumes give the needed note of vivid contrasting color or of brilliant opalescent white." ("Chase's Long Island Studio,"* The Brooklyn Daily Eagle, *January 19, 1896, p. 8.)*

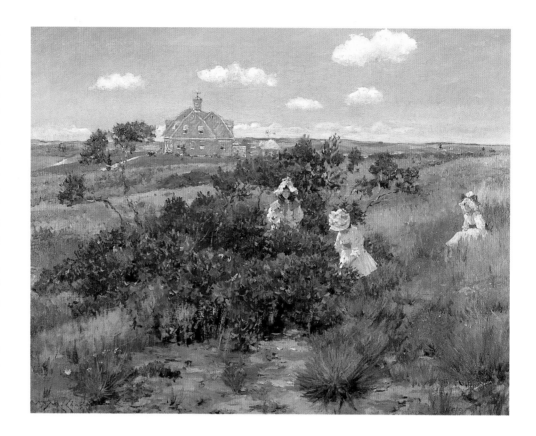

The Fairy Tale

1892. Oil on canvas, 16½ x 24½"
Collection Mr. and Mrs. Raymond J. Horowitz

John Gilmer Speed saw this painting in Chase's Shinnecock studio shortly after its completion and wrote about the painting at considerable length in a article published the following spring. Speed predicted, "When it comes to be exhibited I shall expect to see larger crowds before it than landscapes usually attract." Citing it as "one of the most finished compositions it has ever been my good fortune to see," Speed added, "No one could give any idea by mere description of the poetic beauty of this lovely picture . . ." (John Gilmer Speed, "An Artist's Summer Vacation," Harper's New Monthly Magazine, *vol. 87, June 1893, pp. 11–12.)*

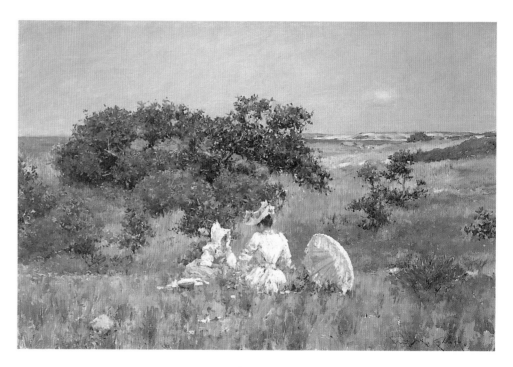

it was never featured in Chase's paintings, per se, the structure is often visible on the distant horizon, lending a domestic, almost protective, presence to the otherwise stark, treeless expanses where the artist's children were frequently portrayed at play. Chase's numerous, carefully composed Shinnecock canvases, exemplified here by *The Bayberry Bush* and *The Fairy Tale,* bear the personal as

Mary Content Chase, Shinnecock

c. 1910. Cyanotype, 2¼ x 3¼"
The Parrish Art Museum, Southampton, New York
The William Merritt Chase Archives,
Gift of Mrs. A. Byrd McDowell

well as artistic stamp of the painter who declared himself a realist, but nonetheless could not resist including elements of the private narrative of his life in thoughtfully conceived schemes that merged landscape and figure genres.

Much of Chase's Shinnecock work contradicts the prevailing opinion of his contemporaries that he was, as artist Kenyon Cox put it, simply a "wonderful human camera." Cox had confused Chase's professions of realism with nonselectivity and had written in 1889, "He cares little for abstract form, less for composition, and hardly at all for thought or story." These sentiments were generally shared by recognized artists and critics, and lingered in Chase criticism, virtually dismissing the notion of any stronger thematic or formal concerns on the artist's part.

Although Royal Cortissoz aptly noted the artificial nature of Chase's Shinnecock landscapes, it seems that only the brilliantly eccentric critic Sadakichi Hartmann perceived the thematic nuances in the artist's landscapes. Hartmann argued, "My contention is that Chase has been a subject painter all his life. . . . Of course, he has always avoided telling a story directly. But he has *suggested* them. It is almost impossible for him to paint an interior without introducing a figure. And even his Shinnecock landscapes he peoples with members of his numerous family."

Hartmann's observations ring true when one continues to examine Chase's subject matter as the expression of a narrowly selective viewpoint governed by private experience. With these considerations in mind, it is difficult to come away from *The Bayberry Bush* without thinking of the three little girls returning to the well-known interior of the distant Chase homestead at the end of their play. The insertion of this narrative element, however slight, imposes itself in even the most casual reading of the painting.

A Study (location unknown) as reproduced in John Gilmer Speed, "An Artist's Summer Vacation," *Harper's New Monthly Magazine,* 87, June 1893, p. 9

This unlocated painting presents an exception to Chase's ordinarily subtle approach to narrative elements in his art. It suggests that more complex readings may be attached to other, ostensibly nonnarrative works by him.

The Lone Fisherman

c. 1895. Oil on mahogany panel, 15 x 11⅞"
Hood Museum of Art, Dartmouth College,
New Hampshire Gift of Mr. and Mrs.
Preston Harrison

The small figure shown fishing at the edge of the Shinnecock Canal was identified by Chase as his father when Preston Harrison purchased this painting from the artist in 1916. The composition's exaggerated perspectival rush to the horizon, however, reveals that Chase's true interest was the radical manipulation of space. As such, this work can be looked to as a critical document of Chase's persistent experimentation with pictorial space which first emerged as a full-fledged concern in his studio paintings of the 1880s.

Peconic Bay

c. 1892. Oil on canvas, 18 x 24"
Berry-Hill Galleries, Inc., New York

The exquisitely minimal composition and tonal palette of this painting owe an undeniable debt to Whistler and also, most probably, to a series of pure marinescapes executed by Alfred Stevens in the 1880s and early 1890s. This painting of the dock and waters near his Shinnecock home demonstrates an unusual lightness of touch on Chase's part, especially in the delicate calligraphic strokes indicating the reflections of marker posts paralleling the line of the dock.

That Chase's concern for the subject was greater than initially suspected is perhaps no better proved than in the case of *The Fairy Tale*. Originally called *A Sunny Day* (or *A Summer Day*) when it was first exhibited in 1893, the painting was known by its present title by the time it was shown again in the same year while still in Chase's possession. As inconsequential as this change may seem, it signals Chase's sensitivity to the importance of a painting's title, and further suggests his desire to be more specific with respect to the thematic potential of the motif.

Chase literally painted *The Fairy Tale* twice; once as it appears here, and once as the painting that Alice Chase had turned from investigating in a work titled *A Study* (now known only through reproduction). The fully developed compo-

CHASE'S LANDSCAPES

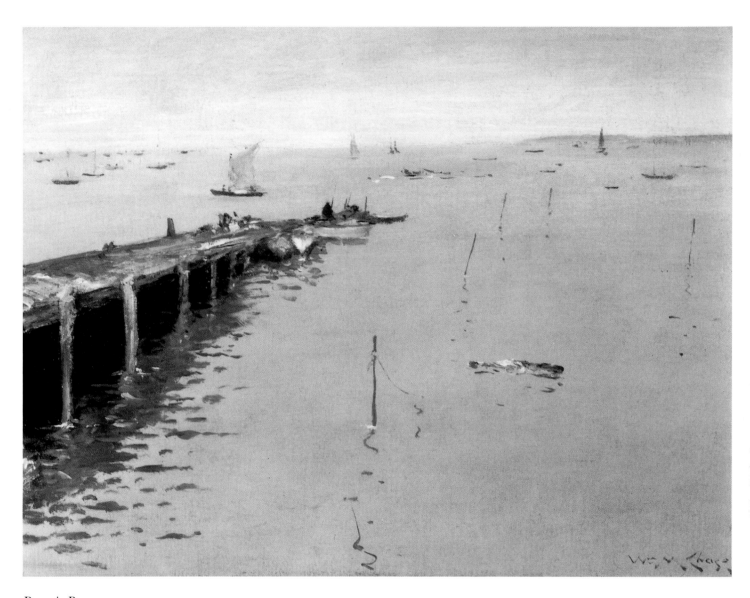

Peconic Bay

Eugène-Louis Boudin
(1824–1898)
Beach at Trouville

1864–5. Oil on wood, 10¼ x 18⅞"
National Gallery of Art, Washington, D.C.
Ailsa Mellon Bruce Collection

Boudin's influence is readily discernible in Chase's beach subjects. However, unlike Boudin, who portrayed the seaside leisure habits of the wealthy French leisure classes (or the "gilded parasites" as he called them), Chase confined his vision to depicting the domestic, family enjoyments of the nearby Shinnecock shores.

Frank Weston Benson
(1862–1951)
Summer Afternoon

c. 1906–08. Oil on canvas, 30½ x 39½"
Manoogian Collection

The paintings that Chase and Benson made of their daughters in sun-drenched outdoor scenes share obvious thematic and stylistic concerns, but how each man treated the motif differs significantly when the issue of portraiture is considered. Benson's interest in portraying the features of his children introduces a literalness to the image, whereas Chase's treatment of his family as "formally anonymous" figures invests his paintings with a timelessness that takes them beyond the limits of realism, but still permits a narrative, biographically based reading.

sition and highly finished appearance of *A Study* belie its simple, generic title and invited the contemporaneous writer John Gilmer Speed to describe it in narrative terms: "His scheme for the second picture of the summer was to have his wife sitting before the picture just described [*The Fairy Tale*], her attention from an examination of the picture just arrested by a remark from someone behind her, and she turning to reply." By means of the "painting within a painting" device, *The Fairy Tale*—and not Alice Chase—assumes the role of the primary subject of *A Study*. However, rather than referring to the nature of the painting within the painting, the title *A Study* can be interpreted to refer to the

CHASE'S LANDSCAPES

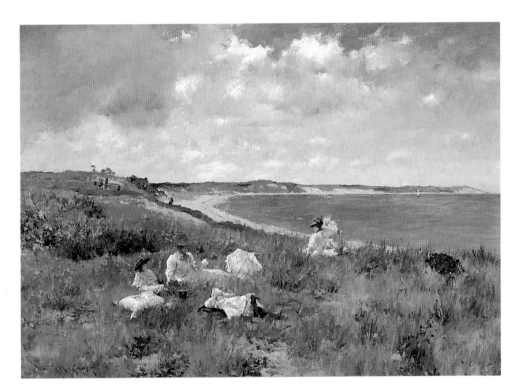

active process of looking, an intellectual exercise that entails a logical progression of thought or, in other words, a mental narrative.

None of this is to say that Chase ignored the purely formal matters involved in rendering the transitory effects of light and atmosphere, for it is in the Shinnecock paintings (and his later Italian landscapes) that he most closely approached an Impressionist aesthetic. Chase's response to Impressionism, however, can only be seen as tangential to his larger artistic concerns and, although he allowed that "The School of the Impressionists has been an enormous influence upon almost every painter of this time," he added, "Most of this

William Merritt Chase,
Mary Content, and Roland,
at Shinnecock Hills

c. 1905. Cyanotype, 2¼ x 1⅜"
The Parrish Art Museum, Southampton, New York
The William Merritt Chase Archives,
Gift of Jackson Chase Storm

Chase Gardens at Shinnecock
(The Potato Patch)

c. 1895. Watercolor on paper, 11¾ x 15¾"
Private collection. Courtesy of Kennedy
Galleries, Inc., New York

This is a rare example of Chase's work in
watercolor and an even rarer instance
of his exploration of a subject involv-
ing labor, a focus that suggests Chase's
awareness of similar subjects by a group
of Scottish artists known as the "Glas-
gow Boys," perhaps even before their
official American debut in 1895. The
Glasgow group had gained internation-
al attention in Munich in 1890, where
they were billed as followers of Whistler
as well as proponents of naturalism as
received through Jules Bastien-Lepage.
That Chase admired their work is con-
firmed by his student Charles Webster
Hawthorne who, in 1896, recalled that
Chase had already cited the Glasgow
School in his lectures.

work I consider as more scientific than artistic." His refusal to submit to any rule of art that smacked of formula prevents his work from being classified as a true Impressionism. Black was never banished from his repertoire; colors were still mixed on his palette and not relied on to blend optically on the canvas; and his plein-air technique, as remarkably fresh as it was in result, was not governed by the tyranny of light and its power to dissolve material form.

As shown especially in *At the Seaside*, one aspect of Chase's plein-air manner borders closely on the "pre-Impressionist" style of the French artist Eugène-Louis Boudin, whose work Chase collected. In addition to sharing similarities in facture, composition, and palette, Chase's seaside paintings and those by Boudin (as for instance, the *Beach at Trouville*) provide more information as to the general custom and popularity of seaside activity than they do the identities of those who participate in it. However, such works as Chase's *Afternoon by the Sea* and *Idle Hours* uphold the apparent dichotomy entrenched in his outdoor figure paintings. Despite the ostensible anonymity of the figures, most viewers, like the critic Hartmann, were quick to realize that Chase was, indeed, portraying his family as well as the Long Island landscape. He was painting portraits, but these depicted the family's way of life which, in turn, was orchestrated by him. Unlike his contemporary Frank Weston Benson, whose *Summer Afternoon* portrays his children in a composition comparable to Chase's *Idle Hours*, Chase

84

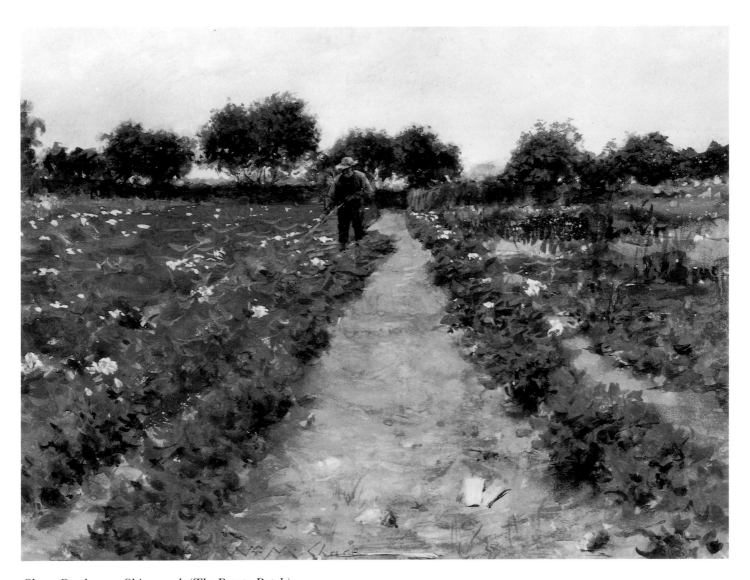

Chase Gardens at Shinnecock (The Potato Patch)

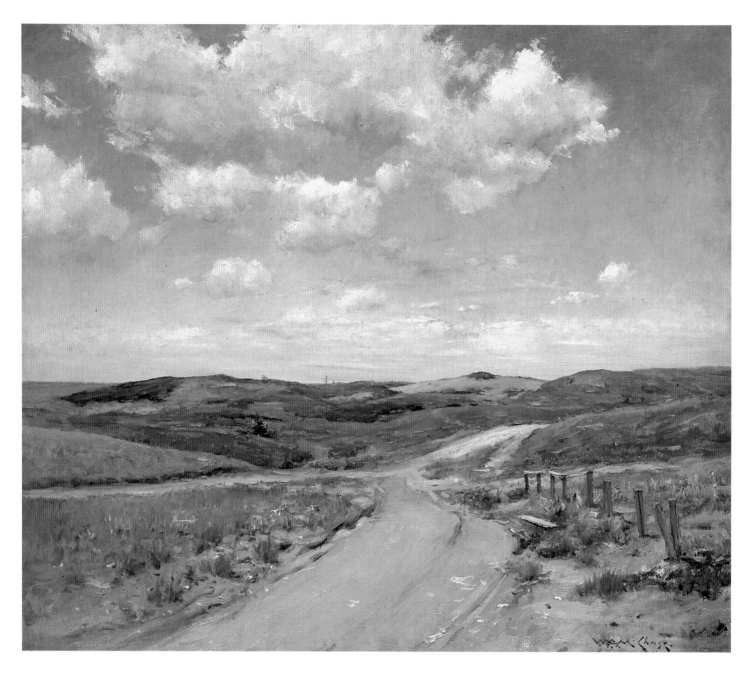

Shinnecock Hills

c. 1895. Oil on canvas, $34\frac{1}{8}$ x $39\frac{5}{8}$"
National Museum of American Art,
Smithsonian Institution, Washington, D.C.
Gift of William T. Evans

By 1896, when Chase auctioned the contents of his renowned studio, public perception of his art already associated him with the imagery of the Long Island landscape. Just slightly more than a week after the auction, an article featuring Chase's Long Island studio appeared in The Brooklyn Daily Eagle, *the timing and content of which seemed geared to discount the ultimate importance of the artist's former studio arrangements. Rather than bemoan the loss of the famous studio, the writer concentrated on Chase's Shinnecock landscapes saying, "The pictorial possibilities hidden under the veils of haze and mist which so often envelope the landscape along the south shore have tempted the brushes of a generation of painters. Of these none has been more fortunate than Mr. Chase in rendering the tones of the silvery summer skies or the delicate ever changing hues of the rolling sand hills." ("Chase's Long Island Studio,"* The Brooklyn Daily Eagle, *January 10, 1896, p. 8.)*

Chase's Villa near Florence, Italy

c. 1911. Cyanotype, 2½ x 4¼"
The Parrish Art Museum, Southampton, New York
The William Merritt Chase Archives,
Gift of Jackson Chase Storm

The Big Oleander

c. 1907. Oil on canvas, 15¼ x 24¼"
Private collection
Courtesy of Berry-Hill Galleries, Inc., New York

The Big Oleander was one of four paintings Chase contributed to the 1910 exhibition of The Ten, three of which were among the first Tuscan subjects he offered to the New York audience. Again, as in the past, Chase did not venture far from his doorstep to find a motif that appealed to him, for, as shown by the photograph reproduced here, the manificent oleander was one of several that dominated the entrance drive of the artist's Italian villa. Although one writer referred to the painting as merely "a decorative bit," Chase's consistent practice of alluding to the extra-pictorial space occupied by the painter as he works is manifested here in the prominent shadowed area in the foreground that prompts the viewer to speculate on the source of the shadow, and therefore, the position of the artist himself.

never presented the facial features of his family models with the same measure of exactitude for his outdoor scenes.

That Chase did not adhere to a single, limited landscape aesthetic is amply demonstrated throughout his paintings of the 1890s. A relatively rare example of his work in watercolor, *Chase Gardens at Shinnecock* (also known as *The Potato Patch*), suggests his affinity for, or at least an awareness of watercolors by the members of the Glasgow School (particularly James Guthrie), whose naturalist subjects were presented in a manner derived from Jules Bastien-Lepage, whose work Chase also admired. Occupying the opposite end of the stylistic spectrum is *Peconic Bay*, a painting whose reductive, almost monochromatic view of the

local Long Island waters recalls similarly simplified compositions of marine subjects executed by Alfred Stevens in the 1880s and displays, as well, a tonalist approach derived from Whistler.

If there is no hallmark style that may be attached to Chase's Shinnecock landscapes, there is, however, a unifying vision in his approach to those landscapes that exclude or at least minimize the presence of the human figure. These paintings, typified by *Shinnecock Hills,* explore the abstract design potential of the relatively uniform landscape that surrounded his Long Island home. Only the fundamental elements of sky, horizon line, and land comprise the core of the compositions that embody the purest and most consistent expression of the art-for-art's-sake imperative that can be found in Chase's work. Nonetheless the Shinnecock region remains a subject that is intrinsically associated with Chase and it is thereby subsumed within the popular narrative of his life.

Similar observations may be made about Chase's paintings of the area surrounding his Italian villa, inasmuch as they are views that are "biographically" conceived; that is, creative responses to the ordinary sights of the artist's day-to-day existence. It must be noted, however, that the emphasis is on *the artist's* experience and, hence, his paintings embody the spectacle of *his* life as he chose to construct it and not the spectacle of the larger, modern world.

View of Fiesole

1907. Oil on canvas, 11¾ x 16"
Smith College Museum of Art, Northampton,
Massachusetts. Purchased 1952

Chase's landscapes depicting the area surrounding his Italian villa demonstrate a lighter palette and a more agitated paint surface, both of which probably reflect his response to the brilliant white-yellow light that suffuses the Tuscan hillsides during the summer months.

CHASE'S LANDSCAPES

View of Fiesole

Portrait of Miss Dora Wheeler

VI. "An Artist's Triumph": Aspects of Chase's Career as a Portrait Painter

In 1908, Chase's article, "How I Painted My Greatest Picture," was published in the periodical *The Delineator*. Although designed for popular consumption, the article is revealing for a number of reasons, not the least of which is that he singled out as among his finest works *Portrait of Mrs. C. (Lady with a White Shawl)* and *Lady in Black (Mrs. Leslie Cotton)* (see pages 93 and 94). As two of the most arresting portraits from his hand, they function as pivotal images in tracking Chase's development as a portraitist and as potent reminders of the importance portraiture held for him, both for the pleasure he derived from the activity and from an economic standpoint.

The model for the 1888 *Lady in Black* was the nineteen-year-old art student Marietta Benedict Cotton, who went on to enjoy a moderately successful career as a society portraitist. Chase recalled meeting her one morning at his Tenth Street studio saying:

She came as a pupil but the moment she appeared before me I saw her only as a splendid model. . . . She consented to sit for me; and I painted that day without interruption, till late in the evening. . . . Such a model is a treasure-find. It is the personality that inspires, and which you depict upon the canvas. That is real art; skill in construction we will take for granted. But to make a vivid personality glow, speak, live upon the canvas that is an artist's triumph.

Lady in Black is the summation of Chase's search for a portrait aesthetic that had occupied him for a decade. In it can be traced his assimilation of influences from such diverse artists as James McNeill Whistler and John Singer Sargent, and the emergence of his own particular style. It is a reminder, too, that Chase's most successful portraits were uncommissioned; paintings originating out of his own desire to create. It was the uncommissioned portrait that established his reputation in the field and became a tool for acquiring patrons in the commercial sphere.

When he returned from Europe in 1878, Chase already had a reputation to maintain and nurture. Granted, his magnificent studio, his teaching, and his vocal presence in a multitude of art organizations did much to promote his standing in the cultural community, but these were merely incidental to his avowed purpose—to paint. Almost immediately Chase saw the need to discard the somber Munich style that had established him as a harbinger of the new American art. Realizing that it ran counter to the growing preference for

Portrait of Miss Dora Wheeler

1883. Oil on canvas, 62½ x 65¼"
The Cleveland Museum of Art.
Gift of Mrs. Boudinot Keith in Memory
of Mr. and Mrs. J. H. Wade, 21.1239

When this work was shown at the 1884 Society of American Artists exhibition, it drew some negative criticism that seems to have been politically motivated, owing to Chase's strong representation in the display. Out of the eighty-six oils and two watercolors chosen from a group of submissions estimated to have been from five hundred to seven hundred works, Chase exhibited six paintings, five of which were hung "on the line." One writer noted Chase's position on the Selection Committee, adding, "We are forced to conclude that he is a prime favorite with the society artists, who absolutely insist that he shall dismantle his studio walls and give a yearning world of art-lovers the benefit of all his productions. . . . Everything points to the conclusion that the society has fallen into the wrong hands." ("Society of Artists," The New York Times, May 25, 1884, p. 9.) Chase's position was vindicated, however, for the following year, he entered a ten-year term as the Society's president.

French and English portrait modes, Chase was forced to reach beyond his training to master an entirely new artistic language that would be more closely aligned with the tastes of potential patrons.

The lengths to which Chase went in experimenting stylistically in the late 1870s and early 1880s are vividly demonstrated in his 1879 portrait of Harriet Hubbard Ayer, the young wife of one of the wealthiest men in Chicago, who later achieved fame in her own right as a manufacturer of cosmetics, a journalist, and a suffragist. In 1879, however, she was known merely for her unconventional beauty and fashion sense and it is partly in this context that Chase's *Portrait of Harriet Hubbard Ayer* (see page 94) must be viewed. Indeed, the image is as unconventional as its subject, who is shown in the Worth dress she purchased on her first trip to Paris in 1871. The angular contours formed by the black figure silhouetted against a foil of shocking pink produce an image of striking intensity that would have been far outside the contemporary viewer's experience. The rationale behind Chase's bold choice of color is realized only when one is privy to the knowledge of the sitter's personal preference for "rooms flooded with sunshine . . . and walls painted pink."

The painting was one of at least two resulting from a commission from the sitter's father-in-law, one of which, *Portrait of a Lady in a Directoire Dress* (since cut down into several sections and its original appearance now known only through reproduction), gained considerable attention for its delicately harmonized palette of soft pastel shades of pink, blue, gray, and green orchestrated against the dominant tones of white and cream. From the beginning, Harriet Hubbard Ayer's modeling sessions were fraught with tension owing mainly to her jealous husband, who found fault with Chase's every effort, and who declared at one point that the only true likeness that Chase had managed was to be found in her slippered feet. With that, the angered Chase reportedly slashed the sketch on which he was working, cutting the figure at the ankles, and gleefully presented the mutilated drawing of the feet to the complaining spouse. Descriptions of the sketch relate it to the portrait mentioned above (it was reproduced as a line drawing in contemporaneous literature), but the eccentrically cropped form of the figure in the painting reproduced here seems a telling souvenir of the incident and the impression it left on the artist. Although it is by no means a successful work, this portrait of Harriet Hubbard Ayer underscores the breadth of Chase's search for an appropriately modern, marketable portrait style in its display of a fashionable brittleness also found coincidentally in Sargent's *Madame Edouard Pailleron*. Although Chase could not have known Sargent's painting at this time, both artists (who were simultaneously seeking their own visual idiom) portrayed their subjects in sufficiently similar poses as to suggest a common source of inspiration.

The coloristic daring of Chase's portrait of Harriet Hubbard Ayer merely foreshadowed the blazing iridescence that characterizes his 1883 *Portrait of Miss Dora Wheeler*, a painting that won acclaim in both Paris and Munich and invoked a storm of controversy in New York at the 1884 exhibition of the Society of American Artists. The attention received by this uncommissioned work not only

Portrait of Mrs. C. (Lady with a White Shawl)

1893. Oil on canvas, 75 x 52"
Courtesy of the Pennsylvania Academy
of the Fine Arts, Philadelphia
Joseph E. Temple Fund

Mystery has surrounded the identity of the beautiful young woman who modeled for this portrait. Although she is often identified as Emily Jewell Clark, an art collector from Michigan, it is doubtful that Chase would have been inspired to portray the fifty-year-old Mrs. Clark (the age she would have been in 1893) in this way. Chase provides the best evidence in settling the matter of his model's identity by stating that his subject was "the model who made Charles Dana Gibson, the creator of the Gibson girl, known all over the world." (William Merritt Chase, "How I Painted My Greatest Picture," The Delineator, vol 72, December 1908, p. 969.) Gibson's model was Minnie Clark, a woman well known in the New York art community, who also sat for Thomas Wilmer Dewing and James Carroll Beckwith, among others.

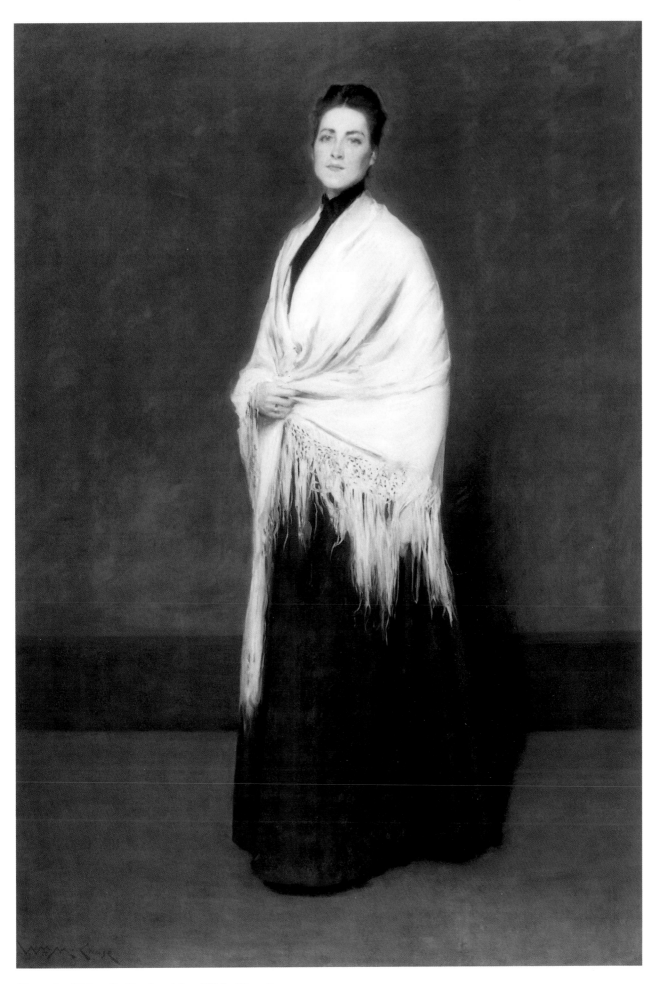

Portrait of Mrs. C. (Lady with a White Shawl)

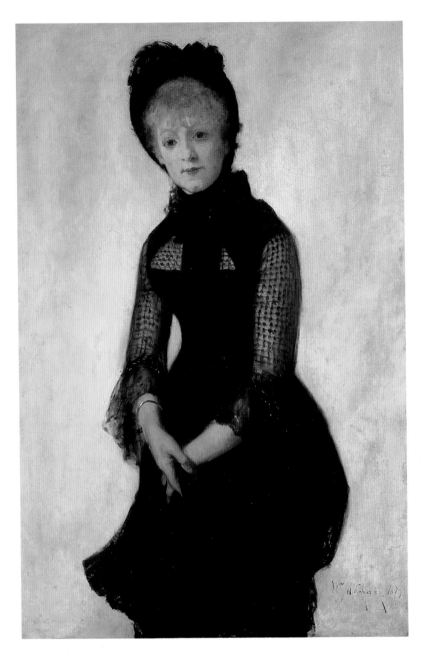

Portrait of Harriet Hubbard Ayer

1879. Oil on canvas, 48⅛ x 32¼"
The Parrish Art Museum, Southampton, New York.
Museum Purchase

The color contrasts and lively pose in Chase's painting of the wealthy Harriet Hubbard Ayer (1854–1903) separate it from the mainstream of contemporaneous American portraiture. Chase's unorthodox approach suggests his desire to create an image that would equal the sitter's reputation as one of the most stylish women in America. Her Chicago apartment was visited by Oscar Wilde in 1882 and deemed by him to be the most beautifully decorated home in the West.

Lady in Black (Mrs. Leslie Cotton)

1888. Oil on canvas, 74¼ x 36⁵⁄₁₆"
The Metropolitan Museum of Art, New York.
Gift of William M. Chase, 1891

When Chase exhibited this portrait in 1888, one critic noted, "Among portraits, the best is that of Mrs. Leslie Cotton by William M. Chase, presumably a good likeness, but certainly painted in a most charming fashion. At a distance the outline of waist and swelling skirts makes a contour of questionable beauty, but a nearer view reveals in the painting of the hands and face, more especially the hands, work of the greatest delicacy and distinction." ("The Autumn Acade-

my," The New York Times, *November 19, 1888, p. 4.) The exaggerated contours that define the figure and the motif of resting the right hand on a small table were most likely inspired by Sargent's infamous 1884 portrait,* Madame X *(Madame Pierre Gautreau,* The Metropolitan Museum of Art, New York*). While Sargent had perhaps unintentionally led his shocked viewers to interpret the model as a personification of sensuality, Chase, on the other hand, created a thoroughly wholesome statement that incorporated the ideals of feminine intelligence, directness, and beauty.*

John Singer Sargent (1856–1925)
Madame Edouard Pailleron

1879. Oil on canvas, 82 x 39½"
Corcoran Gallery of Art, Washington,
Museum Purchase, Gallery Fund and gifts of
Katharine McCook Knox, John A. Nevius, and
Mr. and Mrs. Lansdell K. Christie

Although Chase is not likely to have known this work in 1879, considering it in relation to Chase's Portrait of Harriet Hubbard Ayer *of the same year provides compelling insight into the mannered approach each artist took as he sought a personal portrait style. Chase ultimately concluded that Sargent was the "greatest portrait painter in the world" and freely incorporated elements of the expatriate's later works into his own.*

confirmed its inherent significance as a unique aesthetic statement, but also gave evidence of the recent elevation of the portrait genre to a status of central importance in the international art world. No less critical to the reading of the painting is Dora Wheeler's identity, for the painting marks Chase's former student's return from Paris training and her entry into the professional arena.

For this canvas, Chase opted to depict the artist in her studio, surrounded by objects reflecting her own taste, yet a taste that echoed her teacher's influence. Despite its positive reception in Europe, few American critics were able to see the work as anything but "a vast conceit of decoration." Such response speaks volumes about the habit of seeing, and the difficulty that even professional art writers had when they encountered a portrait that presented the sitter in terms that not only addressed issues of verisimilitude, but also expressed the essence of a life devoted to aesthetic pleasures.

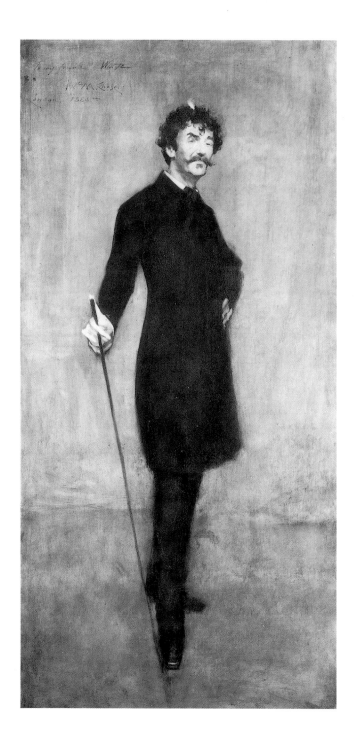

James Abbott McNeill Whistler

1885. Oil on canvas, 74⅛ x 36¼"
The Metropolitan Museum of Art, New York
Bequest of William H. Walker, 1918

This portrait was first shown at Chase's huge 1886 one-man exhibition at the Boston Art Club, where it caused a sensation. As one critic remarked, "At first sight the picture certainly does look like a caricature of Whistler's person as well as his method, but those who know the eccentric genius will recognise it to be the truth—the harsh truth—neither more or less." (Art Amateur, April 1887). Whistler, who vehemently protested the painting's display, doubtless would have found another writer's description of Chase's muse as "a big butterfly of art flashing his gay, strong wings . . . without rest, without apparent direction, yet alighting with certainty on everything high, splendid and attractive," especially galling given that his own famed colophon was the butterfly. (Greta, "Art in Boston," The Art Amateur, vol. 16, no. 2, January 1887, p. 28.)

Chase's disposition toward the total aestheticization of his private and public existence was by this time already demonstrated by such things as the studio environment he created, his personal dress, and his art. It is no wonder, then, that his own inclinations drew him into the orbit of the century's most marvelous aesthete, James McNeill Whistler. Their brief but intense moment of friendship occurred in London over the summer of 1885 and is documented by Chase's portrait of the mercurial artist (called by Whistler a "monstrous lampoon") and in Chase's 1910 article "The Two Whistlers." Chase, perhaps above all others because of his own self-constructed persona, was fascinated by the public and private aspects of his fellow artist, which he neatly described in his

essay: ". . . one was Whistler in public—the fop, the cynic, the brilliant, flippant, vain, and careless idler; the other was Whistler of the studio—the earnest, tireless, somber worker, a very slave to his art, a bitter foe of all pretense and sham . . ." Chase had come to know both aspects of the man in just a short time. After having once lost his nerve on the way to visit Whistler, whose art he so admired, Chase finally summoned the courage to knock on the sharp-tongued artist's door. To his amazement, Whistler welcomed him graciously, saying that he recognized him immediately from the descriptions he had received from fellow artists. In the succeeding weeks, their relationship evolved from one of warm camaraderie to one of friction caused not so much by differing opinions, but more by the brutally insensitive ways those differences were expressed by the vituperative expatriate. The two parted acrimoniously after visiting the international exhibition in Antwerp together, and met briefly only once thereafter.

Part of the emotional toll Whistler exacted from Chase had to do with their agreement to paint each other's portrait. True to form, Whistler was unable to produce an image that satisfied him and pressed Chase into hours of tedious posing while he worked and reworked his canvas. Chase, on the other hand, was confident about his part of the bargain and wrote to Alice Gerson saying, "I am getting on well with my portrait of Whistler which promises to be the best thing I have ever done." The finished portrait did indeed fulfill Chase's expectations. Interestingly, he chose to portray the public Whistler in a manner that paid homage to the "sublimely egotistical" dandy by emulating his low-toned, elegant portrait style.

The effects of Chase's contact with Whistler reverberated in his art for several decades. Even before meeting the acerbic master, Chase had been deeply impressed by Whistler's *Harmony in Grey and Green: Miss Cicely Alexander*, which had convinced him of the necessity of an introduction to the painter when he saw the portrait at the Grosvenor Gallery in London in 1884. The painting forms the basis for a series of full-length portraits by Chase in which young female subjects wearing white dresses are displayed in poses derived from *Harmony in Grey and Green*. The artist's preference for this compositional format may be easily traced from the circa-1887 portrait of his sister *Hattie,* to such later works as *Girl in White* and *Dorothy* (see pages 98 and 99).

Equally apparent in these works, however, is the fleeting impact of Whistler's actual painting method. In *Hattie,* for example, Chase's experimentation with the delicate Whistlerian touch may be assumed and, although tonal in approach, the painting's dramatic chiaroscuro effects erase any notion of the subtle harmonies of Whistler and instead recall Chase's Munich productions. In any case, it is highly doubtful that Chase ever set out to duplicate the distinctive Whistlerian facture, for to do so would admit a lack of personal artistic vision in a highly competitive field and establish him as a mere imitator. Both *Girl in White* and *Dorothy* demonstrate Chase's ability to adapt a particular motif which, when first used, associated him with progressive sources. But these works also proved his allegiance to the solidity of the figure and the fundamental realism of his art.

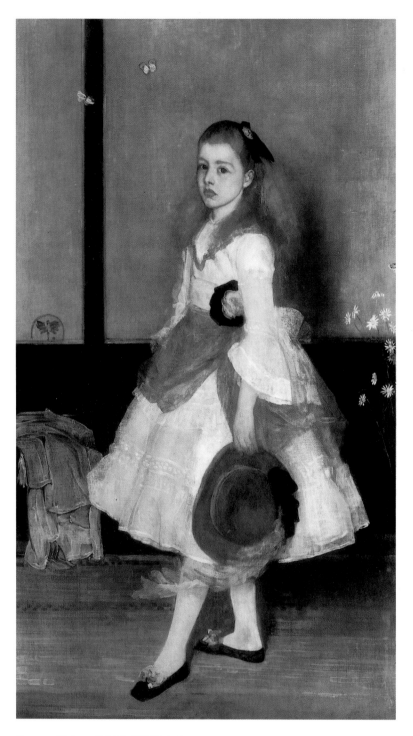

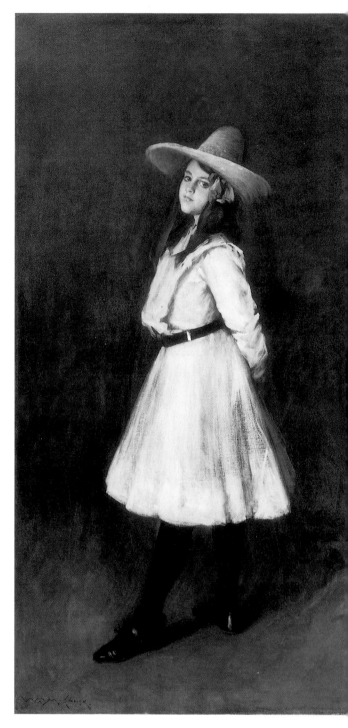

James Abbott McNeill Whistler
(1834–1903)
Harmony in Grey and Green:
Miss Cicely Alexander

1872–73. Oil on canvas, 74 x 38"
The Tate Gallery, London

In a talk on old masters delivered at the
New York School of Art on November 17,
1906, Chase confessed his continuing
admiration for Whistler: "I am thinking
that such a man as Whistler, who did
not produce many pictures, but think he
has done enough. The portrait of his
mother, Little Miss Alexander, and the
portrait of Carlyle . . . are enough to
indicate that the man was a master."

Dorothy

c. 1902. Oil on canvas, 72 x 36"
c 1993 Indianapolis Museum of Art.
John Herron Fund

Chase's paintings of his daughters were
especially successful, no doubt because
his affection for them registered in the
images. One writer, in comparing this
work to a similar painting of Alice Evans,
wrote: "but Dorothy *has more of the*
challenge of the young miss who feels her
power, but wants you to know she feels it
. . . young girlhood just making itself
felt." (Lorinda Munson Bryant, Ameri-
can Pictures and Their Painters. (New
York: John Lane and Co., 1917, p. 115.)

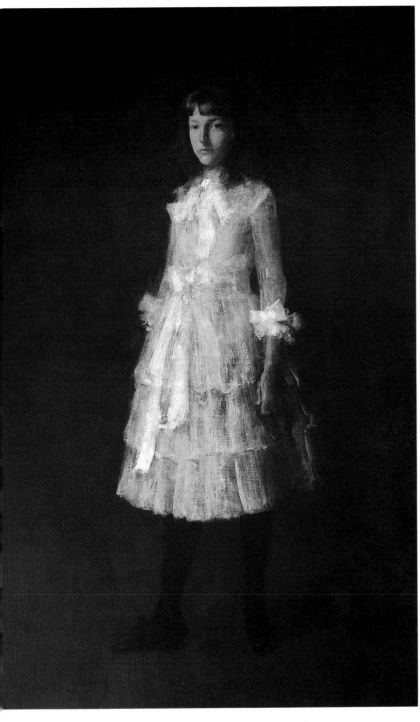

Hattie

. 1886. Oil on canvas, 64¾ x 38″
Collection Mr. and Mrs. Richard J. Schwartz

Chase's portrait of his young sister Hattie reveals the strong influence of Whistler's Harmony in Grey and Green: Miss Cicely Alexander *in terms of pose, limited palette, and the light, painterly treatment of the girl's dress. However, Chase's use of the sharp raking light to illuminate the figure, throwing it into relief against the dark obscurity of the ground, is a product of his Munich training. The melding of two essentially antithetical styles—Munich and Whistlerian—demonstrates*

Chase's ability to adapt separate aspects of several techniques or "schools" to his own aesthetic purposes, the result being a work that not only affiliated its maker with current international trends, but also established his own stylistic idiom.

Girl in White

c. 1898–1901. Oil on canvas, 84⅜ x 40″
Collection of the Akron Art Museum.
Bequest of Edwin C. Shaw

Chase's subject was the young Irene Dimock (1888–1962), the sister of one of his students, Edith Dimock (later Mrs. William Glackens). The portrait reveals an uncommonly mannered aspect of Chase's portrait style, which here draws on Whistler's portrait of Cicely Alexander for its pose, but also suggests a kinship with Sargent's acclaimed 1899 portrait of the Honourable Victoria Stanley in the casually imperious attitude assumed by the subject.

To a considerable extent, Chase's portraits form the American nexus at which international portrait styles intersected. Throughout his career, and especially in the 1880s, Chase readily drew inspiration from works of artists based in Europe. His frequent trips to Europe in the early 1880s gave him an international perspective on developing artistic trends that allowed him to assimilate these aesthetic impulses selectively without limiting himself to a particular school or style. Moreover, Chase's responsibilities in connection with the Statue of Liberty drive—selecting works for the 1883 "Pedestal Fund Art Loan Exhibition"—forced him to assess contemporary European art with an especially analytical eye.

The circa-1885 *Ready for a Walk: Beatrice Clough Bachmann* (see page 102) represents an amalgam of influences and verifies Chase's admiration for Whistler, Sargent, Manet, and ultimately, Velázquez, the artist to whom all in this group owed aesthetic allegiance. In the same full-length portrait format used by Manet and popularized by Whistler, Chase portrayed the young Beatrice Clough Bachmann against a flat, carefully modulated, monochromatic background comparable to that found in Manet's *Woman with a Parrot*. Again, Whistler's limited palette may be cited as inspiration, but Chase's relatively crisp transitions in shape, volume, and light give a weight and presence to the figure that derive from Manet. Like Sargent at this time, Chase was investigating a new mode of portrayal in which the subject was presented without regard for the conventionally idealized notions of grace and beauty that had dominated the aesthetic of female portraiture for decades. Sargent, however, directed these energies to creating a new vernacular for the stylish society portrait, whereas Chase devoted his best efforts to uncommissioned images whose appeal was founded, in many cases, on the expression of a type.

In Chase's own words, he discovered in the model for *Portrait of Mrs. C. (Lady with a White Shawl)* "the very subject I had long hoped to find, a perfect type of American womanhood." The meeting of artist and model has been somewhat romanticized, owing to published accounts that repeat the anecdote of Chase's servant spotting her on the street, recognizing her as a suitable subject for his master, and taking her to the studio. Although this story may actually refer to their first formal introduction, the model, Minnie Clark, could hardly have been unknown to Chase inasmuch as she was already a popular model frequently painted by artists in Chase's circle. She had posed for Thomas Wilmer Dewing for *The Piano* (Freer Gallery of Art, Smithsonian Institution, Washington) in 1891, that artist's first sale to the major collector Charles Lang Freer. In addition, she sat for Beckwith and was the model for the famous "Gibson Girl" invented by Charles Dana Gibson. Thus, Chase's reaction to Minnie Clark was doubtless colored by associations already established in other images of her.

Regardless of the circumstances of the meeting between artist and model, *Portrait of Mrs. C. (Lady with a White Shawl)* is a fresh, unpretentious, and candid artistic response to her natural beauty. Utterly real in the sense that the presentation depends not on finery or surroundings to elaborate the personal

qualities of the subject, Chase's reality nonetheless conformed to a preconceived idea based on a previously established artistic ideal, one that already incorporated the meaning he sought to express—the "perfect type of American womanhood."

The painting was widely exhibited at venues including Philadelphia, Paris, and Berlin and, perhaps more than any other portrait from his hand, established him as a portraitist of the first rank in America. That the canvas was never exhibited under a title that would disclose the identity of the subject signals his wish to follow in the tradition of the great English portrait painters, who, as Chase said, "make pictures as well as portraits, hence their work will live and be lauded in every age and generation." Despite this idealistic view of what the portrait painter's aim should be, Chase was not above persuading well-known public personalities to sit for him, knowing that the completion of a fine portrait of a famous subject guaranteed immediate recognition for its maker. Although his portraits of Whistler and Carmencita ultimately performed the same function in bringing him attention, the circumstances of their making rested on Chase's serendipitous connections with the subjects. On the other hand, the artist's *Elsie Leslie Lyde as "Little Lord Fauntleroy"* (see page 103) marks a deliberate move on Chase's part to seek a sitter who was, indeed, a "personality."

Chase had attended the opening night of the hit Broadway production of Frances Hodgson Burnett's *Little Lord Fauntleroy* in 1888, in which America's first child star, Elsie Leslie, played the lead role. Like the rest of the New York audience, Chase was captivated by the child's performance and confided that night to W. H. Patten, the art editor of Harper and Brothers, that he planned to paint the seven-year-old's portrait and present it to her if the results were satisfactory. Patten, who was acquainted with the child's mother, arranged a Sunday afternoon visit to Chase's studio, where Elsie was promised she would be entertained by "curious things and lots of pictures" as well as Chase's little baby, who would be dressed in black Japanese silk.

The painting, completed in 1889, depicts Elsie Leslie dressed in full costume for her stage role. In that sense, it echoes the already well-established iconography of the actress as Fauntleroy that had reached the public through myriad photographs and engravings, and proves that the portrait exists not so much as a rendering of Elsie Leslie as an individual, but as a continuation of the theatrical fiction she had helped to create. The innate appeal such fictions possessed for Chase (as witnessed by his own passion for constructing his life as if it were a stage production, and his love for the fancy dress masquerades and tableaux then in vogue) must have made the prospect of painting this particular subject doubly attractive. It offered the pleasurable process of painting a sitter with whom he was sympathetic, and it also represented a smart career move. As he had intended, Chase gave the painting to the child star, but apparently, not without first ensuring that it would be his to exhibit. It immediately drew favorable reviews at the 1889 annual of the Society of American Artists and continued to gain him critical honors a decade later with a silver medal at the 1900 Paris Exposition.

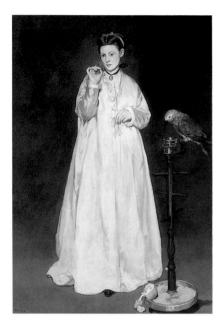

Edouard Manet (1832–1883)
Woman with a Parrot

1866. Oil on canvas, 72⅞ x 50⅝"
The Metropolitan Museum of Art, New York.
Gift of Erwin Davis, 1889 (89.21.3)

It was possibly Chase's great admiration for Manet that ultimately persuaded his friend J. Alden Weir to acquire this painting and Manet's Boy with a Sword *(The Metropolitan Museum of Art, New York) for the collector Erwin Davis, who later lent both works (the first by Manet to enter an American collection) to the "Pedestal Fund" exhibition in 1883.*

Ready for a Walk:
Beatrice Clough Bachmann

c. 1885. Oil on canvas, 84 x 48"
Terra Foundation of the Arts,
Daniel J. Terra Collection, 1992.26
Courtesy of Terra Museum of
American Art, Chicago

This painting marks an important point in the development of Chase's portrait style. Its title, Ready for a Walk . . . *recalls that of his famous 1877* Ready for the Ride *in which another young woman is shown preparing for an outing. However, where the earlier painting relied on Chase's appreciation of old-master styles, this portrait declares his new aesthetic concerns shaped by the art of Whistler, Manet, and Sargent, and the congruent titles may have been intended to provoke recognition of the new direction in his art.*

Ready for a Walk: Beatrice Clough Bachmann

Elsie Leslie Lyde as "Little Lord Fauntleroy"

Elsie Leslie Lyde as "Little Lord Fauntleroy"

1889. Oil on canvas, 69¼ x 39½"
Thyssen-Bornemisza Collection

The celebrity photographer Napoleon Sarony (Chase's friend and fellow Tile Club member) photographed Elsie Leslie as Fauntleroy in 1888. Like Sarony, Chase also portrayed the slight girl near a chair whose thronelike proportions accentuated her diminutive stature. While speculation has arisen regarding Sarony's possible influence on Chase's theatrical portraits, it is most likely that common iconographic elements in their respective works stem from the already established public images of the celebrity subjects formed by their stage roles.

Chase's stunning painting *Lydia Field Emmet* (see page 106) is also key among the group of uncommissioned works that established him as a major contender in the portrait market and, with *Lady in Black,* stands as a masterwork among his many portrayals of his students. Emmet's imperious stance and aggressive gaze capture the essence of the independent young painter whose recognition factor in the art world registered twice at the 1893 Chicago World's Fair: for an award given her own mural installed in the Women's Building; and for the display of Chase's portrait of her in the American Fine Arts section.

Discounting for a moment the resonant effect of Emmet's strong personality as conveyed on the canvas, Chase's painting recalls the work of Whistler in terms of its subdued palette, the remarkably subtle black-on-black definition of fabric details, and the austere setting. Both Whistler and Sargent, the latter of whom was, in Chase's opinion the greatest living portrait painter, can also be looked to as sources for the eccentric pose marked by the marvelously fore-shortened left arm and nervously fluttering fingers of her right hand glimpsed at the edge of a pink ribbon that trails down her back.

Chase was also politically adept in exhibiting his portraits at venues where they would be most appreciated. His activities in progressive, often secessionist artists' associations did not preclude his participation in the older, conservative National Academy of Design. After a nine-year hiatus from the Academy's annual, Chase resumed his activity in that organization in 1888, marking his election to associate status with the display of five paintings. Over the next three years, his few contributions consisted only of portraits, the most interesting being the *Portrait of Worthington Whittredge* that was shown in the year following Chase's elevation to full Academy membership. Whatever the politics of the Academy's jury or viewers, no one could have taken issue with the portrait of the seventy-one-year-old past president of the Academy whose art was synonymous with the Hudson River School aesthetic. Probably executed in Whittredge's own Tenth Street studio, the painting is one of many portraits of male artists executed by Chase. They show his genuine affection for the men, and also occasionally function as conciliatory nods to the academic community from the painter who was characterized in the press as a "reformer and iconoclast."

In 1904, Chase again chose a timely subject when he painted *Hilda Spong* (see page 107), the English-born actress whose American stardom was assured with her 1901 performance in *Lady Huntsworth's Experiment.* After a several years' absence from the New York stage, Spong returned to feature in a number of drawingroom comedies and was greeted by reviews that gave equal billing to her pleasant stage presence and her famous Paris gowns. For his 1904 portrait, Chase portrayed her in glittering costume, holding her cloak and the curtain in her left hand as if poised to sweep both back in a single motion for a dramatic stage entrance. Although imaginative in its presentation of the actress, who seems to be intently listening for her cue, the painting demonstrates Chase's stylistic absorption into mainstream portrait modes, and specifically calls to mind the work of the French painter Charles-Emile Auguste Durand, called Carolus-Duran.

Portrait of Worthington Whittredge

c. 1890. Oil on canvas, 64 x 53"
Collection Mrs. W. Whittredge Katzenbach,
Westport, Massachusetts

Even in his article on Chase and Central Park, Charles De Kay was moved to cite Chase's strength as a portrait painter: "At the National Academy's Exhibition now open, his likeness of Mr. Whittredge is excellent." (Charles De Kay, "Mr. Chase and Central Park," Harper's Weekly, vol. XXXV, no. 1793, May 2, 1891, p. 327.) The portrait, previously published with a circa 1902 date, can now be more accurately placed within Chase's oeuvre because of this important, albeit brief, statement.

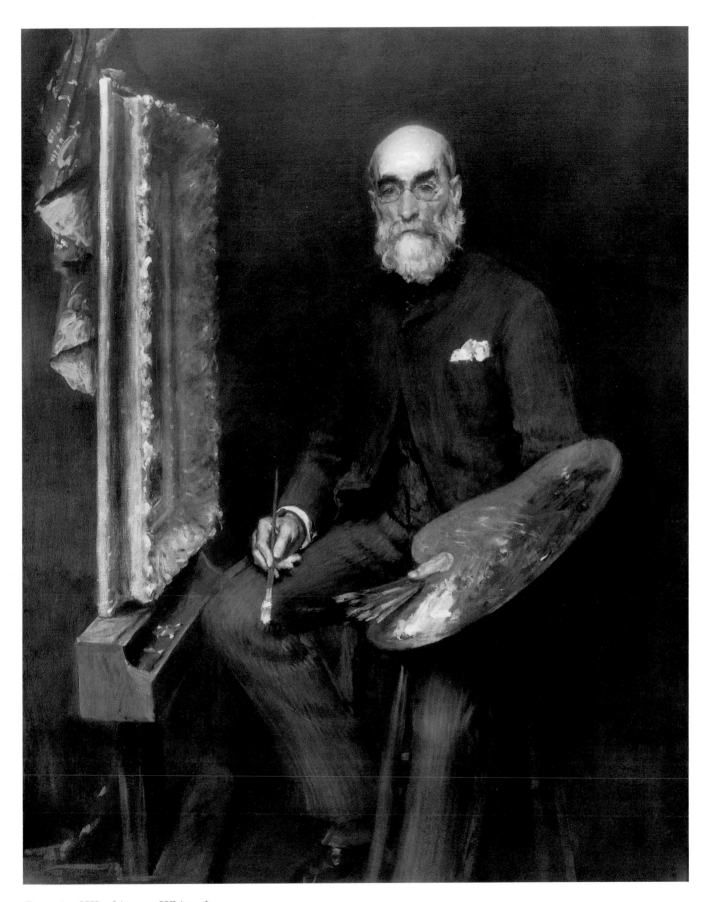

Portrait of Worthington Whittredge

Lydia Field Emmet

c. 1892. Oil on canvas, 71⁷⁄₈ x 36¹⁄₄″
The Brooklyn Museum, 15.316.
Gift of the Artist

Lydia Field Emmet had studied with Chase at the Art Students League for several years before becoming an instructor in the Preparatory Department at the Shinnecock School of Art, where she worked for the summer sessions of 1891 through 1893. She enjoyed a successful career as a specialist in society portraiture, and in 1912 was declared the "painter of the American aristocracy" by artist-critic Guy Pène du Bois. In this portrait, Chase dramatically captured the sensibility of Emmet's own privileged background and her strong-willed independence with an angular pose borrowed from Whistler's Arrangement in Black and Brown: the Fur Jacket *(c. 1876, Worcester Art Museum, Massachusetts) and a facial expression that conveys her aggressive intelligence.*

Hilda Spong

1904. Oil on canvas, 84⅛ x 39½"
Virginia Museum of Fine Arts, Richmond.
Gift of Ehrich-Newhouse Galleries in memory
of Walter L. Ehrich

This portrait probably depicts the actress Hilda Spong as she appeared in her role as Lady Algeron Chetland in the successful revival of the comedy Lord and Lady Algy *that opened in New York in December 1903. One* New York Times *reviewer wrote of her performance, "Her Lady Algy is a breezy, sympathetic, and altogether winning person. The role is one to delight any actress, and Miss Spong plays it with easy naturalness and charm, lending to it also a satisfying element of personal beauty."*

Carolus-Duran was perhaps best known to American connoisseurs as the teacher of John Singer Sargent, that is, until 1890, when a spate of articles about him began to appear in the American press. Carolus-Duran, like Chase, thrived on the theatrical, and part of his reputation was built on the "artistic" existence he had created for himself. Noted for attire that often included bracelets, lace cuffs, pointed shoes, a satin doublet, and lightcolored trousers, the artist was considered to be as sensational as his pictures. While this superficial kinship between the two men may have provided an introductory common ground, a more important factor joining them was the international renaissance in portraiture that had begun in the 1880s and took particular hold in New York and Boston in the 1890s, as evidenced by a series of benefit portrait exhibitions. The first of these exhibitions, organized to benefit New York's Orthopaedic Hospital and St. John's Guild, was held in 1894, modeled after the enormously popular Grafton Gallery "Exhibition of Fair Women" recently staged in London. Chase participated prominently as an exhibitor in this and subsequent portrait exhibitions in Boston (1894) and New York (1895, 1899). And, given one anonymous artist's statement about his poor chances to exhibit because of Chase and White's "one-sided" preferences, it can be concluded that the task of selecting works for display rested largely with Chase and his friend the architect Stanford White.

Although nearly forgotten today, this important series of exhibitions signaled the simultaneous surge in market demand for old-master paintings by such artists as Thomas Gainsborough, Joshua Reynolds, George Romney, and Thomas Lawrence. It also marked the height of a portrait renaissance in America when American patrons flocked to such European painters as Carolus-Duran, Léon-Joseph Bonnat, Anders Zorn, and Pascal Dagnan-Bouveret (all of whom were included in the New York portrait exhibitions) and to such American painters as Sargent and Chase, their principal counterparts.

Chase's contact with the celebrated Carolus-Duran (who made several guest lectures at Chase's New York School of Art in 1898) underscores his ongoing efforts to bring contemporary European painting to an American audience and, conversely, to present American painting in an international context. With the institution of his famed summer classes abroad following the close of the Shinnecock School in 1902, Chase further promoted an international view of contemporary art by arranging visits to the studios of foreign painters, many of whom were portrait specialists. At home, he helped advance the cause of portraiture through his activity as a founding member of the Society of American Portrait Painters, formed in 1902 and dedicated "to the promotion of good fellowship among American portrait painters and the advancement of their reputation at home and abroad." While the Society never gained momentum, Chase was later active in the 1912 founding of the more successful National Association of Portrait Painters, whose goals reiterated those of the earlier Society.

However genuine Chase's beliefs were concerning the aesthetic importance of portraiture, it must be remembered that his greatest promotional enthusiasm for it coincided with his increased commercial activity in the field. His uncom-

missioned portraits and his participation in exhibitions that placed his portraits among those of renowned portrait masters of the likes of Sargent and Carolus-Duran, if not explicitly designed to stir demand for his portrait skills, certainly did so in any event.

The 1890s also marked the low point in Chase's financial affairs, which could be attributed as much to the general depression in the art market as it was to his extravagant spending. The decade had opened with yet more disappointing results from the sale of sixty-seven works offered without reserve at an Ortgies auction in March 1891. By 1895, the artist was even more overextended owing to the necessity of maintaining the Shinnecock house and the Tenth Street studio, and the purchase of a townhouse at 234 East Fifteenth Street on Stuyvesant Square. Despite the crushing need to conserve, Chase apparently never curtailed his collecting activities and thus exacerbated his increasingly desperate financial situation.

Although some newspaper reports attributed the closing of the Tenth Street studio and the sale of its contents to the artist's need to divest himself of the collections whose size had grown to unmanageable proportions, the likely truth was that he could no longer support the public image he had created for himself. At the same time, he stepped down from the presidency of the Society of American Artists and declared that he would give up teaching altogether. The resolve was short-lived. Following the disastrous January 1896 studio sale, he announced his departure for Madrid, where he planned to establish a school. Six months later, Chase returned to America to take up teaching at the Pennsylvania Academy of the Fine Arts in Philadelphia and to open the Chase School of Art in New York. His reemergence after this brief absence from the American scene saw him reborn in a sense, freed from the economic encumbrance of a studio whose promotional value had outlived itself, and freed from the political burden of straddling the line between conservative and progressive forces at the Society of American Artists and the Art Students League. The clean slate notwithstanding, Chase gave even greater energy to commissioned portraiture to ensure the continuation of his somewhat stabilized financial situation.

For the most part, Chase's commissioned portraits lack the creative vitality that he had lavished on, for example, *Lady in Black* or *Lydia Field Emmet*. Moreover, the social status of his sitters simply did not lend itself to portraying them in grand costumes or settings, thus leaving many of Chase's commissioned portraits in the aesthetic middle ground between high-society images à la Sargent and official portraiture. To be sure, Chase painted his share of well-off American matrons and their daughters, but he rarely had the opportunity to paint a subject possessed of the financial stature of a Vanderbilt or an Astor, whose portrait commissions usually went to artists of a more fashionable (i.e., foreign) reputation.

Many of Chase's commissioned portraits conform to a smaller scale than his uncommissioned works, a fact that reflects the nature of the upper-middle-class interiors for which they were intended. The 1895 *Portrait of Mrs. George B. Ely (Caroline Boies Ely)* (see page 112) is a distinguished example of this segment

Mr. Francis Guerin Lloyd

n.d. Oil on canvas, 38⅜ x 29"
Dale and Margaret Bullough Collection

This straightforward painting of Lloyd, the first president of Brooks Brothers, is a fine example of Chase's privately commissioned male portraiture and illustrates the artist's guiding philosophy behind his portrait aesthetic: "Some persons erroneously think the portrait painter finds his greatest pleasure in painting the ideal face. The real pleasure lies in painting the subject as he is, whether he has an ideal or a commonplace face. The chief enjoyment consists in bringing out the character of the man as it is, expressing his personality on canvas as the artist conceives that personality to be." (Chase quoted in Benjamin Northrup, "From a Talk by William M. Chase," Art Amateur, February 1894, p. 77.)

of Chase's output. The elderly widow of a Wisconsin lawyer who served as a Lincoln appointee during the Civil War, Caroline Boies Ely was depicted in the seated, half-length format that recalls similar motifs used by Renaissance masters to portray eminent church or statesmen. Chase's simple approach to his subject, whose alert, responsive expression is highlighted by the white cap she wears, gives lie to the criticisms commonly aimed at his portraits that centered on the artist's failure to convey the personality of the sitter adequately. His own high opinion of the work may be assumed because he chose to include it in the 1898-99 "Exhibition of Portraits for the Benefit of the Orthopaedic Hospital," where it prompted one critic to admit that it overcame the painter's usual stress of the painterly in favor of human interest.

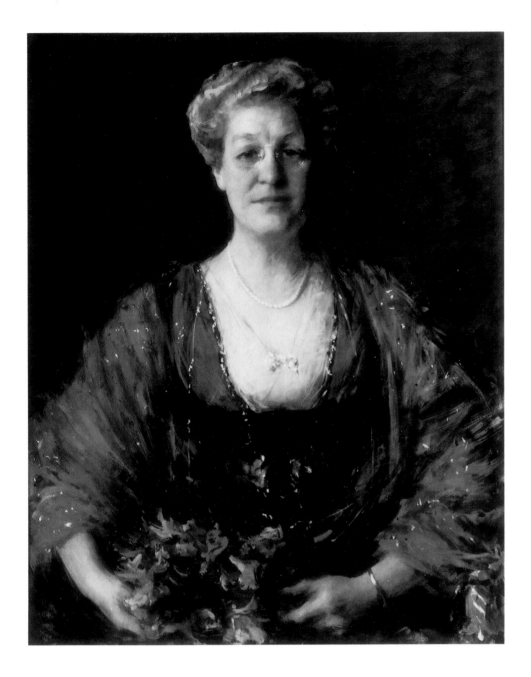

*Mrs. Francis Guerin Lloyd
(Matilda Lloyd)*

n.d. Oil on canvas, 36¼ x 28¾"
Collection Joseph M. B. Guttman
Galleries, Los Angeles

*Matilda Hedenberg Herbert married
Francis Guerin Lloyd in 1875. Although
there is a slight difference between the
measurements of this work and those of
Chase's portrait of her husband repro-
duced here, it is probable that the two
were commissioned at about the same
time and intended as a pair. The two
works display an unpretentious, pleas-
ingly decorative painterliness that was
appropriate to the nature of the commis-
sion, in that it called for neither an offi-
cial nor a grand manner treatment.*

The likely stylistic norm for Chase's later, privately commissioned portraits
may be cited in a pair of canvases: *Mr. Francis Guerin Lloyd*, depicting the man
who was president of the New York haberdashery Brooks Brothers from 1903 to
1920, and *Mrs. Francis Guerin Lloyd (Matilda Lloyd)*, his wife. These otherwise
unassuming images are enlivened by the colorful, active paint surface and
relaxed affability of the two sitters.

With few exceptions, Chase's post-1900 portraits lack the spark of his earli-
er works and are symptomatic of the stylistic doldrums that the portrait mode
fell into during the first decade of the new century. Little could be added to the
iconographic language of the formal portrait as elucidated by Sargent, and the
once-revolutionary alla prima brushwork that had caused critical sensation in

Portrait of Mrs. George B. Ely
(Caroline Boies Ely)

1895. Oil on canvas, 48¹/₁₆ x 36¹/₄"
Los Angeles County Museum of Art.
Miss Elizabeth L. Ely Bequest

Chase did not restrict his best efforts in portraiture to painting attractive young women. Works such as this sensitive rendering of the elderly Mrs. Ely prompted one critic to say, "Chase excels in portraits of women because he never descends to flattery of his sitter through smooth, unmeaning features and pretty gowns and furbelows, but gives them distinction of expression . . . and paints draperies and flesh with a rare skill that seldom fails to come at his call." (Charles De Kay, "Notable American Painters," The Illustrated American, vol. 23, March 12, 1898, p. 322.)

Portrait of Annie Traquair Lang

1911. Oil on canvas, 59¹/₂ x 47³/₄"
Philadelphia Museum of Art.
The Alex Simpson, Jr. Collection

Lang (1885–1918) was one of Chase's prized students, whose promising career was cut short by her death at the age of thirty-three. She spent a number of summers in Europe beginning in 1910, during which she occasionally taught her own students and sometimes joined Chase's classes. Her paintings of Chase at work in his Bruges studio, the interior of his villa in Italy, and a number of portraits of him are valuable artistic documents of Chase's life and also track the development of an artist who followed closely in her teacher's stylistic footsteps. Shortly after her 1917 solo exhibition at Knoedler's, the New York gallery displayed a number of paintings by Chase, all from her collection which at the time was deemed to be the finest private holding of his work in the country. (Guy Meredith, "Annie Traquair Lang," The International Studio, vol. LXI, no. 244, June 1917, pp.cxvii–cxx.)

the 1880s had been subsumed into the realm of common facture. Occasionally, however, as witnessed by *Annie Traquair Lang,* his 1911 portrait of a talented student, Chase was able to achieve a pleasing balance of painterliness, compositional interest (that here relies on a pose favored by Sargent), and personality. The obvious joy taken by the artist in painting this picture is transmitted in the almost palpable energy of the attractive young woman who seems about to rise from the settee to greet us. It is this fleeting sense of personal immediacy that is a vital reminder of Chase's belief that it was the artist's sympathetic response to the model that governed the success of any portrait.

Portrait of Annie Traquair Lang

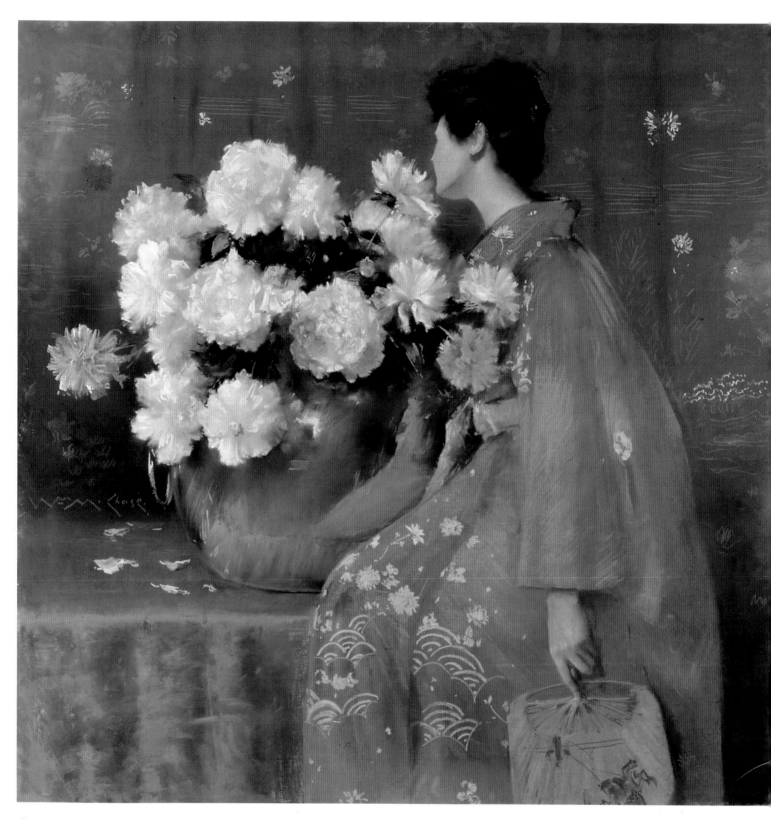

Peonies

VII. Still Life: "A Thoroughly Sympathetic Kind of Painting"

IT WAS IN THE AREA OF STILL-LIFE PAINTING that Chase best fulfilled his reputation as a realist and experienced the greatest painterly freedom. The artist produced more than one hundred canvases that can strictly be categorized as still life, but from a broader perspective, it is not too great a conceptual leap to consider the paintings of his studio as more complicated essays in the still-life genre. For a man whose collection and arrangement of objects represented one of the supreme pleasures in life, the extension of that habit into his art takes on no small meaning. In his eagerness to disassociate himself from the conventional upon his return from Munich, Chase also used his still lifes to announce the particularly exotic atmosphere of his studio as in, for instance, in *Still Life with Cockatoo* (see page 117). Whether seen or implied, Chase's studio is the milieu for the majority of his still lifes and the idea of the larger studio surroundings often shapes the viewer's reception of the still-life image.

In the Studio (see page 119), although a portrait of Alice Gerson Chase in her husband's Shinnecock studio, is also a potent reminder of the strong role still-life elements played in his studio-genre paintings. Here, forming a decorative backdrop for the figure, are familiar objects from Chase's daily life; objects that were not only familiar to him, but now, through their repeated appearances in his paintings and contemporaneous photographs, are items in which part of Chase's personal identity permanently resides for the viewer. The series of studio paintings (of both the Tenth Street and the Shinnecock studios) introduces a temporal element to Chase's art, for in them, we witness the results of the artist's joyful arranging and rearranging of his environment. This is made clear in comparing *In the Studio* with *Did You Speak to Me?* (see page 118). Both display a corner of the Shinnecock studio and, as in many of the pictures set there, the patterned tapestry backdrop and piano remain constants. But other objects in the two works also document the passage of time: Paintings on the wall are replaced with others; the candles in the candelabra vary in length; and the objects on the top of the piano (traditional still-life elements in themselves) shift or—as in *Did You Speak to Me?*—are obscured by a new "still life" arrangement of canvases. Whether deliberately or not, Chase augmented the notion of passing time by giving a prominent place to the unfinished canvas in *Did You Speak to Me?* The viewer thus has reason to expect that when it is next seen, it will be a finished work hanging independently on a gallery wall, or at least, in a more advanced stage of completion in yet another studio picture. In this way, we are given a selective view of the artist's manipulation of his private world.

Peonies

c. 1895. Pastel on tan paper mounted on linen, 48 x 48"
Berry-Hill Galleries, Inc., New York

The hot color and sweeping lines of this large, broadly conceived pastel create a striking visual statement within an iconography then current among American artists, which set up associations equating the female with the flower juxtaposed with her.

In the two paintings discussed here, Chase melded the figures of his wife and daughter into carefully balanced compositions where the weight of portrait against still life setting nearly attains equivalence. However, the same cannot be said of most the Tenth Street studio paintings in which the figures function more or less as staffage inserted to fulfill a compositional need or to elaborate on the uses and purposes of the specific space. The artist's inclination to treat the figure as yet another still-life component is forcefully demonstrated in the large pastel *Peonies* in which a massive bowl of flowers vies successfully for compositional priority over the figure. The deliberately anonymous model reads simply as another decorative means to complete the design and thereby proves Chase's intermittent desire to align himself with a Whistlerian aestheticism that negated narrative and emphasized "arrangement."

Chase's practice of emphasizing still-life elements in many of his figure paintings does not come as a surprise if it is remembered that the paintings of his early career featured the still-life genre. Except for a brief period surrounding his Munich years, the artist produced a relatively steady output of still-life paintings—not only because of their eminent market appeal, but also because of the opportunity they offered him to address a subject for the pure pleasure of painting. As a discrete division in his oeuvre they reveal glimpses of his personal taste, teaching techniques, and most of all, insight into his basic adherence to an "art for art's sake" philosophy.

While Chase's admonition to his students to "paint the commonplace in such a way as to make it distinguished" finds its most elaborate expression in his studio paintings (inasmuch as the studio *was* his *common place*), the majority of his still lifes focus on simple motifs of humble items. Oddly, Chase's fame as a master of this genre rests principally on the humblest and perhaps one of the most inherently unappealing subjects an artist could choose—the dead fish—a theme that he repeatedly elevated to high art by virtue of the technical mastery displayed in these canvases. Explaining his preference for the subject, Chase contrasted the freedoms it afforded to the restrictions often entailed by portraiture:

I enjoy painting fishes; in the infinite variety of these creatures, the subtle and exquisitely colored tones of the flesh fresh from the water, the way their surfaces reflect the light, I take the greatest pleasure. In painting a good composition of fish I am painting for myself. I can understand Sargent's disinclination to paint any more portraits for money; he has doubtless felt the annoyances to which the portrait painter is constantly subjected—the habitual frequent interruptions, the client's restlessness, the uninformed criticism which falls on the painter's ear—such typical experiences, happily not always the lot of the portrait painter, make this branch of art, to me, sometimes a punishment rather than an inspiration and a delight.

To be sure, Chase may have been painting for his own pleasure as he so declared, but the fish still life was often the subject for the painting demonstrations Chase performed for his classes in which he recommended that his

Still Life with Cockatoo

c. 1880. Oil on canvas, 32¼ x 46⅛"
The Parrish Art Museum, Southampton, New York
Littlejohn Collection

Still-life subjects rarely drew much attention from the critics, whose main concerns rested with portrait, landscape, and genre subjects. Chase's efforts in this area, though admired, were usually glossed over, even when the critic could say, "In still life and flowers Mr. Chase leaves nothing to be desired." However, Mariana Griswold van Rensselaer was sufficiently impressed with this painting to mention it by title in an 1881 article, saying that it had been reproduced in the May 1880 Appleton's Art Journal. Surely Chase sought to demand such attention and more by virtue of the sheer size of this canvas, which enabled him to lavish his lush, painterly Munich technique on the exotic objects and bird that would have led the viewer to associate the arrangement with his by then famous studio.

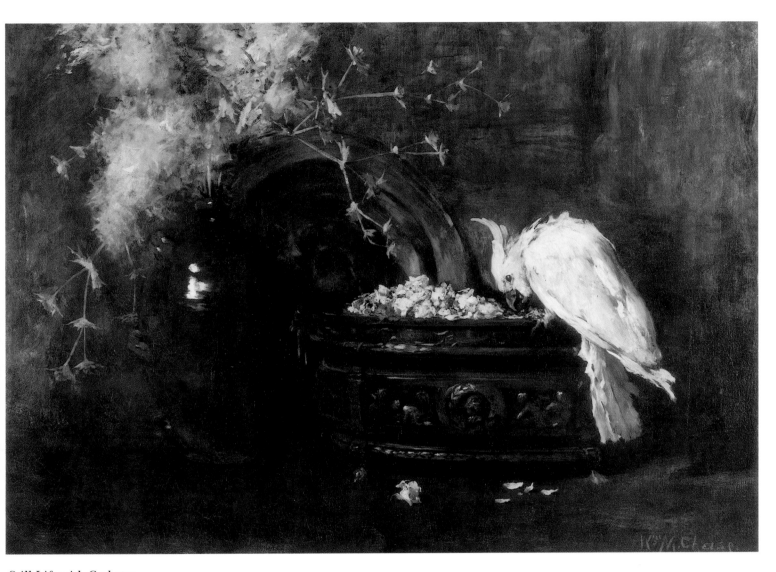

Still Life with Cockatoo

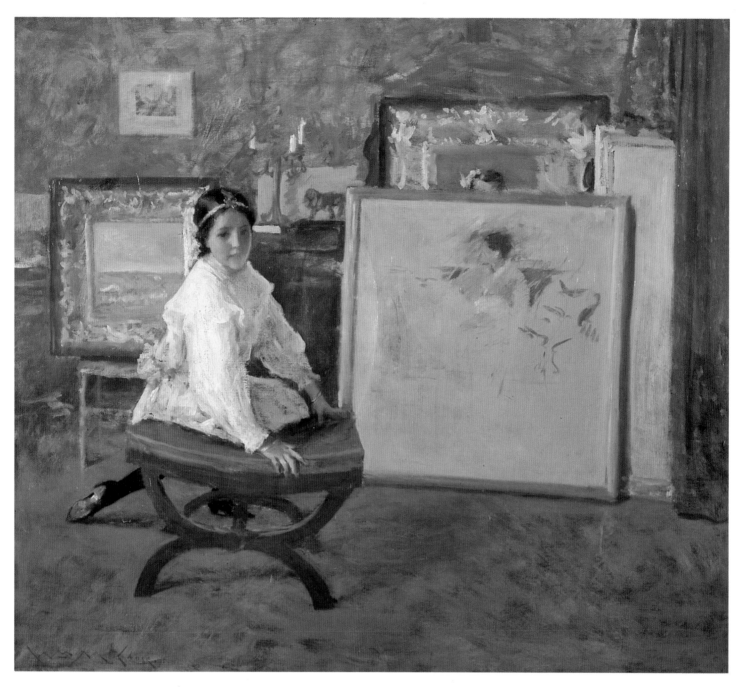

Did You Speak to Me?

c. 1897. Oil on canvas, 35 x 40″
The Butler Institute of American Art, Youngstown

In this example of Chase's "genre/portraits," he again addressed the theme of looking at art that had first entered his iconography with the studio paintings of the 1880s. Here, his daughter (probably Alice) is shown in a context related to his earlier A Study *(see page 000) in which a simple narrative is established involving the artist's(?) arrival on the scene that interrupts the quiet viewing experience.*

In the Studio

1892. Oil on canvas, 29 x 23″
Collection Erving and Joyce Wolf

Although obviously a portrait of Alice Gerson Chase, some writers ignored this aspect of the work. As one wrote, "In the Studio, by Mr. William M. Chase, has all the spontaneity and freshness which characterize his pictures, and is carried further than many, with a brilliant arrangement of color that is thoroughly decorative." (Charles Caffin, "Art. Notes on the 73rd Annual Exhibition of the National Academy of Design," Harper's Weekly, *no. 2155, April 9, 1898, p. 351.)*

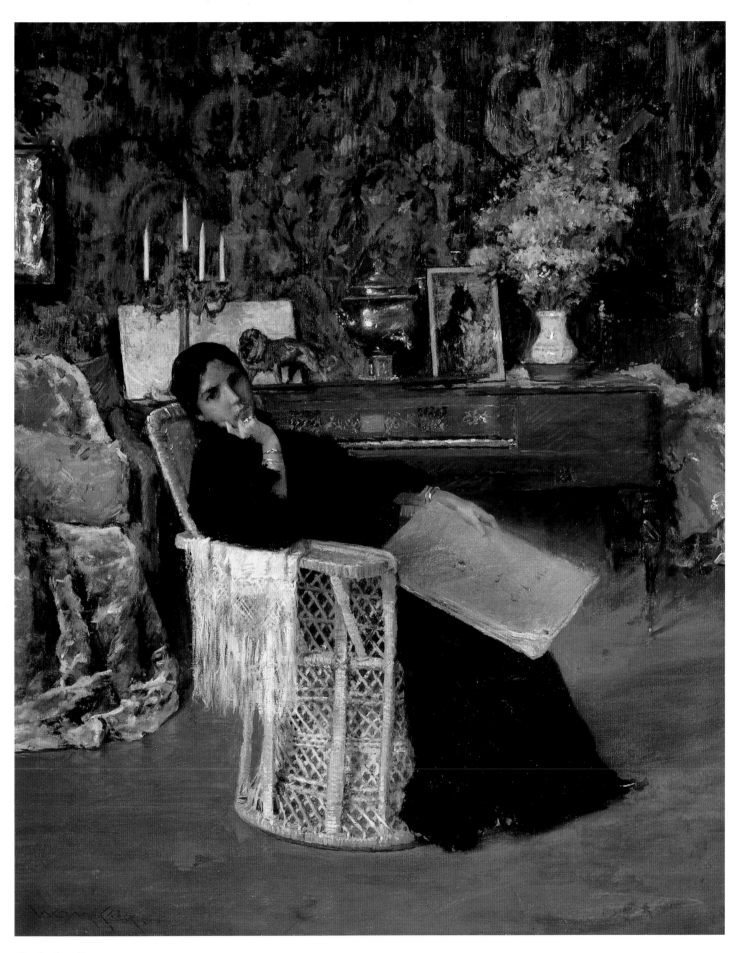

In the Studio

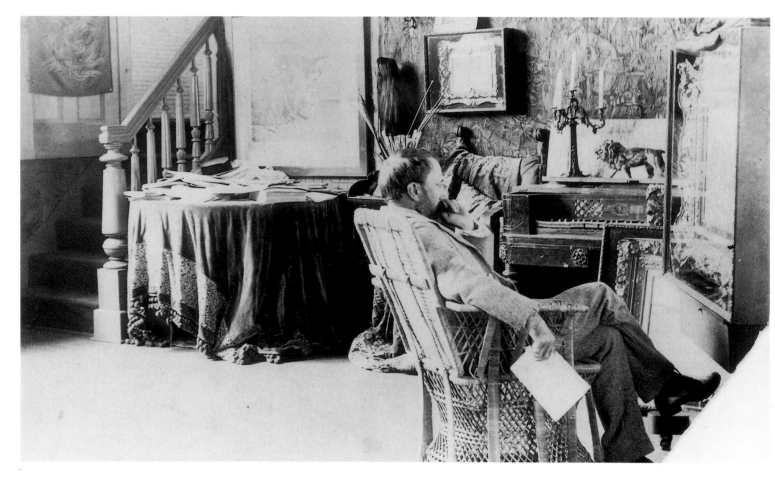

William Merritt Chase in his summer studio, Shinnecock Hills, Long Island

students address still-life subjects as "one of the best exercises in form and color." These demonstrations assumed a theatrical atmosphere where the audience, according to one witness, watched with "nervous interest and enthusiasm" as a painting developed before their eyes over the course of a single morning.

The first instance of Chase's interest in the fish subject is in the variously titled, salon-sized *Fishmarket in Venice* (see page 122) executed in that city in 1878, then, in about 1890, modified by the artist to function as pure still life. Even in its first state, the painting confirms Chase's preoccupation with still-life elements. The prominent foreground placement of the fish, shown in abundant variety and painted with the fluid Munich facture, defies the viewer to see the male figure in the upper right in anything other than an ancillary role.

Recognition of Chase's particular skill as a painter of marine life resulted from the overwhelmingly positive critical reception of the 1904 *An English Cod* (see page 123), a painting whose popularity was enhanced by the highly publicized account of its making. According to Chase, he had left his London studio and, turning a corner, suddenly spied "a magnificent cod stretched out for exhibition on a clean slab of white marble" at a fishmonger's stall. Chase continued, "Whatever my mood for color was that morning, that fish completely fitted and filled it." The anecdote proceeds, giving the details of negotiating the loan of the fish for the day and the fishmonger's amazed delight at the painter's results. Although there is no reason to doubt the truth of the narrative, it does read as an apocryphal tale of traditionally mythic construction in its emphasis on discovery, creative effort, and the need to fulfill a bargain within a specified time. That it was recounted often is instructive in assessing the nature of the publicity that Chase generated. Such was the romance that surrounded this simply composed painting of the famed cod on a Chinese platter when it was displayed at the Pennsylvania Academy of the Fine Arts annual of 1904. To a degree, similar romance has been attached to the entire body of Chase's fish paintings because of his ability to find beauty of form, color, and reflected light in these homely subjects, most of which had the added cachet of having been executed in less than a day's time.

As witnessed by their almost immediate acquisition by major museums, these Piscean images, more than any other group of Chase's paintings, provided the most direct statements of the artist's status as a master of the oil medium. It must be added that it was in the museum setting, where they could be viewed in the context of the Western still-life tradition, that they were best appreciated. For despite their obvious formal appeal, the lusciously painted surfaces could not overcome the basic problem of how to integrate such images gracefully within a domestic environment.

For the collector whose taste required a more pleasing subject, but one that also bore the stamp of Chase, the alternative lay in purchasing one of the artist's many tabletop compositions featuring arrangements of bric-a-brac, fruits, or vegetables, or a combination of all. Among the best known of these in his own time was the 1912 *Just Onions* (see page 124), a painting that reiterates the artist's dedication to finding the picturesque in the plain, and reveals his response to

William Merritt Chase in his summer studio, Shinnecock Hills, Long Island

c. 1896. Gelatin printing-out paper, 3 x 5⅛"
The Parrish Art Museum, Southampton, New York
The William Merritt Chase Archives,
Gift of Jackson Chase Storm

The Yield of the Waters (alternate titles: *Fishmarket in Venice* or *Venetian Fish Market*)

1878 (altered c. 1890). Oil on canvas, 49 x 65"
The Detroit Institute of Arts.
City of Detroit Purchase

Although several American artists had established themselves as specialists in the fish still-life subject, none had painted the subject on a scale that matched Chase's elaborate scheme. The artist's unusual treatment of the subject prompted Mariana Griswold van Rensselaer to write: "The elements of the picture are far removed from those which are usually called either beautiful or picturesque, but are so treated as to be very true to nature and very effective as art." ("William Merritt Chase—Second and Concluding Article," American Art Review, 2, February 1881, p. 137.)

Engraved reproduction of *A Fishmarket in Venice* (original 1878 version) that illustrated "The Collection of Mr. S. A. Coale, Jr., St. Louis," from *American Art Review*, Vol. 1, 1881, opposite p. 425. This serves to document the painting's original appearance.

An English Cod

1904. Oil on canvas, 36¼ x 40¼"
Corcoran Gallery of Art, Washington, D.C.
Museum Purchase, 1905

Undoubtedly the most famous of Chase's fish subjects, this painting was widely publicized when it was purchased by Washington's Corcoran Art Gallery for two thousand dollars soon after it was exhibited at the Pennsylvania Academy's 1904 annual—an eminently respectable amount for a still life at that time.

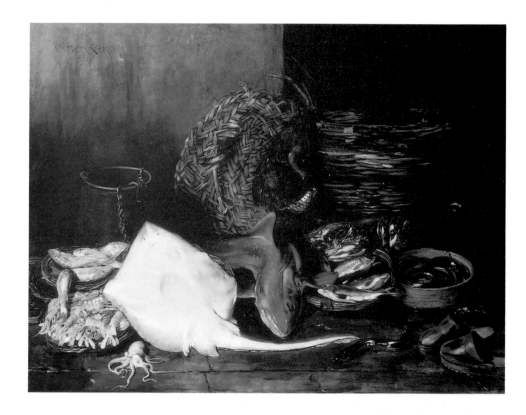

the nineteenth-century resurgence in popularity of the work of Jean-Baptiste Chardin stimulated by the French painter Antoine Vollon (1833–1900). Vollon, a leader in the revival of the realist "kitchen" still life, also drew on the Spanish and Dutch painting traditions that had inspired the style that Chase acquired in Munich. Vollon's early tabletop subjects concentrated on common kitchen uten-

STILL LIFE

An English Cod

Just Onions

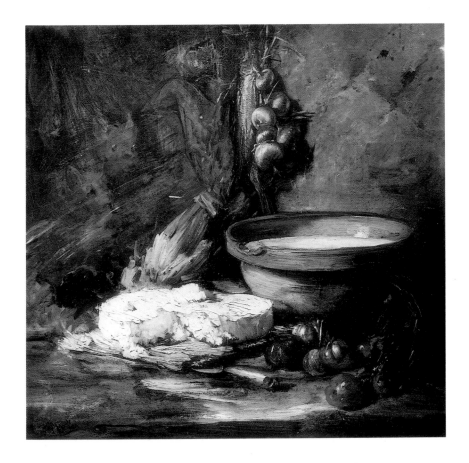

Antoine Vollon (1833–1900)
Still Life with Cheese

n.d. Oil on canvas, 33⅜ x 35⅝"
The Metropolitan Museum of Art, New York

Chase's own attitudes toward still-life painting corresponded with qualities he noted in the art of Antoine Vollon. Over the years, his collection numbered twenty works by the French realist, including the one reproduced here. Chase often spoke of Vollon in his lectures, once saying, "I have one [painting] by him which I prize most highly—a big cream-cheese and a bowl of milk. At the Chicago Exposition he had one of a pumpkin. At the next Salon there were dozens of pumpkins—but not like his! He painted it because he loved it, not because somebody else did." (Frances Lauderbach, "Notes from Talks by William M. Chase," The American Magazine of Art, vol. 8, September 1917, p. 437.)

Just Onions

1912. Oil on wood panel, 21 x 25¹¹⁄₁₆"
Los Angeles County Museum of Art.
Mary D. Keeler Bequest

Despite their popularity, Chase's food still lifes were not immune to the occasional critical jibe. In 1912, one writer complained, "Thus William Merritt Chase serves up the same dish of fish that has graced so many banquets before. . . . But we wish he would occasionally change the menu and not always give us a Lenten dish." (J. N. L., "Ten Americans Going Stale," Boston Evening Transcript, March 23, 1912, part 2, p. 8.) The following year, Chase garnered critical accolades for Just Onions. *The change in subject was appreciated, with one writer referring to the painting as "Just Genius" in its demonstration of color and brushwork and "superb restraint." ("News and Notes of the Art World," The New York Times, March 16, 1913, section IV, p. 15.) Yet another reviewer wrote about it, "Here it would hardly be extravagant to say that the painter has given a touch of poetry and romance to this humble vegetable by the magic of his virtuosity, which recalls the splendid still-life work of Vollon." ("Ten American Painters," Boston Evening Transcript, April 12, 1913, pt. 2, p. 8.)*

sils and food arrayed seemingly randomly, but to these compositions he later added more precious objects, a move that probably reflected the taste of his growing upper-middle-class patronage. Vollon and his compatriots François Bonvin (1817–1887) and Théodule Ribot (1823–1891) had weathered the critical storms waged against Realism in France in the 1860s largely because their still-life compositions involved a neutral content. Nonetheless, they had achieved some notoriety by participating in the 1863 Salon des Refusés and in the 1869 International Exhibition in Munich, where they exerted influence on the Leibl-Kreis artists.

Chase undoubtedly knew Vollon's art from his Munich days and it is possible that his large *Fishmarket in Venice* had been fashioned to some extent after similarly large fish subjects for which the Frenchman was also especially admired. Chase's fondness for Vollon's art also amounted to considerable patronage in that his private collection contained approximately twenty works by Vollon including *Still Life with Cheese*. Vollon was also represented by nine paintings in the 1883 "Pedestal Fund Art Loan Exhibition" curated by Chase and Beckwith.

In contrast to the simplicity of *Just Onions*, many of Chase's still lifes united widely disparate items in the same composition merely for the sake of exploring the formal relationships they presented. Samovars, copper plates and silver pitchers, Chinese and Japanese wares, paintbrushes, leather-bound books, multihued fruits and vegetables—all were likely subjects for a Chase still life and all

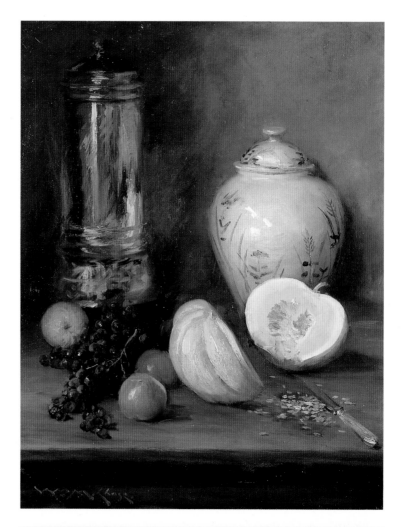

Still Life (with Ginger Jar, Pumpkin and Samovar)

by 1903. Oil on canvas, 30 x 28″
George Walter Vincent Smith Art Museum,
Springfield, Massachusetts.
Presented by Katherine S. Dreier

*Although Chase did not figure among critic Sadakichi Hartmann's particular favorites, Hartmann adamantly declared him "the best still-life painter we possess." Hartmann continued, saying, "There is nobody in America, and scarcely anybody in Europe, who can excel him in painting brass. There is a shimmer of brass throughout his personality, studio splendor, and work. How it sparkles, but the sparkle is so genuine because he has never catered to the taste of the public, but invariably painted for his pleasure; through this attribute, which is outside of the domain of painting, Chase, the painter, becomes an artist." (*The Daily Tatler, *November 18, 1896, p. 6.)*

Still Life, Flowers

c. 1910. Oil on panel, 26 x 21″
Collection Mr. and Mrs. Walter H. Rubin

The scarcity of floral still lifes in Chase's oeuvre is testimony to his opinion that he considered them "the most difficult things" to paint.

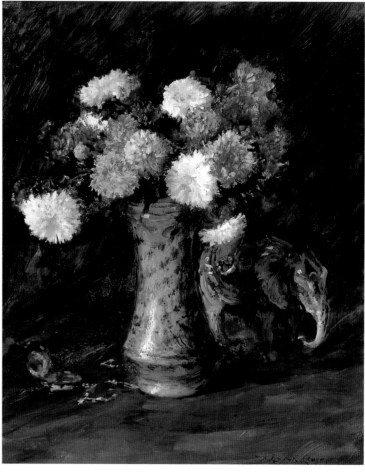

were readily available given that they were usually only an arm's length away regardless of which studio Chase occupied. One such work, *Still Life (with Ginger Jar, Pumpkin and Samovar),* typifies the colorful, glowing canvases in which the rich paint surface takes aesthetic precedence over content.

Rarer are Chase's floral paintings, an important example of which is *Still Life, Flowers.* Although his floral still lifes also confirmed his fundamental concerns for capturing varied surfaces, colors, and textures, they are characterized by simpler compositions that often focus on a single vase of flowers. If they seldom match their more fully orchestrated nonfloral counterparts in complexity, they surpass them in their capacity to convey the transient delicacy of the object, an idea that Chase emphasized in this work by including the glistening watch on the left.

The vast majority of Chase's still lifes were painted from the late 1890s onward. His increased output in this genre parallels his heightened activity in commissioned portraiture, which, with the sales of his still-life canvases, comprised the bulk of his income. His visibility as a specialist in the genre allowed Arthur Edwin Bye, the author of the first modern history of still-life painting, to state uncategorically that Chase was "during his lifetime, the most conspicuous still-life painter in America."

It is safe to say, however, that Chase would have pursued the still-life subject just as passionately even if it had not been as financially rewarding as it was. His description of it as "a thoroughly sympathetic kind of painting" provides insight into the personal joy he realized from recording his eye's delight in the material world over which he held dominion.

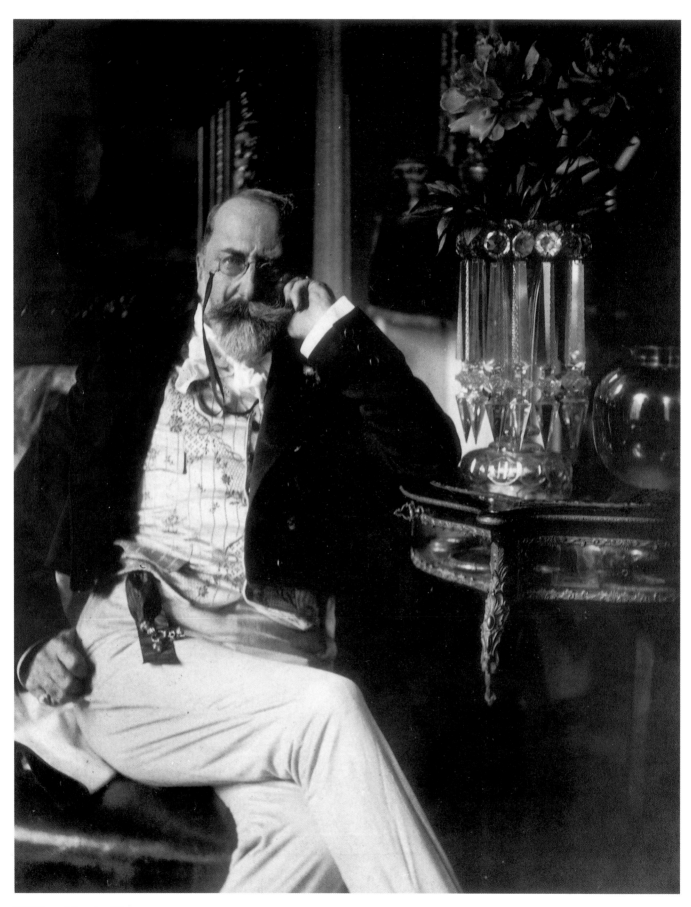

William Merritt Chase

Epilogue: "The Ideal of Work Well Done"

CHASE DIED OCTOBER 15, 1916 in his Fifteenth Street town house, having suffered a rapid and painful decline after a year of generally poor health. Alice Chase had kept the facts of his condition (probably liver cancer) private, perhaps to protect him from the rigors of seeing well-meaning visitors, but perhaps, also, to keep him to herself in his last weeks. His death came as a surprise to many, and the quiet, private funeral arranged by Alice Chase allowed no opportunity for a public expression of grief. The apparent suddenness of Chase's death was pointedly conveyed in collector Duncan Phillips's tribute article to the artist, which began simply, "Chase has vanished." Phillips continued, "No more, under their militant brows, shall those peering, keen, appreciative eyes suddenly soften with sympathy or gleam with the flame of allegiance to the painter's ideal—the ideal of work well done." The rest of Phillips's essay summarized Chase's accomplishments over the years, emphasizing the evolution of his stance from that of radical to conservative in the face of modernist influences. In the end, however, Phillips's introductory words appropriately described the aims of Chase's career: the ideal of work well done.

Only a few months before his death, Chase had delivered a speech at the annual dinner of the American Federation of the Arts in Washington, which, with hindsight, reads as a farewell address. He opened proudly, saying, "I happen to be a member of the most magnificent profession that the world knows." The text of his speech reveals the genuine joy that painting had continued to give him over his more than forty years in the profession, and the almost ingenuous, but justifiable pride that he took in having made a place for himself in the field. Despite the recognition he had consistently received for his art, his committee work, and his teaching, Chase retained the same unjaded view of what art could and should be, and his words conveyed the same sense of wonderment that had drawn the small Indiana boy of his past under the spell of the art ideal.

The cosmopolitan existence that had become Chase's was a far cry from his midwestern beginnings, but his modest origins were rarely far from his thoughts as witnessed by his classroom references to his own early art experiences or by his putting in a humorous appearance at a student costume party as "The Duke of Indiana." Although the mock title was purely a matter of whimsy, it is nonetheless revealing in that it betrays Chase's awareness of the distance he had come and also confirms a consciousness of his roots. He had explored the world, but for the most part painted what was within the radius of his day-to-day experience, be it family, landscape, or studio, the latter of which he could shape at will. It was a fundamental pragmatism overlayed with a strong dose of optimism

William Merritt Chase

c. 1912. Gelatin silver print, 6⅞ x 4⅝"
The Parrish Art Museum, Southampton, New York
The Willliam Merritt Chase Archives,
Gift of Jackson Chase Storm

129

that allowed Chase to shape his dreams into a reality that he constructed even to the extent that he reinvented himself. Although for many years he was an adept and often sophisticated interpreter of the most progressive aesthetic trends in European and American art, his was essentially a nonintellectual approach to art; his work was governed primarily by the belief that the artist must "express what he sees and feels in a way which may be lasting." Generations of students received this basic directive and, although the most accomplished of them (including such diverse talents as Charles Sheeler, Arthur B. Carles, Georgia O'Keeffe, Rockwell Kent, and Joseph Stella) elected to go their own separate aesthetic ways, they gained from Chase an attitude of professionalism, knowledge of technique, and the tendency to eschew narrative, or as Chase put it "story telling," subjects. Indeed, the common theoretical thread that ran through this teaching was the injunction to discard the story-telling picture that relied on sentiment for its appeal.

To be sure, Chase successfully avoided the sometimes saccharine, often moralizing themes that had populated American art in the decades before the "new men" of 1878 arrived on the scene. He could not, however, escape the narrative essence, for a chronological survey of his subjects provides a continuous flow of images that vividly recount the people and places, themes and techniques that marked the phases of his life. His entire oeuvre may be looked to as a biography of sorts. And, if it does not present that biography in an episodic, literal mode, it does relay the shape and mood of his life in the terms that he prescribed—expressing what he saw and felt in a way that was indeed lasting.

Self-Portrait

n.d. Monotype, $7\frac{1}{4}$ x $5\frac{5}{8}$"
Terra Foundation for the Arts. Daniel J. Terra
Collection, 1987.18 Terra Museum
of American Art, Chicago

Chase executed numerous self-portraits, particularly in the late years of his career, depicting himself as the distinquished patriarch of a generation of American painters. Although early on Chase had tried his hand at etching with promising results, he had little patience for the exacting, linear facture demanded by the medium. It was within the monotype technique that the artist found a compromise that allowed for a freer, painterly approach to form in a print mode.

Self-Portrait

Chronology

1849 William Merritt Chase born November 1, in Williamsburg, Indiana, to David Hester and Sarah Swaim Chase.

1861 Family moves to Indianapolis. Helps in father's shoe store; takes private drawing lessons from local schoolteacher.

1867 Clerks in father's store; takes art instruction from Barton S. Hays. Enters U.S. Navy apprentice pro gram, trains briefly, asks father to arrange for his release; returns to Indianapolis. Resumes study with Hays, receives advice from painter Jacob Cox. Continues clerking in father's store.

1869 Goes to New York, takes studio, studies privately with Joseph Oriel Eaton and at National Academy of Design (NAD), principally with Lemuel Wilmarth. Julian Alden Weir and Albert Pinkham Ryder are classmates. On brief return to Indianapolis, shares studio space with still-life painter David Munsey.

1870 Returns to New York. Financial support ceases when father's business closes. Eaton helps him secure portrait and still-life commissions. Goes to Saint Louis, where family has moved. Shares studio with James W. Pattison; concentrates on still lifes. Meets John Mulvaney, who talks of recent studies at Royal Academy in Munich.

1871 Receives two awards at Eleventh Saint Louis Fair. Exhibits at NAD annual. Saint Louis businessmen, led by W. R. Hodges, offer him a stipend for two years' study in Europe.

1872 Summers in London and Paris; enrolls at Royal Academy, Munich. Rooms with Walter Shirlaw and later, Frank Duveneck. Studies with Alexander von Wagner.

1873 Receives Academy bronze medal for drawing after the antique. Has contact with Leibl-Kreis artists.

1874 Joins Karl von Piloty's master classes; wins silver and bronze medals for classwork.

1875 Sends *The Dowager* to patron Hodges, who enters it in NAD exhibition; purchased by Eastman John-son. Active in Munich's American Art Club.

1876 Wins medal of honor, Centennial Exhibition, Philadelphia, for *"Keying Up"—The Court Jester.* Stipend ceases.

1877 *Ready for the Ride* sold to American dealer Samuel P. Avery. Piloty commissions portraits of his chil-dren. Goes to Venice with Duveneck and John H. Twachtman.

1878 Exhibits four paintings at inaugural exhibition of Society of American Artists (SAA). Accepts teach-ing position at Art Students League, New York. After brief visit to Munich, returns to New York; takes space in the Tenth Street Studio Building. Joins the Tile Club.

1879 Elected to SAA. Organizes renowned Tile Club three-week barge trip up Hudson River. Joins Amer-ican Water-Color Society. Founds exclusive Art Club with Weir, Ryder, William Gedney Bunce, et al., devoted to discussion of progressive trends. Through Frederick S. Church, meets Julius Gerson and his children, including Alice, who later becomes his wife.

1880 Elected president of SAA.

1881 Visits Antwerp and Madrid (studies Velázquez). In Paris, meets Carolus-Duran, John Singer Sar-gent, and Alfred Stevens. *The Smoker* (believed destroyed) wins honorable mention at Paris Salon. Returns to New York, takes Tile Club Long Island trip and experiments with plein-air painting.

1882 Sails to Antwerp with James Carroll Beckwith, Robert Blum, Arthur Quartley, and others. In Paris, sees John Singer Sargent, meets Giovanni Boldini. Spends five weeks in Madrid with Blum (they work together on illustrations for *Scribner's*) and Frederick Porter Vinton. Is founding member of Society of Painters in Pastel.

1883 Summers in Europe. With Beckwith organizes Bartholdi "Pedestal Fund Art Loan Exhibition," to help finance the Statue of Liberty pedestal.

1884 Enters sixteen works in Pastel Society's first exhibition. *Portrait of Miss Dora Wheeler* causes great stir

at SAA show. Summers with Blum in Holland. Exhibits with Belgian secessionist group, Les Vingt. With Beckwith and Edwin Blashfield, joins Frank D. Millet in Washington to speak before House Ways and Means Committee on repeal of foreign-art import tariffs.

1885 Paints portrait of Whistler in London; they go to Antwerp together to view international exhibition; Chase and Whistler part acrimoniously. Stays with Blum in Holland. After brief hiatus, resumes teaching at Art Students League. Is again elected SAA president and holds office until 1895.

1886 Marries Alice Gerson. First one-man exhibition of 133 works at Boston Art Club is major critical success.

1887 Birth of first child, Alice ("Cosy") Dieudonnée, February 9. Teaches at Brooklyn Art School. Disappointing results from auction of ninety-eight works at Moore's Art Gallery, New York. Growing financial worries.

1888 Elected NAD associate member. Is a major presence in Pastel Society's exhibition.

1889 Birth of second daughter, Koto Robertine, January 5. Seventy-four works shown at Chicago Exhibition Building. Wins silver medal at Paris Exposition Universelle.

1890 Birth of William Merritt Chase, Jr., June 5. Elected to full membership at NAD. Visits Long Island home of Mrs. William S. Hoyt in Shinnecock; is persuaded to establish summer art school with financial backing of Mrs. Hoyt and others.

1891 Shinnecock Hills Summer School founded; first of twelve consecutive summer sessions held. Death of William Merritt Chase, Jr. Poor results from auction of sixty-seven works at Ortgies. Birth of daughter, Dorothy Brémond, August 24.

1892 Family first occupies Shinnecock summer home designed by Stanford White; it will be their summer base until 1916.

1893 Birth of daughter, Hazel Neamaug, August 2. Exhibits five works at World's Columbian Exposition, Chicago, and is on committee of judges.

1894 Purchases town house at 234 East Fifteenth Street; birth of daughter, Helen Velazquez. Teaches one-month class at Art Institute of Chicago.

1895 Announces closing of Tenth Street studio; resigns teaching positions; declines to run again for presidency of SAA.

1896 Auction of contents of Tenth Street Studio. Six-month stay in Europe with Alice, Cosy, and Dorothy; teaches American students in Madrid. Returns to New York, takes studio space in Glaenzer Building, Fifth Avenue and Thirtieth Street. Summers at Shinnecock. Begins teaching at Pennsylvania Academy of the Fine Arts (PAFA). Opens Chase School of Art.

1897 One-month leave of absence from PAFA to teach life class at Art Institute of Chicago, where seventy-one of his works are shown.

1898 Chase relinquishes administrative role at Chase School of Art, which is renamed the New York School of Art (parent institution of Parsons School of Design). Birth of Robert Stewart Chase, December 19.

1900 Brief trip to Europe to arrange transport of earlier purchases to New York.

1901 Birth of Roland Dana Chase, November 19. Awarded Temple Gold Medal at PAFA, gold medal at Pan-American Exposition, Buffalo.

1902 Closes Shinnecock School. Sargent paints Chase in London. Charter member of Society of American Portrait Painters.

1903 Conducts summer classes in Holland. Solo exhibition at M. Knoedler, New York.

1904 Birth of Mary Content, February 2. Conducts summer classes in England; receives gold medal, Louisiana Purchase Exposition.

1905 Conducts summer classes in Spain; joins The Ten, filling vacancy from 1902 death of John H. Twachtman; solo exhibition at McClees Gallery, Philadelphia.

1906 Vacations in Europe; no summer classes held.

1907	Long-running dispute with Robert Henri results in Chase's resignation from New York School of Art; resumes teaching at Art Students League. Receives commission for self-portrait from Uffizi Gallery, Florence; rents villa near there to teach summer classes.
1908	Takes additional New York studio in Tiffany Building on Fourth Avenue. Elected member of American Academy of Arts and Letters. Receives knighthood in Order of Saint Michael from prince regent of Bavaria. Conducts summer classes in Florence.
1909	Resigns teaching post at PAFA, but retains studio in Philadelphia for private teaching and portrait sittings. Important traveling exhibition of his work organized by Herron Institute, Indianapolis. Conducts summer classes in Florence.
1910	Retrospective of 142 works at National Arts Club, New York. Receives Grand Prize, International Exposition, Buenos Aires. Purchases summer villa in Florence.
1912	Teaches summer classes in Bruges; resigns from Art Students League faculty. Wins Proctor Portrait Prize at NAD. Auction of work and portion of private art collection at American Art Association yields poor results. Founding member National Association of Portrait Painters.
1913	Exclusion from exhibitors' roster in Armory Show is disappointment; attends show six times, but remains unconvinced of worth of European modernism. Conducts summer classes in Florence.
1914	Teaches summer class in Carmel, California; brief trip to England. Numerous speaking engagements begin including a debate, "The Spectre of Cubism," held at the Contemporary Club, Philadelphia.
1915	Gallery devoted to his work at Panama-Pacific Exposition.
1916	Dies at Fifteenth Street home October 15 after rapid decline in the course of a lingering ailment (possibly liver cancer); buried in Green-Wood Cemetery, Brooklyn.
1917	Memorial Loan Exhibition, Metropolitan Museum of Art. Auction of family-held works arranged by Alice Gerson Chase at American Art Galleries, May 14–17, realizes only $60,151.50.
1920s	Series of exhibitions mounted with Alice Gerson Chase's cooperation to promote sale of work remaining in estate.
1927	Alice Gerson Chase dies March 31.

Selected Bibliography

Although William Merritt Chase did not leave studio records or diaries, there is an extensive body of literature devoted to his life and art. The major holdings of archival material directly related to Chase are the William Merritt Chase Archives, Parrish Art Museum, Southampton, New York, and the William Merritt Chase Papers, Archives of American Art, Washington, D.C. In addition, the papers of numerous institutions, galleries, and contemporaneous artists and collectors also held by the Archives of American Art provide essential information pertaining to Chase.

The works cited here represent sources of particular value to a basic study of the artist's career, and those marked by an asterisk include comprehensive bibliographies. It should be noted as well that the periodical literature of Chase's own time yields a wealth of information, as indicated by the sampling of quotations provided in the illustration captions in this volume.

*Bryant, Keith L., Jr. *William Merritt Chase: A Genteel Bohemian*. Columbia, Missouri and London, 1991.

Chase Centennial Exhibition. Introduction by Wilbur D. Peat. Exh. cat., John Herron Art Museum, Indianapolis, 1949.

Chase, William Merritt. "The Two Whistlers: Recollections of a Summer with the Great Etcher." *Century Magazine* (June 1910), 219–26.

———."How I Painted My Greatest Picture." *The Delineator,* 72 (December 1908), 967–69.

Cikovsky, Nicolai, Jr. "William Merritt Chase's Tenth Street Studio," *Archives of American Art Journal* 16 (1976), 2–14.

De Kay, Charles. "Mr. Chase and Central Park." *Harper's Weekly,* 35, no. 1793 (May 2, 1891), 324–28.

Downes, William H. "William Merritt Chase: A Typical American Artist." *The International Studio* (December 1909), xxix-xxxvi.

Fox, W. H. "Chase on 'Still Life.'" *The Brooklyn Museum Quarterly,* 1 (January 1915), 197–200.

*Gerdts, William H. *American Impressionism*. New York, 1984.

*Heisinger, Ulrich W. *Impressionism in America: The Ten American Painters*. Munich, 1991.

* *The Index of Twentieth Century Artists,* 2 (November 1934), "William Merritt Chase," 17–26.

In Support of Liberty: European Paintings at the 1883 Pedestal Fund Art Loan Exhibition. Essays by Maureen C. O'Brien, Ronald G. Pisano, et. al. Exh. cat., The Parrish Art Museum, Southampton, New York,1986.

*Milgrome, David Abraham. "The Art of William Merritt Chase," Ph.D. dissertation, University of Pittsburgh, 1969.

Munich and American Realism in the 19th Century. Essays by Michael Quick and Eberhard Ruhmer, catalogue by Richard V. West. Exh. cat., E. B. Crocker Art Gallery, Sacramento, 1978.

Pilgrim, Dianne H. "The Revival of Pastels in Nineteenth-Century America: The Society of Painters in Pastel." *The American Art Journal,* 10 (November 1978), 43–62.

Pisano, Ronald G. *William Merritt Chase*. New York, 1979.

*———. *A Leading Spirit in American Art: William Merritt Chase 1849–1916*. Seattle, 1983.

*———. *Summer Afternoons: Landscape Paintings of William Merritt Chase*. Boston, Toronto, London, 1993.

——— and Alicia Grant Longwell. *Photographs from the William Merritt Chase Archives at The Parrish Art Museum*. Southampton, New York, 1992.

Roof, Katherine Metcalf. *The Life and Art of William Merritt Chase*. 1917. Reprint, New York, 1975.

The Students of William Merritt Chase. Exh. cat. by Ronald G. Pisano. Heckscher Museum, Huntington, New York, 1973.

Ten American Painters. Essays by William H. Gerdts, et al. Exh. cat., Spanierman Gallery, New York, 1990.

William Merritt Chase in the Company of Friends. Essay by Ronald G. Pisano. Exh. cat., The Parrish Art Museum, Southampton, New York, 1979.

William Merritt Chase: Portraits. Essay by Carolyn Kinder Carr. Exh. cat., Akron Art Museum, 1982.

William Merritt Chase: Summers at Shinnecock 1891–1902. Essays by D. Scott Atkinson and Nicolai Cikovsky, Jr. Exh. cat., The National Gallery of Art, Washington, 1987.

*Includes comprehensive bibliography

Photograph Credits

The author and publisher wish to thank the libraries, museums, and archives for permitting the reproduction of works in their collections. Photographs have been supplied by the following, whose courtesy is gratefully acknowledged.

Index

Page numbers in *italics* refer to captions.

All works by Chase unless otherwise noted.